The Folk Art of Java

The Folk Art of Java

JOSEPH FISCHER

assisted by
James Danandjaja
Clare B. Fischer
Haryoguritno
A. Hari Santosa

KUALA LUMPUR
OXFORD UNIVERSITY PRESS
OXFORD SINGAPORE NEW YORK
1994

Oxford University Press

Oxford New York Toronto
Delhi Bombay Calcutta Madras Karachi
Kuala Lumpur Singapore Hong Kong Tokyo
Nairobi Dar es Salaam Cape Town
Melbourne Auckland Madrid

and associated companies in
Berlin Ibadan

Oxford is a trade mark of Oxford University Press

Published in the United States
by Oxford University Press, New York

© Oxford University Press 1994
First published 1994

British Library Cataloguing in Publication Data
Data available

Library of Congress Cataloging in Publication Data
Fischer, Joseph, 1926–
The folk art of Java/Joseph Fischer; assisted by James
Danandjaja . . . [et al.].
* p. cm. — (The Asia collection)*
Includes bibliographical references.
ISBN 967-65-3041-7 (boards):
1. Folk art—Indonesia—Java. 2. Decorative arts—Indonesia—Java.
I. Danandjaja, James. II. Title. III. Series.
NK 1060.J3F57 1994
745'.09598'2—dc20

Typeset by Indah Photosetting Centre Sdn. Bhd., Malaysia
Printed by Kyodo Printing Co. (S) Pte. Ltd., Singapore
Published by Oxford University Press,
19–25, Jalan Kuchai Lama, 58200 Kuala Lumpur, Malaysia

Foreword

THE study of folk art is part of the more general study of folklore, but, unfortunately, folk art scholarship has tended to lag behind mainstream folkloristics. One reason for this is that the bulk of folk art discussion tends to be purely descriptive rather than analytic. Typically, folk art books tend to be coffee-table productions, laden with handsome illustrations. It is as though students of folk art were ignorant or unaware of current theoretical and methodological techniques in folkloristics proper. The second reason is that art historians—who have admittedly devoted more energy to folk art than have folklorists—have a strange and idiosyncratic definition of folk art which has little to do with folk art as it is conventionally understood by folklorists.

While it could legitimately be argued that *all* artistic products in a culture are worthy of serious study, it is also true that academic practice distinguishes between several different levels or kinds of art. First, there is so-called élite or 'high' art, the 'great tradition'. Then, there is popular or mass art. This includes comic book illustrations, television or motion picture images, and advertising art. Finally, there is folk art or traditional art. The folklorist defines folk art as part of folklore, which means that any item of folk art must manifest 'multiple existence' and 'variation'. In other words, there must be two or more versions of any item of folk art in order for that item to be considered as authentic folk art, and, furthermore, no two versions of a folk art object will be absolutely identical. In this way, folk art differs from popular or mass art where machine-like production methods ensure that every object manufactured is more or less identical.

Undoubtedly, there is interchange and borrowing between the three levels. Thus, an élite artist may borrow from his or her folk tradition in the same way that a novelist may be inspired by a folk-tale or joke. Similarly, popular or mass culture can borrow from folk tradition. The direction of transmission is almost always from the folk to the popular/mass or to the élite, rather than the other way around. This runs counter to a commonly held misconception in South and South-East Asian scholarly circles where some scholars continue to maintain that it is the élite tradition which filters down to the folk level. This outmoded theory, termed *gesunkenes Kulturgut* (meaning 'sunken cultural goods') in the folkloristics literature argues, for example, that shadow plays and the like derive from the 'classical' epics such as the *Ramayana* and the *Mahabharata*, not realizing that these

epics were not the source of the images. These literary epics were clearly preceded by oral, *not* written traditions. We know that everywhere on the face of the earth oral tradition preceded written tradition. The very terminology of 'great tradition' to refer to the élite arts as opposed to the 'little tradition' to refer to the folk arts is a sad reminder of the persistence of this absurd and unfounded élitist theory of origins.

Art historians have added to the confusion surrounding folk art by using the term to refer to naïve art or art produced by 'untrained' artists, that is, artists who were not educated in an official art academy. Accordingly, books or essays on folk art written by art historians will often contain illustrations of paintings by named naïve artists like Grandma Moses in the United States. Inasmuch as the artistic creations of these naïve artists are, like the works of élite artists, one of a kind productions, they *cannot* be considered as folk art in the folkloristic sense, simply because there must be two or more versions of an item in order for it to be deemed authentic folklore. In most instances in folklore, the artist or creator is *not* known by name. Most folk art, like most folklore, has an anonymous creator. Just as there is no known original author of *Cinderella*, there is no artisan known to be the inventor of *wayang* (shadow theatre) puppets.

In the matter of children's art, that is, the art produced by children, the art is *not* usually folk art at all. Drawings made by children in elementary school are individual creations which may or may not owe anything to a folk art tradition. Poorly drawn pictures may well be considered a form of naïve art, but they are not folk art. Although art historians may consider children's art as naïve art to be bona fide folk art, no professional folklorist would label children's art as folk art unless it could be shown to be part of a tradition displaying multiple versions and variation such as may be the case with some of the examples shown in Chapter 7 of this book. Children's games, in contrast, are rarely made up by individual children. The preponderant number of children's games are traditional ones whose traditionality can be easily documented by comparative reference to collections of games in the literature. Doing this with children's art is much more difficult and complex.

Another significant problem in the contemporary study of folk art concerns the relationship between unselfconscious creativity within a definite tradition and the conscious manipulation of folklore materials, say, for the tourist market. The taking of folklore out of its original context and placing it in another, typically a commercial one, is termed 'folklorismus', and is surely worthy of study by folklorists and other academics. But puppet figures mass-produced for sale in airport shops to visiting tourists are not to be confused with the original puppets actually used by *dalang* (puppeteers) in shadow puppet plays. The commercialization of folk art is unquestionably a world-wide phenomenon, and purist academic folklorists have no right to object to artisans making a living by cashing in on their folk art traditions. Nevertheless, 'folklorismus' and tourist art should not be confused with folklore and folk art.

The marvellous richness of folk art traditions in Java provides an exemplary opportunity for students to explore all the critical issues surrounding the study of folk art in the modern world. The excellent 162-page survey by folklorist James Danandjaja, *An Annotated Bibliography of Javanese Folklore*, Berkeley: University of California, Center for South and Southeast Asian Studies, 1972, does include coverage of some of the early folk art scholarship.

Those readers with an interest in some of the issues discussed above might profit from reading in the international debate devoted to folk art theory, for example, Michael Haberlandt, 'Volkskunde und Kunstwissenschaft', *Die Volkskunde und Ihre Grenzgebiete, Jahrbuch für Historische Volkskunde*, I, Berlin: Stubenrauch, 1925, pp. 217–31; Arnold Pfister, 'Bemerkungen zu den Grundlagen der Volkskunst', *Schweizerisches Archiv für Volkskunde*, 43 (1946): 391–438; Friedrich Sieber, 'Begriff und Wesen der Volkskunst in der Volkskunstforschung', *Wissenschaft Annalen*, 4 (1955): 22–33; Giuseppe Cocchiara, 'L'arte popolare come problema', *Annali del Museo Pitre*, 11–13 (1962): 88–111; Henry Glassie, 'Folk Art', in Richard M. Dorson (ed.), *Folklore and Folklife: An Introduction*, Chicago: University of Chicago Press, 1972, pp. 253–80. For a discussion of naïve art versus folk art, see Volker Dallmeier and Werner Pöschel, 'Naïve Kunst—Volkskunst: ein Gegensatz?', *Volkskunst*, 5 (1982): 79–87; for the distinction between folk art and so-called high art, see Renate Itzelsberger, *Volkskunst und Hochkunst: Ein Versuch zur Klärung der Begriffe*, München: Mäander, 1983.

Also recommended are Nelson H. H. Graburn (ed.), *Ethnic and Tourist Arts*, Berkeley: University of California Press, 1976; and John Michael Vlach and Simon J. Bronner (eds.), *Folk Art and Art Worlds*, Ann Arbor: UMI Research Press, 1986. For those curious about how American folklorists approach folk art, see Thomas J. Schlereth (ed.), *Material Culture: A Research Guide*, Lawrence: University Press of Kansas, 1985; Simon J. Bronner (ed.), *American Folk Art: A Guide to Sources*, New York: Garland, 1984; and Susan Steinfirst, *Folklore and Folklife: A Guide to English-language Reference Sources*, 2 vols., New York: Garland, 1992.

For access to the burgeoning theoretical literature devoted to the concept of 'folklorismus', most of which is written in German, see Herman Bausinger, 'Toward a Critique of Folklorism Criticism', in James R. Dow and Hannjost Lixfeld (eds.), *German Volkskunde*, Bloomington: Indiana University Press, 1986, pp. 113–23; and Regina Bendix, 'Folklorism: The Challenge of a Concept', *International Folklore Review*, 6 (1988), 5–15.

It is to be hoped that the scholarship devoted to the folk art of Java will prove worthy of the exciting tradition itself.

November 1993

ALAN DUNDES
Professor of Anthropology and Folklore
University of California, Berkeley

Preface

DURING the years 1990–1, an extraordinarily large and ambitious Festival of Indonesia was held in the United States. It included more than forty art exhibitions and many more dance and musical performances. It was by far the largest and most comprehensive display of Indonesian culture and art ever held outside Indonesia, and one that is not likely to occur on such a vast scale again. The exhibitions featured ethnographic objects from the major Indonesian islands (except Java and Bali), classical sculpture (mainly pre-sixteenth century), and *pusaka* (heirloom treasures) from various royal courts throughout the country. With respect to folk art, that is, the ordinary objects of traditional culture, little was shown in general and even less from Java. There were some exhibitions of puppets, masks, and fine textiles—the most popular arts among foreigners interested in things Indonesian, and the subject of a far greater number of publications than any of the folk objects represented in this book. For this reason, such artefacts as batik, krises, jewellery, puppets made for the royal courts, and objects of sterling silver or precious stones (things which the Javanese call *halus* or refined) have been intentionally omitted.

This volume presents mainly objects, many of which took their present form in the nineteenth century, and are still in traditional use today, though at a much reduced level. It focuses on that part of material culture that is to be found in rural areas and certain urban centres. It is here generally termed folk art and includes such things as roof tiles, paintings on glass, game props, brass votive figures, household objects, naïve carving and painting, village masks and puppets, and pottery.

The chapter headings in the book reflect a particular selection based on factors that both limit its scope and define its special purposes. Despite the wide range of materials presented, a general survey of folk art was never intended because of limited accessibility to, and incomplete documentation of, many art objects. This meant, for instance, that comparisons of the material culture among the various regions of Java could not be presented in any comprehensive way. In addition, the chapters represent a variety of approaches, definitions, and materials that cut across the boundaries of folklore, folk art, naïve art, academic art, and crafts. Clarity of focus was, in part, sacrificed to obtain inclusiveness so as to make the definition of folk tradition as reasonably broad as possible. Chapter 1 presents a number of definitions of folk art and describes some of its principal characteristics that contribute to this broader view.

Chapter 2 focuses on the diversity of folk art objects which reflect the extraordinary syncretism of Javanese culture. Within this, it is clear that anyone wishing to work on the folk art of Java will have to be informed by and understand the imported Hindu–Buddhist tradition and the influence of Islam. Chapter 3 attempts to cover this within a discussion of the related subject-matter depicted on glass painting. Again, anyone seeking to appreciate and comprehend the culture of Java must also look closely at the *wayang* (shadow theatre) tradition and especially at the folk heroes and special characters that are so much a part of it. Chapters 4 and 5 present some of the *wayang* stories and personalities in relation to their expression in folk art.

Another revealing source of Javanese culture is its folk literature and, particularly, its folklore. Chapter 8 deals with one of the most popular past and living legends in Central Java, that of the story of Ratu Kidul, Queen of the South Sea. Other folk stories are found in Chapter 3 (for example, Joko Tarub) and in Chapter 7 on children's art. Furthermore, the folk tradition as a source is brought into modern focus in Chapter 9 with reference to the contemporary work of selected naïve and professional artists.

This volume is intended primarily to illustrate the richness and diversity of Javanese folk art and thus, hopefully, to stimulate research on, and greater interest in, this much neglected part of Indonesian cultural expression. Much work needs to be done on the evolution of particular folk art objects as well as on their makers and traditional users. Ideally, several folk art sources need to be studied from past historical records, from literature, from interviews with contemporary folk artists and artisans, and from research on the where, what, and how of that which was—or is—being produced. This would include, for example, looking at pottery-making villages like Kasongan, at small foundries in Central and East Java which still produce brass and bronze figures, at the renaissance of painting on glass in the cities of Çirebon and Surakarta, at shadow puppet makers in and around Yogyakarta, and at the continuing production of rural arts throughout Java for both cultural and modern commercial purposes. Here, tradition and modernity are often in competition because of social changes and economic constraints, but this need not be so. It is clear that what truly distinguishes Javanese culture in the eyes of the world are its arts, both plastic and performing. Indeed, these arts are a distinctive hallmark of all major ethnic groups in Indonesia. The art produced and used by ordinary folk in Java over centuries and continuing today is singularly impressive and instructive. It can tell us about time, past and present. It is a precious resource for cultural identity, for ethnic creativity, and in the promotion of Indonesia's national motto, 'Unity in Diversity'. It is the hope that others will take up the task of research and scholarship on the folk arts of Java. Thus, any errors and omissions which are bound to be found in a volume of this scope will be rectified in the future and the needed scholarship extended and intensified by others.

Berkeley, California
October 1993

JOSEPH FISCHER

Acknowledgements

THE visual materials so essential to a book of this type come mainly from three sources, the most important of which were colour transparencies provided by NU-AGE (Jakarta) from the collection of its creative director, Emmo Italiaander. Without his enthusiastic support and collaboration, the writer probably would not have undertaken the project. I wish also to thank D. H. Dhaimeler and the Duta Fine Arts Foundation for providing some visual materials. Most of the other objects reproduced are from the author's personal collection, sensitively photographed by Dennis Galloway of Berkeley, California. Additional objects were photographed by the author in Indonesia (1992) at the homes of private collectors and at various antique shops, mainly in Yogyakarta. In this connection, I wish to thank Nyonya Cut Nariman Yaman, Dr Djuretna Adi Imam Muhni, Djuhertati Iman Muhni, and Ardiyanto for opening their homes, and D. Sukardi (Ancient Arts Gallery) and the Asikin Antique and Art Shop for being so helpful. The collections of the Museum Sono Budoyo were made available due to the kindness of its director, Dr Roedjito, and the help of one of its curators, Bejo Haryono.

For assistance in Bandung in introducing me to the renowned maker of *wayang golek* (rod puppets), Aming Sutisna, I deeply thank two prominent women artists, Erna Pirous and Farida Srihadi. In the same city, I am indebted to the Mastran Fine Art Gallery for permission to photograph part of its modern Indonesian art collection.

For assistance and hospitality in Surabaya, I am grateful to Dr Budiman Christiananta and his wife, Mrs Parlinah Moedjono, Mrs Siti Sundari Rangkuti, and an expert on the culture of East Java, Soenarto Timoer. Soedarso SP introduced me to Sagio, a highly skilled maker of *wayang kulit* (shadow puppets) in Bantul. Tis A. Lingga, a wonderful friend and superb guide, assisted me in Yogyakarta. Hani Winotosastro was kind enough to permit me to photograph in her family's batik store and factory in Yogyakarta. For translation work, Clare Fischer and I wish to thank Dr Roosyana Hasbullah.

My mentor on all things Javanese, and especially *wayang kulit*, is Haryoguritno, who supplied information for the chapters on the *wayang kulit* and the *panakawan* (clown-servants). He is a constant producer and promoter of traditional art, especially shadow puppets and the kris. I am also grateful to members of his family for help in translation.

The chapter on games is partly based on material supplied by Professor James Danandjaja of the University of Indonesia, a close friend of long-standing and Indonesia's most famous folklorist.

The section on children's art is based on the experience, support, and collection of A. Hari Santosa, an unusually gifted art teacher and founder of a superb children's art school in Yogyakarta, the Sanggar Melati Suci. He is instrumental, every year, in organizing a children's public art exhibition which inspired me to appreciate this art as part of the folk tradition of Java and thus include it in this volume.

The chapter on Ratu Kidul was written by Professor Clare B. Fischer of the Starr King School for the Ministry. Her special interests are the sociology of religion, ritual, and women's studies. Her contribution particularly reflects what is sorely needed in Java folk studies—scholarship based on historical sources and comparative perspective.

I wish to thank William Sinkford for his patience and expert use of the computer on my behalf. He enabled me to dispose of the tedious but necessary work of transcription. I am also very grateful to Sylvia Fraser-Lu who was very supportive of this undertaking from the beginning.

My constant companion and supporter, both emotional and intellectual, in all my endeavours has been my wife, Clare.

Contents

1 Introduction: Definitions and Distinctions

IT has been written that 'in a living tradition art was a means of communication, another kind of language, a way of conveying without words some basic concepts of philosophy and religion—to educate or to inspire, to help put the individual in harmony with the universe, or to give him magic protection'.[1] If this is a valid view of art in general it applies even more profoundly to folk art in particular: 'Folk art ... has been the primary vehicle through which people have expressed their dreams and fears, courted their lovers, amused their children, worshipped their gods and honored their ancestors.'[2] It 'becomes the totality of objects that vary at the pleasure of their creators while holding steady over time to preserve and express a culture's deepest ideas'.[3] In the varying discourses on what constitutes folk art, there is a notable tendency to link this genre primarily to the traditions and efforts of village and countryside. In this context:

The rural arts ... are the visual expression and technological processes of people living at several cultural, religious and sociological levels. They are the art of the settled village and countryside, of people with lives tuned to the rhythm of nature and its laws of cyclic change, and with a central concern with the earth and with harvesting. It is the art of people with memories of ancient migrations forced by war, epidemic, hunger and of live myth that makes the archaic ... gods and legend contemporary; an art involved with household and fertility ritual ... and ... rites that invoke and establish the goddess, the quickened kernel of energy and power, within the hut and the village community.[4]

The above was written with reference to India but it applies just as readily to most folk art traditions throughout the world, and in this case is particularly appropriate to Java. As with India, the folk art of Java 'should be regarded not only as an essential constituent of [Indonesian] art, but also ... as a clue to the latter's history and this ... because of its long and continuous traditions, ... because of its wide dissemination throughout the [nation] and ... because of its identification with the people as a whole'.[5] There is, however, among the many definitions of the character and value of folk art a thin line between description and adulation. For many scholars and collectors, the term 'folk'—and its rural connotations—is extraordinarily seductive and can lead easily to a sentimentalization of the artistic past

and a bias against contemporary urban culture. It must be kept in mind that 'one of the factors that adds complexity to the rural situation is that in its memories are a fusion of the sophisticated and the naïve, the sublime and the shamanistic, the classical equilibrium and the savage distortion, the cosmic appreciation and the demonic ritual'.[6]

In the case of Java, one of the most densely populated regions in the world, the distinction between urban and rural and village and town cannot exactly be defined. The search for genuine folk objects to be used in this book was conducted mainly in Yogyakarta, which is a city composed of many village-like compounds, surrounded in its special administrative province by clusters of large villages and small towns, and serving as a major market for consumers and artisans alike throughout the region. Çirebon in West Java and Surakarta in Central Java are similar cities in their urban–rural connections and as centres of folk art. There is hardly a part of Java that is not riddled with the objects of folk culture, though some of these are dying out and some are being subverted by commercialism; a few are still thriving. This is in contrast with Europe where the distinction between rural and urban and folk and city culture has been in the past quite clear.

The continuity of this folk art, in contrast with so-called 'high' art, is achieved solely by means of constant reproduction and repetition, yet with a great deal of variety and more creativity than is generally assumed. Almost by definition, this art of the people is ephemeral; it is not like the artistry to be found on the great temple of Borobudur or the impressive stone sculptures found in sites like Prambanan. The materials used for the most part in making folk objects are perishable and their makers anonymous. Materials used in their production, such as fibres, leather, paper, scrap metal, wood, and matting, are readily available.

There is a general scholarly agreement on the major aesthetic characteristics of folk art. These consist primarily of five main components: two-dimensionality, a preference for symmetry, a lack of perspective, the importance of decoration, and some functional purpose.[7] In Java, the shadow puppets, folk paintings, batik, and paintings on glass conform fairly well to these characteristics, while other objects, such as masks, statues, wood carvings, and pottery, do so only in part. The folk art depicted in this book was selected generally to illustrate some aspect (myth, ritual, symbol, etc.) of traditional culture in Java. Thus, the term 'folk' refers to those people living on the island largely outside cities and includes the two major ethnic groups that dwell there—the Javanese (in Central and East Java) and the Sundanese (in West Java). It is to be noted that the stories, characters, and symbols connected to the selected art objects are fairly widespread throughout Java. However, practical considerations have dictated that there is much more material represented from Central Java, the heart of ethnic Javanese culture.

A major problem in any selection of folk art involves making valid distinctions between art and craft. In Java, this problem is compounded by the dramatic rise of tourism in Indonesia over the last twenty

years. For example, batik painting, which hardly existed before 1975, has now become a major commercial enterprise emanating mainly from a large residential compound within Yogyakarta of 'folk' batik painters and designers whose work is sold throughout Java and Bali. It also includes a number of modern artists working in the major contemporary art centres of Jakarta, Bandung, Yogyakarta, and Surakarta. Much of this batik painting, depicting heroes and scenes from the *Ramayana* and *Mahabharata*, highly decorative designs of flowers and animals, idyllic landscapes, and romanticized village settings, is obviously tourist art. However, many folk art traditions that had practically died out twenty or more years ago are now being revived, though not for cultural reasons. For example, the *loro blonyo* or so-called bride–groom figures that were formerly only used in the Javanese nuptial ceremony are now being produced in great quantity, obviously for other than ceremonial purposes. The same can be said of new puppets and masks that are not intended for performance, and metal statues of gods, goddesses, and mythical figures that make attractive souvenirs. What counts here is the extent to which the rendition of new 'folk' objects is authentic, that is, true to past types, and the maintenance of a certain traditional aesthetic of preferred colour, shape, and form as well as a high quality of skill and material. The fact is that many traditional Javanese cultural practices are changing and fading away so that finding a 'genuine' antique folk art piece does not mean that the symbol, idea, or practice it represents is still in traditional use. The distinction, then, between original and newly produced folk art becomes less meaningful if the object is 'authentic' as noted above. The reference point is whether the object represents a true type, and by this test is connected to some past or present important element of tradition in Java. The fact that 'consumers cease to be producers and the product is no longer made where it is used' is to be regretted but does not necessarily mean that the art no longer has historical significance or contemporary cultural value.[8] The academic purist who holds strictly to the rule that the maker and user be locally and traditionally linked, and that all materials be naturally available within the culture will of course disagree with this broader definition of folk art.[9] The grounds for including folk art in this volume are based on four main criteria: aesthetic attractiveness, skilful rendering in technique and materials, authenticity based on traditional depiction, and custom and cultural relevancy based on past or contemporary use.

The producers of folk art in many countries have been variously categorized and differentiated. Unfortunately, there have been hardly any major studies of Indonesian folk art in general and almost none of either the folk artisans or crafts people involved. This lack is particularly noticeable in Java where the large quantity, high quality, and diversity of folk art, past and present, is so striking. Furthermore, studies that have been made, for example, of the puppet tradition in Java, have dealt only in passing with their makers and their skill and techniques, with the traditional conventions used in the figures, and with their aesthetics. The need for serious research on the makers

themselves is underscored by the fact that 'there is very little information to be gleaned from early literary sources on the history and nature of folk art'.[10] Though this statement was again written with reference to India, it applies just as well to Indonesia. This is noteworthy because the majority cultures in both these countries have extensive literatures. The customary anonymity of folk artisans, the development of élitism in religion, the rise of court culture, the impact of colonialism, and the advent of industrialization are some factors that accounted for the low status of folk art and its general lack of appreciation in Indonesia. The living folk tradition can be a major source for examining Indonesian art and related history. In a sense, one is almost forced to work backwards in Java, using interviews with artisans and local users of folk art objects to determine their historical evolution, past cultural context, and contemporary meanings.

There are in Java and in many other places in the world at least four categories of folk art producers. The first are artisans, many of whom, generation after generation, have made objects for practical and ritual use by local consumers. They are governed by the requirements of dominant religions, by trade, and by barter. They were often, and to a lesser extent still are, members of craft guilds or special castes who congregated in particular geographical areas. In Java, by the end of the nineteenth century, these artisans, under the impact of colonialism and tourism, also began to make objects for sale as curios and gift items for local as well as foreign buyers. In present-day Java, the bulk of their artisanship is directed towards this commercial market. They produce most of the puppets, masks, pottery, decorative carvings, and the like that are available in shops and department stores everywhere on the island. The quality of this 'folk' art varies greatly in its skill of execution and its cultural authenticity. A great deal of it is neither skilled nor authentic; many Javanese, of course, know the difference and do not buy or pay accordingly. Moreover, the most sophisticated and knowledgeable collectors tend to reserve their best aesthetic judgements and preferences for the 'highest' forms of art, such as the intricately carved and gilded puppets that derive from royal court traditions, or *halus* (finely hand-drawn) batik, and perhaps most strongly for that extraordinary example of metalwork, design, decoration, and Javanese symbolism, the kris. These local connoisseurs are no different from most consumers of so-called fine art anywhere in the world.

A second category of folk art producers may be termed amateurs. These people produce traditional objects on an irregular basis since they are employed in regular occupations such as farming and/or they occupy traditional roles as parents and grandparents. They may or may not sell what they make, but in any case the object will be used locally by the maker or by a neighbour or family member. Many of these amateurs are women who paint, weave, or make batik. Some may develop into regular folk artists who make their objects mainly for sale. The woman artist Ibu Masmundari of East Java is such a person (her work is discussed later in this volume). She is a folk artist producing paintings of traditional life about her village. Most amateurs who remain part-time creators, however, are anonymous and

may not necessarily produce objects that have any particular traditional content. These are the whittlers, dabblers, and hobbyists who may make something just for the fun of it or for personal satisfaction, and once in a while create something that is quite distinctively individualistic yet reflects traditional culture (several examples are presented in Chapter 2).

The third category is that of naïve artists (usually painters). They are folk artists who are not part-time amateurs; they learn their trade as students or apprentices from schools, teachers, or other artists. Naïve painters, by contrast, are largely self-taught and are ordinarily inspired by what they feel and see close at hand. Their subjects and objects appear to be frozen in time: 'what you see is what you see'.[11] Within this definition, the inclusion of certain kinds of children's art is appropriate as much of it, as exemplified in Java, is without artifice; it deals, in a straightforward manner, with ordinary life and culture. In analysing both these latter categories, folk artists seem to prefer in their own work religious figures, didactic prints, national heroes and heroines, political and social satires, astrology, and historic cultural events. The naïve artists, on the other hand, be they adults or children, seem to favour mythology, folklore, personal dreams, imaginary voyages, flowers, portraits, and daily life.

While Masmundari and many children represented in this book easily fit into these categories, an artist like Sukamto Dwi Susanto of Yogyakarta, who had formal art training, who paints mostly village life, and is now a commercial success, is not so easy to label but belongs to a separate category. He is clearly a folk artist despite the fact that local people and outsiders tend to associate him with the naïve tradition.

Whatever the case, art historians and anthropologists need to begin research into the life and work of folk artists in countries like Indonesia so that authoritative analyses can be made of their history, their characteristics, and their cultural importance. The enormous number of serious publications on American folk art over the last thirty years has allowed statements such as 'the American emphasis on individuality is unique among world art, making it more appropriately naive rather than folk' to be made.[12] With respect to Indonesia, we need to know whether, as has been the case in India, the 'craftsman was the link between the monumental forms of the great tradition, the rural gods and the tribal deities of forest and mountain'.[13] With the recent rise of post-modern criticism in the West and the world-wide dissemination of traditional art forms and indigenous art criticism from and about Africa, Asia, and Latin America, a further coalescence of folk and contemporary art is slowly taking place so that at some not too distant time there will be universal acceptance that 'not fine, nor folk, nor primitive, not sensual nor conceptual, useless nor useful, traditional nor original, art is'.[14] Before this can be fully realized,

the disciplines of social anthropology, art history, a study of oral traditions and of vernacular literary theory will have to coalesce to give future research

[on folk arts] content and meaning. . . . [These] arts arise out of a primordial vision that reaches out towards the cardinal directions, observing the sacred contours of the land, delineating the sanctity of enclosed spaces, naming the guardians of the cardinal points of direction, and establishing the sacred altars ... of the Goddess at the extremities of the country. An insight charged with delight that established the holy places ... on the peaks of mountains, on the sea shore and in the midst of dense forests.[15]

Grand words! Java is a good place to begin this pursuit; and in this pursuit a broad definition of folk art is used. It is one which selects those objects, drawings, and paintings which are significant elements of past or present traditional culture. It is a compromise that may permit, and certainly should encourage, the aesthetic as well as the anthropological exploration of the folk art tradition.

1. Schuyler V. Camman, 'Symbolic Meaning in Oriental Rug Patterns', *Textile Museum Journal*, III, 3 (1972): 6.

2. Marion Oettinger, Jr., *The Folk Art of Latin America*, New York: Dutton Studio Books and Museum of American Folk Art, 1992, p. 1.

3. Henry Glassie, *The Spirit of Folk Art*, New York and Santa Fe: Harry N. Abrams and Museum of New Mexico, 1989, p. 88.

4. Pupul Jayakar, *The Earthen Drum: An Introduction to the Ritual Arts of Rural India*, New Delhi: National Museum, 1980, p. 2.

5. Heinz Mode and Subodh Chandra, *Indian Folk Art*, New York: Alpine Fine Arts Collection, 1985, p. 35.

6. Jayakar, *The Earthen Drum*, p. 6.

7. For a discussion of these characteristics, see Ernst Schlee, *German Folk Art*, Tokyo: Kodansha International, 1980, pp. 105–10.

8. For an excellent analysis of folk art definitions, methods, criticism, and historical analyses, see Jean Cuisenier, *French Folk Art*, Tokyo: Kodansha International, 1977, particularly pp. 9–13, 27–9, 60–4, and 98–9. See also the various pertinent references discussed by Professor Dundes in the Foreword.

9. For examples of my use of this broader definition as it applies to certain textiles, see Joseph Fischer, 'The Character and Study of Indonesian Textiles', in Mattiebelle Gittinger (ed.), *Indonesian Textiles: Irene Emery Roundtable*, Washington, DC: The Textile Museum, 1980, pp. 339–54.

10. Mode and Chandra, *Indian Folk Art*, p. 32; see their extensive treatment of the subject, pp. 22–37.

11. Cuisenier, *French Folk Art*, pp. 98–9.

12. Lynette I. Rhodes, *American Folk Art: From the Traditional to the Naïve*, Cleveland: Cleveland Museum of Art, 1978, p. 13.

13. Jayakar, *The Earthen Drum*, p. 17.

14. Glassie, *The Spirit of Folk Art*, p. 258.

15. Jayakar, *The Earthen Drum*, p. viii.

2 Diversity and Significance in the Folk Art of Java

THE Republic of Indonesia consists of over 13,000 islands stretching in a 2850-kilometre arc from Sumatra to Irian Jaya encompassing over 1 090 000 square hectares of land on which live over 183 million people and more than 100 distinctive ethnic groups each with its own language and art forms. Historians have described Indonesia as a syncretic civilization where ancient primal religion lies beneath a layer of Hindu–Buddhist tradition which itself underlies what became the main faith of the country, Islam. Add to this diverse history the arrival of the Portuguese in the sixteenth century, the establishment of Christian missions over a 200-year period, the more than two centuries of Dutch colonial rule, the Japanese occupation during the Second World War, and the gaining of independence through revolution in 1947, and you possess a country which is one of the most diverse nations in the world. While this has created problems for political integration and for economic development, the diversity of traditions and cultures has resulted in an extraordinarily remarkable social development of art and craft, much of which is centred in Java. Whether it be the magnificent bas-reliefs in stone temples such as Borobudur, the marvellous statuary, such as the three giant Buddhist figures in Mendut temple, the beautiful ancient bronzes of 'bells, dancers, disciples and gods', the forceful renditions of the *Mahabharata* epic in the *wayang beber* paintings (episodes on a cloth scroll which are unfolded during performance), the golden jewellery of the Majapahit period, or the exquisite gilded shadow puppets of the royal courts of Yogyakarta and Surakarta, it is all present. High art, fine art, folk art and craft, however it is defined, is in Java. If you include textiles, you get an even more amazing diversity of artistic traditions, forms, techniques, and subjects that is difficult to replicate elsewhere. It is indeed not only the quality of this art that has been impressive but the sheer variety and creativity of the forms that it takes. The architecture, classical statuary, and objects associated with the performing arts in Java have been relatively well studied and, by world standards, have been judged to be the aesthetic hallmark and artistic high point of the cultures of Java. The folk art tradition, however, is, in its own underestimated context, equally diverse and impressive. What follows is intended to give visual evidence and meaning to this creativity and

diversity and to raise the folk art of Java to the level of serious inquiry and high praise which it deserves.

The discussion in this chapter is mainly guided by the visual material displayed in this book. These objects have been selected to illustrate the great variety of folk art still being produced in various regions of Java. This variety is illustrated by comparing similar objects made in West, Central, and East Java and describing, if not accounting for, differences. These pertain as well to those folk art pieces that are no longer made, or are rarely being made, which are generally found in museums, antique shops, and in the homes of private collectors. Some are of moderate antiquity; some have only recently become rare. All the art objects presented here in some way reflect, or are linked to, the traditional culture of Java. Some of these links are significant, like painting on glass and *loro blonyo* (bride–groom) figures, some less so, like roof tiles and Kasongan pottery. Regardless, objects were selected because they have seldom been reproduced in books or studied. The omission of these so-called minor arts has left the impression that the only significant folk art in Java consists of puppets, masks, and textiles. Thus, folk figures such as Hanuman and the *panakawan* (clown-servants) are usually depicted or represented as masks and puppets; they are rarely reproduced in their other forms. Similarly, this is so with common mythological and real animals. Some examples of the above include cheap, popular prints of characters like Semar and Hanuman (Plate 1), humorous paintings on glass of Gareng and Petruk (Plate 2), Hanuman in the form of an oil-lamp stand (Plate 3), wooden printing blocks of *wayang* (shadow puppet) figures and animals like elephants, pigs, and tigers (Plates 4 and 5), and kris boards (Plates 6–9).

In the naïve tradition, three wooden sculptures are presented as evidence of both the quality and diversity in this category of folk art. There are certainly many more to be found in rural Java but they have generally been shunned by Indonesian collectors and museums. Their distinctiveness somewhat diminishes their value as primary cultural objects that can be compared from period to period and from region to region. However, they clearly attest to the fact that even in the most traditional societies there are always individuals independently dabbling and scribbling in the arts. Naïve art may not always reveal something about local culture but in Indonesia, at least, much of the time it does. Shown in Plate 10 is a seated figure of a musician playing a stringed instrument. He is wearing a traditional Javanese hat and a jacket of *lurik* (a special cotton textile woven in Central Java) that is glued to his wooden body. The painting is sparse and without much attention to detail. The figure appears to be that of a travelling musician who circulates from town to town with a troupe of performers or it may be that of a lone musician playing on a street corner or in villages on special occasions.

Plate 11 shows an apparently young village woman with bent back leaning on a stick for support; she appears to be ageing well before her time. It is a striking and unique piece of art; it has almost a refined

1. Hanuman, contemporary colour print.

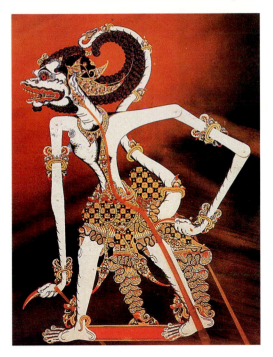

2. Gareng and Petruk as soldiers, contemporary glass painting.

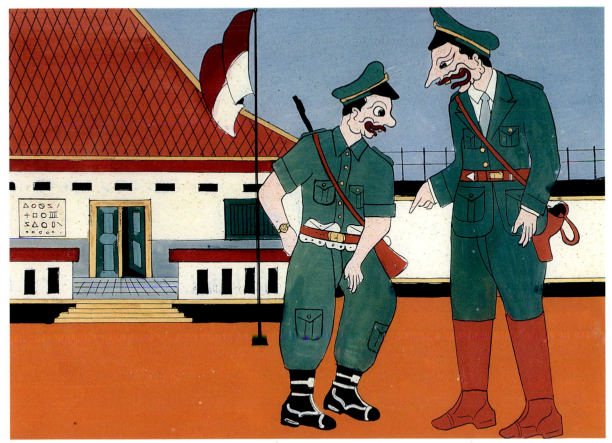

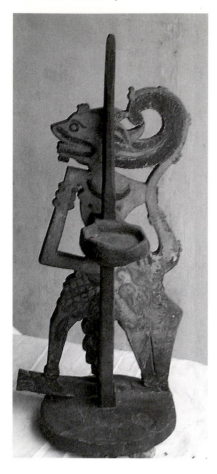

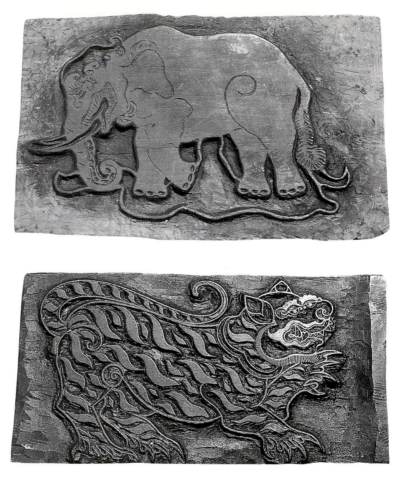

3. Hanuman, painted wooden oil-lamp stand, pre-1950.

4. Elephant, wooden printing block, pre-1960.

5. Tiger, wooden printing block, pre-1960.

sculptural quality rare in the naïve tradition and uncommon in the Javanese repertoire. The last one of a kind example in the naïve mode is the bust of an old man (Plate 12). It is a portrait of a Javanese man wearing a traditional batik hat. The careful and deep carving on his face highlights lines of ageing and contributes to an outward expression of calm and control. There is a meditative quality about this folk sculpture enhanced by its inward containment of feeling, a *halus* (refined) trait so highly desired by the Javanese.

Finally, there is a ceramic sculpture of a Javanese figure, mythological or historical, whose identity is uncertain but may possibly be Antareja, the eldest son of Bima (Plate 13). It was purchased in 1992 in one of the hundred or so stalls selling antiques, curios for tourists, and bric-à-brac in Jalan Surabaya in Jakarta. Its origin and identity are somewhat of a mystery that will no doubt be solved by someone in the future.

One of the most interesting examples of folk art in Java is associated with an extremely important Javanese traditional rite of passage, the wedding, with its elaborate pre-nuptial ceremonies. They are the *loro blonyo* wood or ceramic figures in the form of a stylized couple representing Dewi Sri (the goddess of fertility) and her consort, Sadono.

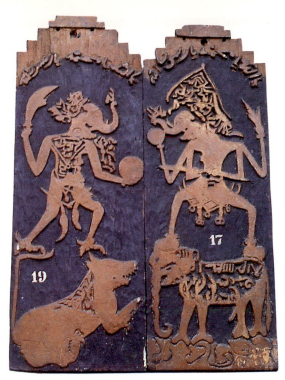

6. Kris board of wood with elephant
faces and Arabic calligraphy,
Çirebon, 1935.

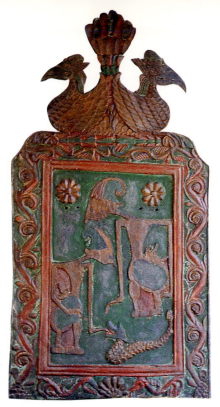

7. Kris board of wood with figures of
Rama and Sita, Yogyakarta.

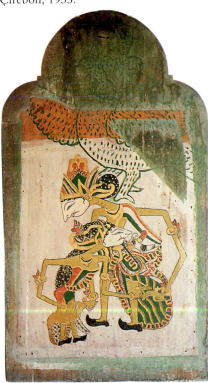

8. Kris board of wood with *wayang*
figures and Garuda.

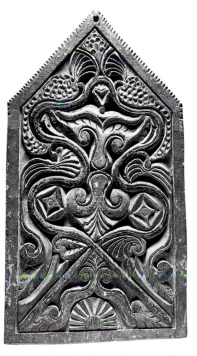

9. Kris board of wood, geometric
design, Çirebon.

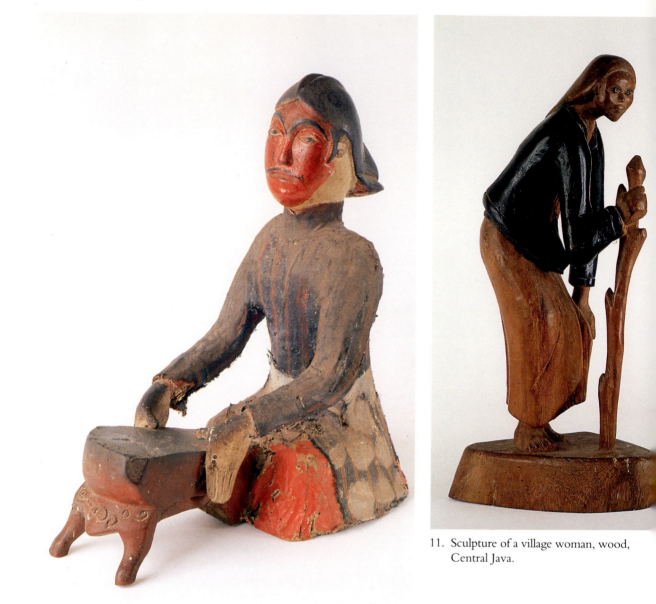

11. Sculpture of a village woman, wood, Central Java.

10. Sculpture of a village musician, wood and cloth, Central Java, pre-1950.

Traditionally, these were placed in front of a special canopied bed (*krobongan*) as a part of the nuptial ritual. This tradition originated in the courts of Surakarta and Yogyakarta and was limited to royal and aristocratic families. It may, however, have first evolved 'from the simple desire of the ordinary Javanese farmer to supply a comfortable place for the female protector to rest'.[1] The *dalem* (special room) in which the figures are placed contained an incense burner, a lamp that was kept lighted, two cuspidors, two earthen water jars, food bowls, and flowers. Once the wedding ceremony had begun, the *loro blonyo* were removed and their place taken by the bride and groom.

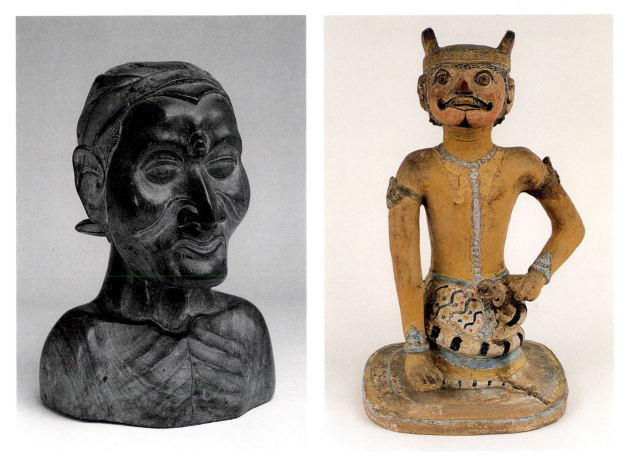

12. Sculpture of a Javanese man, wood, Yogyakarta, pre-1958.

13. Ceramic statue of a *wayang* figure, possibly Antareja, the eldest son of Bima.

Nowadays, the *loro blonyo* are mistakenly called marriage figures but their traditional use is declining and from 1950 to 1980 they were rarely made and were difficult to obtain. Since the 1980s, however, great numbers have surfaced in antique and souvenir shops, especially in Yogyakarta.

Formerly, Dewi Sri was invariably shown in traditional dress with a *kemben* (waist cloth), with bare shoulders, gold jewellery on her arms and wrists, a medallion on her breast, a large buckle around her waist, and gold ornaments and flowers in her highly stylized lotus-like *coiffure*. Sadono was depicted with bare shoulders and arms, gold arm and chest ornaments, a gold buckle, and a batik *kain* (sarong). The couple was intended to be portrayed in a lifelike manner usually sitting cross-legged in a serene pose (Plate 14). Folk artists have since depicted the *loro blonyo* with shoulders and arms covered with bright blouses or jackets. They are either standing or kneeling; their facial expressions are often much more intense than in traditional depictions (Plates 15 and 16).

The *loro blonyo* possibly represent a unique tradition in the annals of folk art around the world. Regardless of their present-day use and changing portrayal, they provide significant links to ancient rites and

13

long-standing customary values. They illustrate the complex connections and history of an evolving tradition in Javanese culture from its old antecedents in Indian mythology (that is, Sri Devi, wife of the god Şiva) to a goddess of fertility among the farmers and villagers of Java, to a special ritual in the royal courts of Yogyakarta and Surakarta, and then changing again in modern times back into a folk art, and most recently into a commercial craft.[2]

One of the most elaborate, revealing, and venerated objects of the Javanese 'high' tradition is a ritual weapon with a snake-like, finely worked blade, special refined fittings, and an aesthetically elegant wooden sheath and hilt—the kris.[3] Together with the shadow play and batik, the kris is regarded among the trio of arts that best express the most sophisticated as well as the most common features of Javanese culture. Though the kris is used by other ethnic groups in Indonesia, it does not have as great a significance as it does in Java, where it represents a singularly important contribution to the study of traditional adornment, ritual, and status.[4] It is not, however, a part of the folk tradition, for its use and meaning developed almost entirely within the court tradition. Moreover, the process of making a kris is technically extremely complex, requiring a great deal of experience, skill, and time on the part of master metalsmiths and other artisans, and thus removing it from the abilities of ordinary folk artists and from the purchasing power of ordinary consumers.

There is, however, one element in the 'dressing' of the kris that appears at times to fall within the ambit of the folk tradition, and that is the kris handle (*ukiran*).[5] It is the *ukiran* that varies greatly from region to region within Java and among various other islands, for

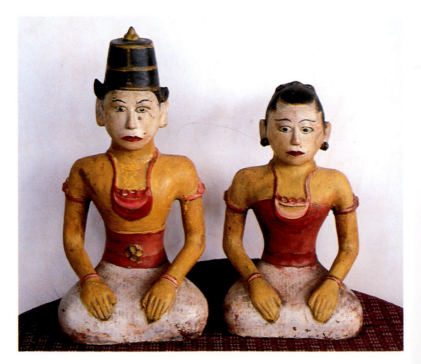

14. Dewi Sri and Sadono (*loro blonyo*), terracotta.

example, Sumatra, Sulawesi, Madura, and Bali, and it is the only part of the whole that can aesthetically stand alone. The impressive art-istry and folk qualities of these handles have, in fact, attracted as much—or even more—interest among collectors outside Indonesia than the kris itself.

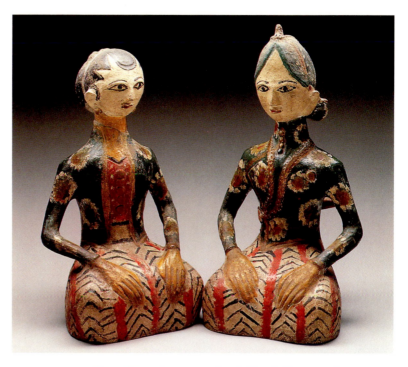

15. Bride and groom (*loro blonyo*), terracotta.

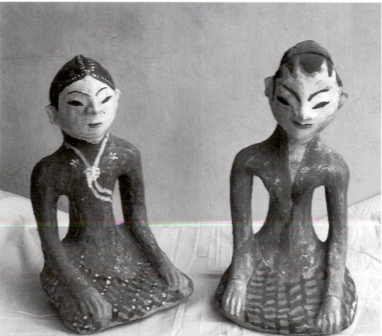

16. Bride and groom (*loro blonyo*), terracotta.

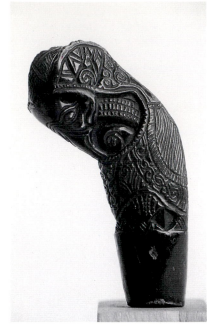

17. Kris handle in the form of an elephant, wood, pre-1955.

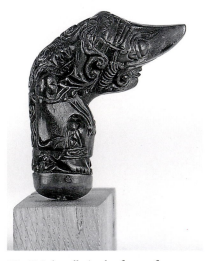

18. Kris handle in the form of a *wayang* figure, wood, pre-1955.

Many *ukiran* are quite stylized, conforming to established conventions of what constitutes in them both traditional authenticity and élite appropriateness. These include an abstract countenance, little decoration, and a rigidity of form.[6] These reflect court and aristocratic origins and preferences, and, because of this, such types are not our concern here. Rather, it is those handles in which is reflected some element of the broader cultural tradition and which thus fall into a folk art category.[7] The *ukiran* of wood from Central Java shown in Plate 17, in the form of an elephant with its disappearing trunk and intricately carved body, is an example. This figure may be a stylized form of Ganesha, the god with the head of an elephant and the body of a man, who is much revered in Java for his wisdom and as the remover of obstacles. This particular handle, in its execution, design, and compactness, forms a small sculpture exhibiting an unchanging yet endearing quality typical of much folk art. Similarly, the *ukiran* in Plate 18, in the form of a *wayang* character, exhibits such qualities, though it is more animated. A more pronounced example of this category of folk art is the *ukiran* in Plate 19, a kind of anthropomorphic figure with the face of a human with bird-like features, and haunches and toes that could be a part of some animal. It is ornately carved and there is a tenseness in its staring face which is shaped with less restraint than the previous two examples. Finally, there is an *ukiran* in which the human figure is so abstracted that it borders on disappearing (Plate 20). This kind of abstraction appears every once in a while in various forms of folk art, such as pottery and baskets, and in some objects that have Islamic motifs. There are, of course, elements of the abstract in some batik sarongs but these are not commonly thought to be part of the folk genre.

Very little research has been done on the *ukiran*. Investigation is complicated by the fact that there is a multitude of types made from a variety of materials (wood, bone, ivory, silver, and gold) all over Indonesia. Because the *ukiran* is the only part of the kris ensemble that permits drastic variation from the court tradition, these variations can be extremely ornate and forceful, as in the case of examples with long beak-like noses from Sulawesi, anthropomorphic figures from Sumatra, and upright renditions (sometimes in sexual poses) of humans and monkeys from Bali. Aside from their diversity, one of the hallmarks of these *ukiran* as an art form derives from the extreme limitation of size and materials; mistakes in such confined spaces cannot by definition be permitted. The emergence of small yet striking pieces of sculpture under these conditions is quite remarkable. The aesthetic attraction of many of these *ukiran* stems from their openness to folk variety as well as their function in 'capping' the prime Javanese symbol of mysticism and spiritual power, the kris. In many of these precious and creative pieces of small-scale sculpture, both art and function are served, and both the folk culture and the 'high' culture are combined. If the kris is Indonesia's unique contribution to art and symbol, so are its *ukiran* which can stand alone as separate creations.

It is not surprising, given the sacred status of krises, that special

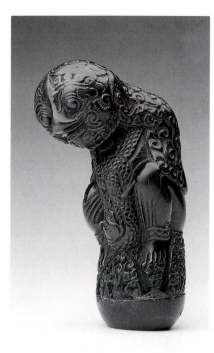

holders or boards are made to display them. These kris boards provide another opportunity for folk art to express itself. Although they exist in great variety in terms of decoration, they are generally contained in a long, curved, triangular form reminiscent of a mountain. The most elaborately carved examples come from the West Javanese city of Çirebon where both Islamic and Chinese influences have predominated due to this city's connection with the early establishment of Islam and as an important trading centre for immigrants from China. This is evident in the kris board shown in Plate 6 where Arabic calligraphy is combined with a Chinese motif, grotesque Sundanese *wayang* figures, an elephant, and an unidentified wild beast. Indicative of the strong aesthetic design and the engaging folk quality of many Çirebon carvings is the wooden food tray shown in Plate 21 and the wall decoration in the form of a fish in Plate 22. Both contain the wavy motifs of Chinese design; the food tray demonstrates the use of a folk image strongly depicted through paint and bas-relief carving.

The mixing of cultural sources in Indonesian society is relatively common and the kris board shown in Plate 6 is a splendid example because it not only combines these sources but also exhibits, in the character of the portrayals and decorations, a strong folk art element.

19. Kris handle in the form of an anthropomorphic figure, wood, pre-1955.

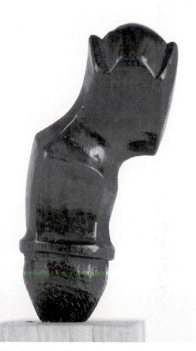

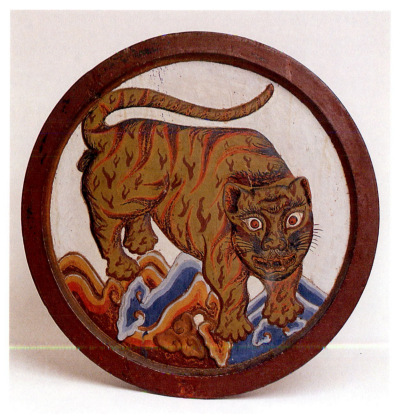

20. Kris handle in abstract human form, wood, pre-1971.

21. Food tray, painted and carved wood, Çirebon, pre-1957.

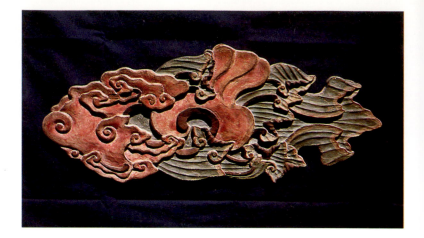

22. Wall decoration in the form of a
fish, painted and carved wood,
Çirebon, pre-1957.

The Yogyakarta and Surakarta areas have also produced kris boards
but these are generally confined to representations of *wayang* figures
such as those in Plate 7. In this one, Rama and Sita are possibly
depicted with a *naga* (snake) and two *yaksa* (birds). The quality and
brightness of the paint, the simple rendering of the figures, and the
cruder decorative carving all point to folk origins. Another kris board
from the environs of Yogyakarta shows two nicely coloured and
painted *wayang* figures below the bare outlines of a faded Garuda
(Plate 8). The painting style of the figures is not in the manner of
wayang kulit and the colouring is rather inexact. The kris board in
Plate 9 is ornately carved but coloured with restraint; a *kala* (guardian)
head emerges from the centre and forms an integral part of the dec-
oration. This board exhibits considerably more refinement than the
previous two. Nevertheless, the colouring and carving in all examples
take place within a conventionally defined space. Moreover, all
exhibit certain common qualities of folk art: some symmetry, a flat
and linear dimension, and robust rendering. They have folk feeling
and, again, constitute a whole category of traditional objects that need
to be studied and compared so that they too may enter the folk art
world of appreciation and discernment.

Indonesia is one of the greatest mask countries in the world. In
Java, the *topeng* (mask)[8] is one of the most widely found traditional art
objects. Masks run the gamut from highly refined and skilfully ex-
ecuted dance masks made for royal courts to those used in public per-
formances of the various episodes of the *Ramayana* and *Mahabharata*,
and finally to those used in small town and village events, celebra-
tions, and festivals throughout Central and East Java. The discussion
here is limited to village masks, in part because the tradition of elegant
performance masks in Java is quite extensive and merits compre-
hensive treatment elsewhere. Moreover, many superb examples of
these *topeng* used in the *wayang* can be seen in museum collections
throughout Java and special elegant sets are part of *kraton* (palace) col-
lections in Yogyakarta and Surakarta. In addition, folk masks have sel-
dom been published or studied. Concern here is with rural

23. Hanuman mask, painted wood, pre-1955.

24. Pentul mask, painted wood, Central Java.

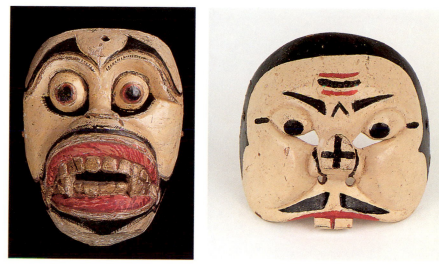

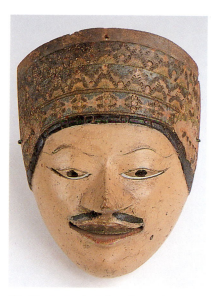

25. Rama mask, painted wood, Yogyakarta, pre-1961.

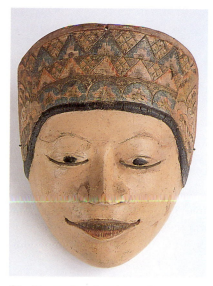

26. Sita mask, painted wood, Yogyakarta, pre-1961.

representations of performance masks where each one is assigned a real name, a genealogy, and a distinctive personality. Four examples are presented here. The first is of Hanuman, the great monkey soldier who is responsible for rescuing Rama's wife Sita from Rawana, the King of Ceylon. The one shown in Plate 23 is deeply carved so that it fits securely over the dancer's face. It has strong but simple facial lines and a worn look, and is coloured in a folk art style with ordinary paint which is not rubbed or lacquered and peels easily. Similar to this is a *topeng* (Plate 24) from Central Java of Pentul, a servant of Prince Panji. This is only one of many different representations in mask form of the same character.[9] His essential characteristics are relatively similar though in some a stupid expression may be more pronounced. In the example shown, the face is somewhat expressionless but made humorous by the odd nose and decorative markings. Its simplicity of form in carving and decoration signify its folk origins.

Plates 25 and 26 show dance masks of Rama and Sita from a small town in Central Java. They are superbly carved, simply but carefully painted, and exhibit a serenity in form and expression that is almost the epitome of the Javanese fondness for restraint and self-control. These *topeng*, in particular, are extremely fine examples of folk art. The painting style and carving of all are quite simple without any unnecessary decoration or added patina. The characters are among the most familiar of the hundreds in the *wayang topeng* (mask theatre) repertoire, rendered here in a plain folk style.

Very different masks are used for folk entertainment, celebrations, and festivals. These constitute a type called *barongan*, and are generally worn by local or travelling performers dressed as ogres and monsters. Usually, each larger village throughout Central and East Java has a set of such masks which are brought out only for special events and entertainment at certain times of the year. Pictured in Plate 27 is a typical *barongan* from a village near Yogyakarta. It is quite large and

19

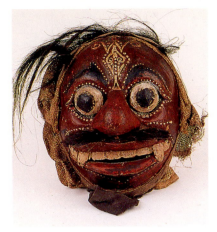

27. *Barongan* mask, wood, burlap, bicycle tyre rubber, and horsehair, village near Yogyakarta, pre-1960.

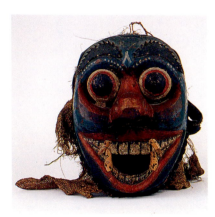

28. *Barongan* mask, wood, burlap, bicycle tyre rubber, and horsehair, village near Yogyakarta, pre-1960.

needs a covering of some kind so that it can be firmly attached to the face and head. It is made of wood, painted red and blue, and has a head strap made of discarded bicycle tyre rubber. Burlap hangs below and covers part of the wearer's upper chest, and horsehair or palm fibre serves as a moustache. The mask shown in Plate 28 is very similar.[10] Both these *barongan* are not elaborately carved. They are made of inexpensive and easily available materials, and in expression inspire both fear and farce. They have been made by local artisans for local use. A more elaborate type of *barongan* from Wonosobo is shown in Plate 29; it is better carved and painted to a higher standard, and is articulated so that the large mouth can be opened and closed by the performer. Finally, there is a village ogre mask from East Java that is roughly carved and has mirror glass for eyes (Plate 30). It has a crudely hewn countenance and shows obvious signs of use. The mask is deeply carved so that it can be worn effectively and comfortably. All these masks demonstrate true folk art.

In the classical 'high' tradition of Javanese art, there are perhaps no more aesthetically impressive and culturally significant objects than those of cast bronze. The most renowned of these were made before the twelfth century and all relate directly to Buddhist and Hindu traditions from India. Splendid bronze bells, lamps, disc mirrors, and ornaments were cast for religious purposes. Some are exquisite small-scale sculptures full of beauty, charm, and movement, such as the twenty-two statuettes unearthed in Central Java in 1976.[11] These small figures, among others, are the classical antecedents of a long line of bronze and brass-casting that continues to be done today. However, most of these objects are now made for the gift and tourist market. Beginning apparently in the late seventeenth or early eighteenth century, small brass and bronze figures began to be made which were not replicas of Hindu–Buddhist objects. They came from individual village metalworkers and small foundries which needed, in light of severely limited demand, to produce something other than

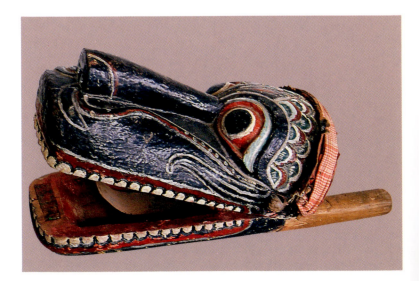

29. *Barongan* mask, wood, articulated, Wonosobo.

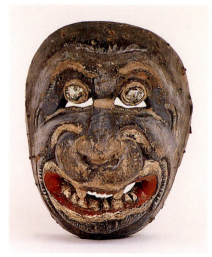

30. Mask of an ogre, painted wood and mirror glass, East Java.

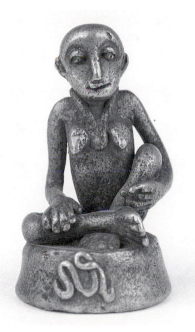

31. Female votive statuette, brass, Central Java, pre-1957.

32. Two bronze devotional figures, East Java.

classical objects. Typical is the brass statuette of a woman in repose sitting with legs crossed; at its base is a Javanese letter, the meaning of which is unclear (Plate 31).[12] It has a simple 'cosy' folk quality about it. It may have been used as a weight or a votive figure. The two bronze figures in Plate 32 are clearly in devotional poses and may have been used by individual Javanese to invoke spiritual feelings in themselves. The three bronze figures in Plate 33 appear to be meditating, an activity habitual to many Javanese. The four statuettes in Plate 34 include a male devotee in appropriate dress meditating or possibly reading some sacred text, a woman in ordinary clothing cradling a baby, a man of high breeding with hand extended indicating he is speaking, and an aristocratic woman (princess?) sitting in a classic, meditative pose. Some of these figures were used as amulets by Javanese *dukun* (shamans) to invoke power but mainly to heal.[13] In more recent times, most of these figures appear to be used for good luck, to promote devotion, and to help make the home secure.

Clearly, some of the casting skills so much in evidence from the eighth to the thirteenth centuries did not entirely disappear and have emerged again in the form of various folk bronzes which served traditional values until today when they have become a very successful commercial craft. Bronze replicas of varying but usually poor quality are being made of gods, goddesses, animals, mythical figures, temples, bells, and charms. They are largely uninspiring. Occasionally, however, one can find amidst this mass of decorative and tourist merchandise a bronze that reflects the strength and folk character of the earlier pieces.

One of the oldest materials used in Indonesian art is terracotta. Because of its relatively brittle quality, however, and because it was considered a material aesthetically and practically much inferior to stone, bronze, and gold, what remains in museums and private collections is fragmented and sparse. There are small statues in the National Museum in Jakarta and larger *kala* faces as well.

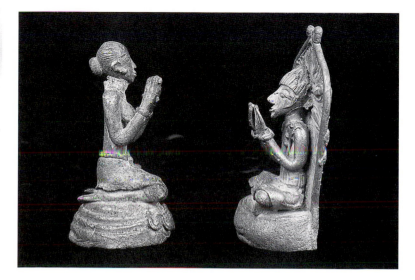

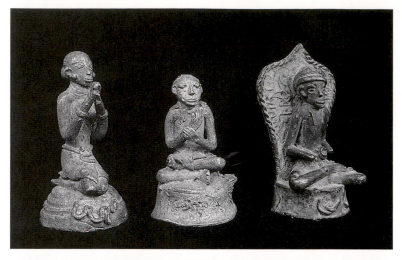

33. Three bronze devotional figures, East Java.

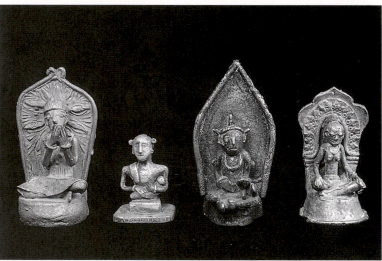

34. Four bronze devotional figures, East Java.

The most common type that remains, and continues to be found and made, is earthenware in the form of pots and jars for cooking, storage, and personal use. These terracotta art and earthenware containers have hardly been studied in Java as folk art, probably because their artistic and decorative elements are generally sparse, particularly in pottery, and do not attract either art historians or collectors. In addition, they tend to be primarily the provenance of archaeologists who are less concerned with appearance than with the historical significance of such artefacts. For these reasons, only a few examples of clay art are presented in this book.

Three kinds of terracotta art are appropriate to this folk art presentation. These include roof tiles, human and animal figures used for room decoration and for gifts, and painted clay household objects like flower holders and coin banks. Roof tiles, once extremely common in Central Java, are now seldom seen except in antique shops, although they are still frequently used in houses in Bali. The typical

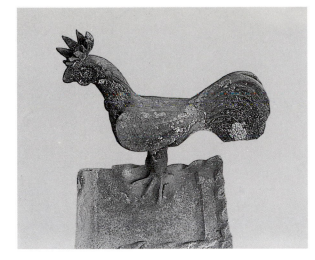

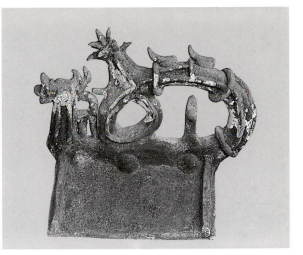

35. Roof tile of a rooster, terracotta, Central Java.

36. Roof tile of a rooster riding a horse, terracotta, Central Java.

37. Roof tile of a double *naga* (mythical snake), terracotta, Central Java.

38. Roof tile of a tiger, terracotta, Central Java.

roof tile is made of unpainted terracotta moulded in various decorative human and animal shapes. The tiles in Java tend to be placed at the end projections of a roof; the tile serves as a symbolic cap to the house, marking it as a completed and secure place. The most common forms are adorned with animals: roosters, various birds, bulls, snakes, and tigers (Plates 35–38). Also quite frequently used are *wayang*-type figures and shapes such as the *gunungan* or *kayon* (mountain or tree) (Plate 39). Islamic motifs like the crescent, stylized calligraphy in Arabic, and other religious symbols of the faith are also present (Plate 40). All these various types need to be compared and analysed against folk art criteria if some real understanding of their significance and history is to be determined. The brief descriptions here are aimed primarily at stimulating such interest.

The second category of terracotta art—household objects—is largely associated with the most famous pottery village in Java, Kasongan, situated some 7 kilometres from Yogyakarta. Kasongan has been producing distinctive terracotta forms since the early years of

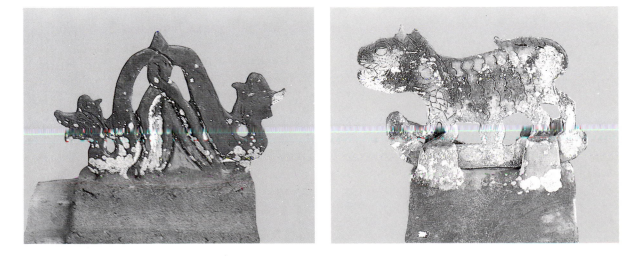

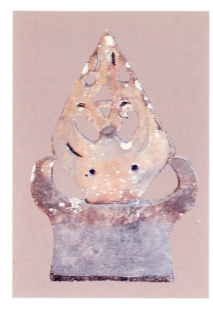

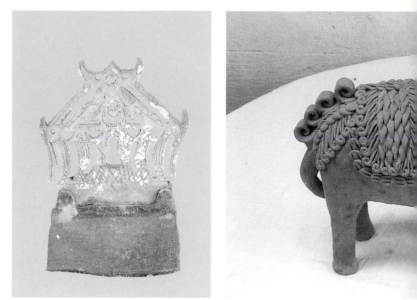

39. Roof tile of a *gunungan* (mountain) shape, terracotta, Central Java.

40. Roof tile with an Islamic design, terracotta, Central Java.

41. Elephant, terracotta, Kasongan, *c.*1970.

Indonesian independence. These are mostly of animals, including elephants (Plate 41), horses, chickens, human folk figures, mythical beasts such as *naga* (Plate 42), and sea creatures and birds in various poses. Much of Kasongan's production comprises only those objects which serve a consumer market. However, within this limited enterprise there needs to be an examination of what folk elements are involved and how these came to be present. The potential value of such an inquiry is underscored by looking at a splendid example of Kasongan folk sculpture shown in Plate 43. It consists of a mythical *kerbau* (water buffalo) carrying on its back a princely man, three children, and a woman sporting a traditional Javanese hair-style holding an *angsa* (goose) and riding a fantastic scaly bird with a dragon's face on whose head a dog is balanced. How to make sense of this composition is puzzling and obviously, as in the case of the other terracotta objects, requires research. It is evident, none the less, that here is a superb example of a sculpture which reflects part fantasy, part traditional mythology, and part cultural lore, and in its whole is a striking work of art.

A third category of terracotta comprises a great variety of household objects: pots, bowls, vases, pitchers, plates, and bells. These are generally without distinctive decoration and, except in the matter of their making, do not lend themselves to folk art analysis. What is interesting are such pieces as flower holders and coin banks in the form of fish, as shown in Plates 44 and 45. These painted terracotta fish are simply but charmingly rendered, complementing both art and function seemingly without effort. They are merely two modest examples of a whole range of folk objects where artistry and utilitarianism are plainly combined.

Another distinct category comprises those many household decorations in Java which are full of traditional images, motifs, and lore.

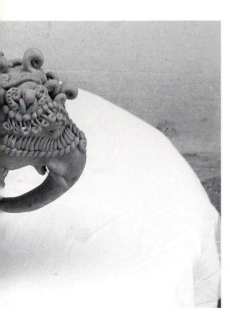

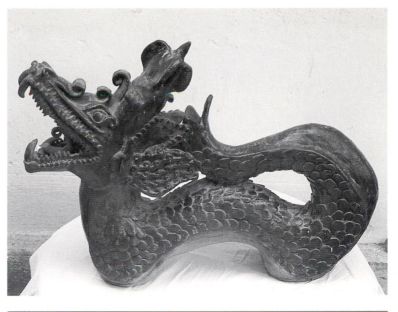

42. *Naga* (mythical snake), terracotta, Kasongan, *c.*1970.

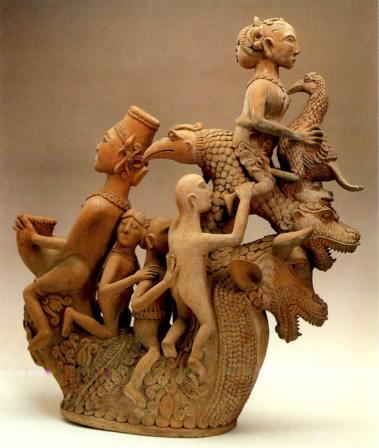

43. Multi-figured sculpture, terracotta, Kasongan.

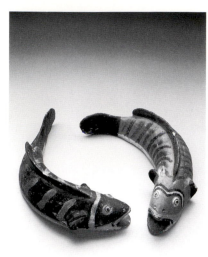

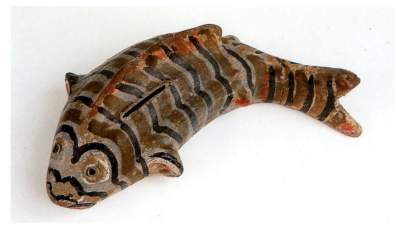

44. Flower holders in the shape of a fish, terracotta.

45. Coin bank in the shape of a fish, terracotta.

Typical are two wooden figures of Rama and Sita used as wall decorations (Plate 46). There are also those useful objects in which traditional decoration is much more prominent than their function. Such is the case with the wooden curtain holders (*gantungan kelambu*) with rooster heads (Plate 47) and one with *wayang* faces (Plate 48). The variety among such decorative household objects is enormous and is indicative of the extent to which traditional representation in one form or another is present in Java.

Another type of folk object consists of utensils and tools. In Java, the chewing of betel nut was once quite common. Among the utensils required in the preparation of the betel quid is a tool (*kaçip*) to cut or slice the nut. The more refined examples are made with gold or silver handles and decorated blades.[14] These elegant and now costly *kaçip* are kept by many wealthier Indonesians as *pusaka* (treasured heirlooms). The simple examples presented here are used in villages,

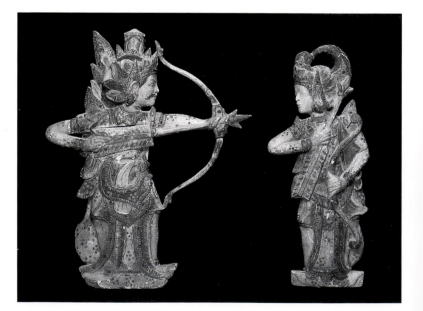

46. Rama and Sita wall decorations, painted wood, pre-1957.

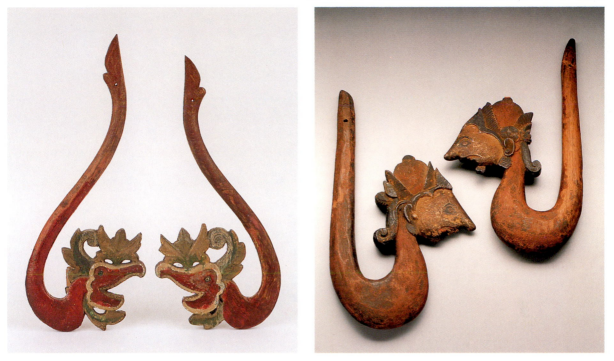

47. Curtain holders with rooster heads, painted wood.

48. Curtain holders with *wayang* puppet heads, painted wood.

towns, and cities by ordinary people. They come in a great variety of shapes despite their common function, demonstrating once again the ingenuity of folk design and decoration. Plate 49 illustrates four *kaçip*: one has the head of a chicken, one some sort of animal, one a horse, and one a rooster with a silver comb. Usually these would all have, as do two of them, silver-encased handles. The incised decoration on the horse is also quite common. Plate 50 shows two more of the many forms to be found in betel cutters; the upper one appears to be that of a hornbill and the lower one some other large bird.

Another tool commonly found in Java is the *ani-ani* (rice cutter).

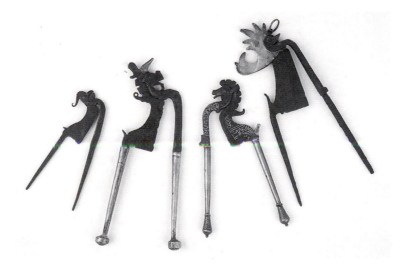

49. Betel nut cutters (*kaçip*), iron and silver, East Java.

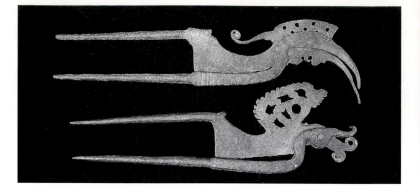

50. Betel nut cutters (*kaçip*), iron and silver, East Java.

Again, *ani-ani* are made in a variety of forms despite their common function, which is to cut off the tops of matured rice plants during harvesting. The tool is made of wood into which is set a razor-like blade. It is held between the fingers and is worked with a sharp downward motion that results in the cutting. Only two examples are shown here, one in the form of a painted bird—the most common form in Java—and the other, more elaborate, with a silver crosspiece, floral decoration, and Chinese motifs (Plates 51 and 52). Some elements of folk imagination and artistic preference have worked their way into this traditional tool that have nothing to do with its essential function. The propensity of people to turn simple tools and utensils into objects of folk art is readily apparent.

It is clear from the foregoing discussion that ceremonies, festivals, and rituals are an important part of life in Java, particularly in villages whose welfare depends on agriculture. All rites of passage, Islamic holidays, celebratory events, and traditional rituals to placate the gods, ensure tranquillity, and increase fertility require ceremonies. Some form of music is almost always a part of such activities. Many examples could be given of various musical instruments like gongs, xylophones, two-stringed violins, and simple drums. However, in the village context, most of these are devoid of decoration or are otherwise aesthetically uninteresting. However, there are rudimentary sounding instruments like slit drums that fall into a folk category. These objects are relatively small, of simple design, and made of wood. They are used to provide music for celebrations and sometimes, as in the case of an eclipse, to drive away demons. Some are fashioned into human figures as shown in Plates 53 and 54. The former is that of a woman with the slit placed at her back. The other is that of a man with his head at the top, two feet protruding at the bottom, and the drum part in the middle with the slit facing outward. Some slit noise-makers are shaped like fish (Plate 55). These instruments, which are very common, are generally used and made in rural areas; they offer obvious opportunities for folk art analysis and comparison.

A very common and popular folk image in Java is the *kuda lumping*, a prop used in the hobby-horse trance dance. Plates 56 and 57 show typical examples. Plate 58 shows a much more elaborately painted

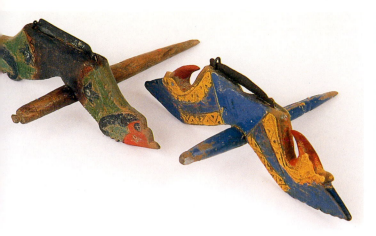

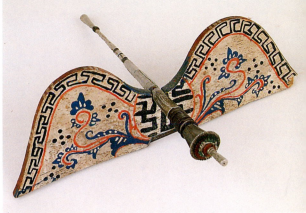

51. Rice harvesting tool (*ani-ani*), wood and metal, Central Java.

52. Rice harvesting tool (*ani-ani*), with Chinese-type motifs, wood, iron, and silver.

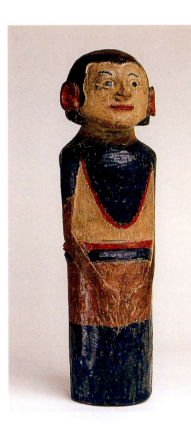

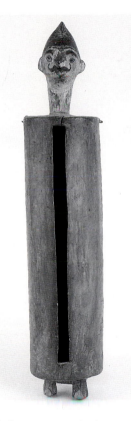

53. Slit drum or noise-maker in the shape of a woman, painted wood, East Java.

54. Slit drum or noise-maker with the head and feet of a man, painted wood.

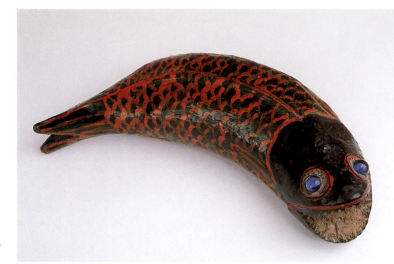

55. Slit drum or noise-maker in the shape of a fish, painted wood, glass, East Java.

form from Banyuwangi in East Java called a *jaranan buto* (ogre horse) which is derived from the *wayang* tradition. In all cases, it is the torso of a horse constructed of painted plaitwork and bamboo upon which men and women feverishly ride until they become entranced. Initially, it was used only in a ritual performed in specific places at certain times of the year. It has since become a prop for *jatilan* troupes (travelling performers) who use it in a trance dance. The performance starts in a setting of magic and mystery with the sounds of drums, gongs, and iron bars calling forth the audience. A performer occasionally cracks a whip. Then four to ten dancers (male and female) enter wearing batik clothing with showy belts, ankle rattles, ear ornaments, and dark sunglasses. The dancers place the bamboo horses between their thighs and ride them rhythmically in pairs. A whip is snapped at one particular dancer who thereby receives magic power and in a trance becomes frantic, appearing to chew glass, eating raw rice,

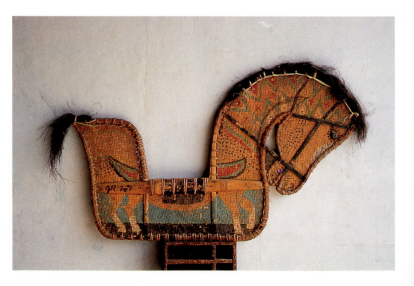

56. *Kuda lumping*, prop for the trance dance, bamboo and painted plaitwork, Central Java.

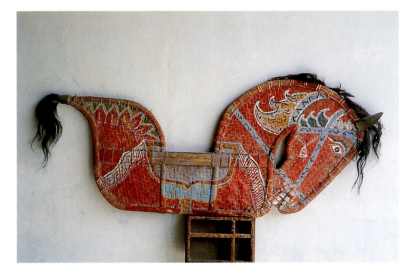

57. *Kuda lumping,* prop for the trance dance, bamboo and painted plaitwork, Central Java.

mouthing fire, and eating a coconut by breaking the hard shell with his teeth. After a short time, the person in trance is 'buried' in a 'tomb' made of two bamboo horses covered with a white cloth. The 'buried' dancer later emerges wearing a grotesque mask and acts more and more wildly. The audience, especially the children, are frightened. Then the troupe leader breaks the actor's trance and order is restored. Bamboo trays are passed among the spectators for donations of money; some people respond, some do not. The show has ended. Such performances and travelling troupes have now virtually disappeared as performing areas have declined and competition from television entertainment rapidly increased. Even in such traditional Javanese cities as Yogyakarta, *jatilan* is difficult to find; apparently only tourism is its ally. Children, however, do themselves play at *kuda lumping* and it is a common subject for their art, as shown in Chapter 7.

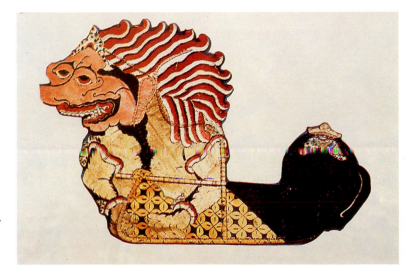

58. *Kuda lumping,* prop for the trance dance, bamboo and painted plaitwork, Banyuwangi, East Java. (Reproduced from Th. A. Darminto, *Album Seni Budaya: Jawa Timur,* Jakarta: Ministry of Education and Culture, 1982–3, p. 157.)

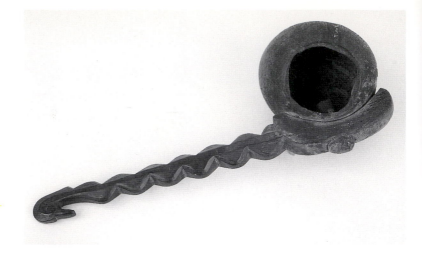

59. Water-dipper, wood and coconut
shell, Central Java.

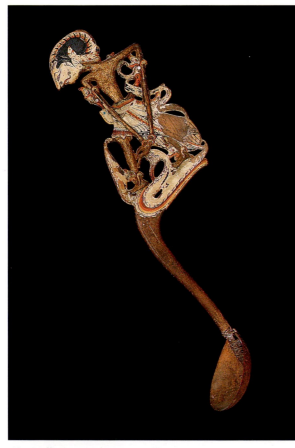

60. Ladle or rice spoon (*centhong*),
wood, coconut shell, and glass
zircons, Central Java.

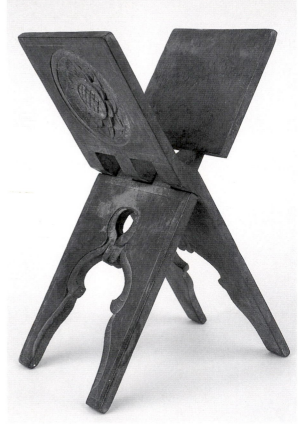

61. Koran stand, wood, articulated,
Central Java, pre-1957.

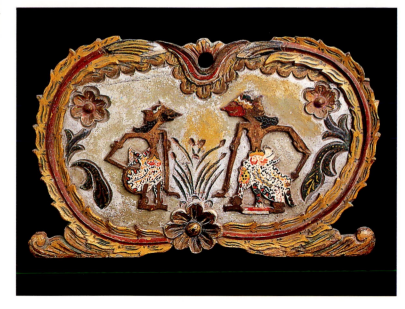

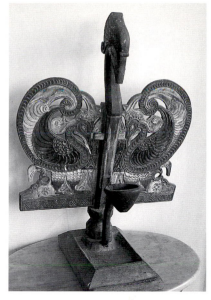

62. Wall plaque decoration with *wayang* figures, wood, Central Java.

63. Oil-lamp stand in the shape of a bird, wood, Central Java.

64. Miniature food vendor, wood and bamboo, Yogyakarta, 1992.

Where does diversity in folk art stop? In Java, quite obviously, it does not. There has been a vast array of cultural and historic factors that have directly affected and diversified all manner of tradition and creativity in art and craft. The imaginative folk element is further evident in such varied objects as a simple water-dipper with a snake-like handle (Plate 59), a painted and intricately carved ladle or rice spoon (*centhong*) with the handle in the form of a puppet figure (Plate 60), a Koran stand (Plate 61), a pre-1950 decorative wall plaque with *wayang* characters (Plate 62), an antique coconut oil-lamp shaped like a bird with wings outspread (Plate 63), a souvenir replica of a Javanese food seller with his portable restaurant (Plate 64), and, finally, a brass

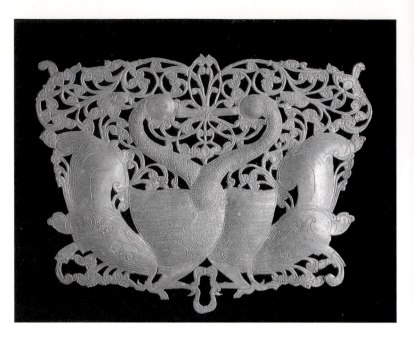

65. Decorative fitting for a trunk, brass, East Java.

fitting in the form of a double goose to be attached to a wooden trunk (Plate 65).[15]

Folk art, naïve art, and traditional crafts in all their variations on Java raise questions of origin, of changes over time, of regional difference and of their contemporary value. The artistic pathways of Java are many, the descriptive signposts too few. Creativity, skill, and traditional culture are still for a time living together on this remarkable island of art bounded by the Indian Ocean and centred by the Equator.

1. Brent Ashabranner and Martha Ashabranner, 'Loro Blonyo: Traditional Sculpture of Central Java', Arts of Asia (May–June 1980): 112–19. This is one of the few sources on the subject and the only one in English that was located. The description in this section relies mainly on information in this excellent article which also contains nine illustrations of various loro blonyo and one of the krobongan. See also Seni Kriya Boneka Jawa, Loro Blonyo, Golek Gambyong dan Menak, Jakarta: Bentara Budaya, 1993.

2. A book published by Prapantja in Jakarta around 1960, entitled Wedding Ceremonials, does not mention the loro blonyo.

3. The most detailed treatment of the kris in English is Garrett Solyom and Bronwen Solyom, The World of the Javanese Keris, Honolulu: East–West Center, 1978; see also Edward Frey, The Kris: Mystic Weapon of the Malay World, Singapore: Oxford University Press, 1986, and Helen Ibbitson Jessup, Court Arts of Indonesia, New York: The Asia Society Galleries and Harry N. Abrams, 1990, especially pp. 64–5, 144–50, 235–6, and 247–8.

4. W. H. Rassers, 'On the Javanese Kris', in Panji, the Culture Hero: A Structural Study of Religion in Java, The Hague: Martinus Nijhoff, 1959, pp. 219–97.

5. For various descriptions and details, see Solyom and Solyom, The World of the Javanese Keris, pp. 30–5, and Jules Engel, Krisgrepen, Amsterdam: Samurai Wapenhandel, 1981.

6. Many of these highly formalized handles are shown in Solyom and Solyom, *The World of the Javanese Keris*, Figures 83–88 and 91–94, pp. 23–33.

7. A number of these are illustrated in ibid., Figures 95–97 and 99–103, pp. 34–5.

8. The most comprehensive study and depiction of masks in Java is Heinz Lucas, *Java-Masken*, Kassel: Im Erich Röth-Verlag, 1973; see also *Pameran Topeng Koleksi Museum Sono Budoyo*, Yogjakarta: Directorate of Culture, 1992.

9. For five different examples, see Lucas, *Java-Masken*, Plates 26–30, pp. 110–13.

10. Despite the fact that these *barongan* masks are fairly common in villages throughout Central Java, no published studies containing pictures of them could be found.

11. Eighteen of these are reproduced in Jan Fontein, *The Sculpture of Indonesia*, Washington and New York: National Gallery of Art and Harry N. Abrams, 1990, pp. 223–30; see also J. E. Van Lohuizen-De Leeuw, *Indo-Javanese Metalwork*, Stuttgart: Linden-Museum, 1984, and P. L. Scheurleer and M. J. Klokke, *Ancient Indonesian Bronzes*, Leiden: E. J. Brill, 1988.

12. This object was purchased in 1957 in Yogyakarta from an old woman selling various brass objects from her small pavement stall on the main street (Malioboro). She claimed it was used as a votive and good fortune piece by Javanese women.

13. See Parsudi Suparlan, *The Javanese Dukun*, Jakarta: Peka Publications, 1991, Plate 5.

14. The most comprehensive book on these Asian utensils (with 110 colour illustrations, many of which are examples from Indonesia), is Henry Brownrigg, *Betel Cutters from the Samuel Eilenberg Collection*, London: Thames and Hudson, 1992; see also Dawn F. Rooney, *Betel Chewing Traditions in South-East Asia*, Kuala Lumpur: Oxford University Press, 1993.

15. The Indonesian Ministry of Education and Culture has published a series of books that illustrate and discuss the folk art and crafts of each cultural region in the country. Those relevant here are: Th. A. Darminto, *Album Seni Budaya: Jawa Timur*, Jakarta: Ministry of Education and Culture, 1982–3; Suwadji, *Album Seni Budaya: Daereh Istimewa Yogyakarta*, Jakarta: Ministry of Education and Culture, 1982–3; and Subroto SM and Parsuki, *Album Seni Budaya: Jawa Barat*, Jakarta: Ministry of Education and Culture, 1983–4.

3 The *Ramayana*, the *Mahabharata*, and Islam: Representations on Glass Painting

PAINTING in Java does not have a long history and it has never been a major art form as it is, say, in Bali. Most of the antique paintings that have survived were done, with few exceptions, mainly in the nineteenth century and were of two kinds: illustrations for books and manuscripts and depictions from Indian epics and Javanese legends on paper and on cloth scrolls that were unfurled to reveal scenes in the rarely performed *wayang beber*.[1] These two types both contain some folk art elements that are worthy of consideration but there are no major collections, and the small ones that exist are either in poor condition or are not readily accessible. One painting tradition of a quite different nature is, however, both common and accessible. It is reverse painting on glass that developed in Indonesia, probably derived from European sources, during the nineteenth century. It flourished during the first three decades of the twentieth century, then drastically declined until very recently when it has enjoyed a modest renaissance.

Glass painting appears to have started in Europe, primarily in Italy and France (where it was called *fixé sous verre*) around the year 1400. However, there are surviving examples from the latter half of the thirteenth century as well as precursors (like pictures on glass vessels and foil engravings) during Roman times.[2] The earliest examples were on bowls, two of which, unearthed in France, date from the thirteenth century. During the late Middle Ages, painting appeared on small pieces of glass for pendants, on so-called kissing pictures, and on insertions for caskets and reliquaries. These were mainly used in connection with various religious activities. Later, the art developed through guilds into regular paintings but, again, the subject-matter was chiefly religious, including portraits of saints, pictures of holy events, and biblical stories. It is to be noted that not all reverse paintings are pictures; many were used as decorations in wooden panels and on the fronts of drawers, and some were made to function as mirrors. The greatest expansion of glass painting during the Renaissance

and the later centuries took place in Eastern Europe—in countries such as Poland, Rumania, Hungary, and Czechoslovakia—where we find such subjects as hunting scenes, landscapes, legendary tales, and portraits.[3] Glass paintings were introduced into India in the eighteenth century under the patronage of various ruling rajahs.[4] These paintings were mostly commissioned and probably done by foreign artisans from China, where the art had been brought to Canton from Europe by Jesuits.[5] The subject-matter comprised mainly portraits of aristocrats, mistresses, and dancing girls. In India, glass painting evolved into a middle-class art form done by Indian artists and devoted to the depiction of some Islamic stories but mostly to Hindu deities and indigenous folklore. These included depictions of the Bouraq with the head of a woman, the body of a horse, and a peacock's tale on which the Prophet Muhammad is supposed to have ridden on his way to Heaven. The Hindu tradition in glass painting included portrayals of gods like Vishnu and Ganesha and personages from the *Ramayana*, including Rama, Sita, and Hanuman. Glass painting flourished in India between 1850 and 1950 but today has largely disappeared.

Reverse painting on glass may be defined as consisting of 'any non-fired decoration that is viewed by reflected light from the opposite side of the object'.[6] The reverse images are created by those painted in colour or engraved through metallic foil or transferred from prints, the outline of which is then coloured by hand. There exist at least sixteen different techniques of applying paint to glass. The methods and materials used in glass paintings make it impossible to clean, re-varnish or re-line them and thus they are very difficult to restore. The glass obviously cannot be separated from the painting for the two pictures are done simultaneously, one from the reversed image viewing side and one from the opposite side. Because of its special characteristics, the full effect of a reverse painting can rarely or adequately be seen in photographs or colour prints.

'The most striking feature of these pictures is their frankly decorative intent.'[7] They exhibit most of the characteristics of folk art, including rhythm and symmetry, frontal presentation, and the filling in of empty areas with ornamentation. The medium itself dictates the two-dimensionality and linearity that is so characteristic of this art form and which conveys an immediacy and a straightforward intent that accounts for much of its attraction and charm.

The history of painting on glass in Indonesia has yet to be recorded in any language. Information on it is sparse and fragmented; documentation is usually non-existent or incomplete. Thus, its historical growth, the factors that have influenced its character, and the techniques that made it an art form have not been adequately studied.[8] We know, however, that it reached its peak between 1930 and 1940 but that it almost died out from then until about 1970. In the past two decades, a number of important collections have been made by private individuals but there are no adequate collections in any Indonesian museum. The dearth of information is somewhat surprising for glass paintings were done—and are found—in many cities of

Java as well as in Madura, Sumatra, and Bali. These were originally sold by itinerant artists, travelling from kampong to kampong and from villages to small towns taking orders. Today, commission work is still done but by studio artists in large cities like Yogyakarta and Solo. It is also known that glass paintings were a common decoration in many Javanese homes. They were usually placed inside the front door, one painting on the left, the other on the right. This possibly reflects the importance of such orientations in the *wayang purwa* (classical shadow play) tradition in which the right side represents the virtuous and victorious Pandawa family of the *Mahabharata* while the left side represents the flawed and defeated Kaurawa family. Right–left orientations with respect to good–bad distinctions are important in Javanese belief. If only one painting is hung, then it is placed above the door. Household decoration was their main function but they also served as *jimat* (good fortune talismans) for the family. Pictures of famous mosques, like those in Mecca and Medina, were also displayed in the homes of Indonesians who had completed the hadj by making the pilgrimage to the sacred Islamic sites in Saudi Arabia.

Glass paintings originating from particular cities in Java often have certain distinguishing features that permit identification.[9] The major centres are Yogyakarta, Surakarta, and Çirebon; however, glass painting has also been done in many other Javanese towns, such as Kudus, Tuban, Demak, and Banyuwangi, and in Sumatra in Bengkulu, Medan, and elsewhere. The subject-matter of this art also varies greatly and includes *wayang* characters, such as the *panakawan* (clown-servants) and Hanuman that are painted traditionally, as well as characters that are presented in humorous and satiric situations. There are also folk paintings in the *loro blonyo* (bride–groom) fashion of a Javanese bride and groom, as well as portraits of European couples and those of mixed marriages. From an anthropological and folk art perspective, perhaps the most interesting glass paintings are those which depict Javanese legends and lore. The most popular of these stories, particularly in the Yogyakarta and Surakarta areas, are of Joko Tarub, the *pak tani* (farmer) who stole the clothes of a heavenly maiden, and of another love story called Rara Mendut.

In contrast to the above are those subjects emanating from Islam. These include *wayang* characters drawn in Arabic calligraphy, pictures of small town or village mosques, scenes of Muslim preachers and their followers, stories about the spread of Islam, Islamic symbols like the crescent, and short sayings from the Koran usually rendered in Arabic and sometimes in Javanese script. It is significant that there is such a wide range of subjects and that most of these relate directly to important features of history and culture in Java, particularly to that which has been incorrectly termed the 'little tradition'. Paintings on glass in Indonesia reflect the four great sources of traditional art: the *Ramayana*, the *Mahabharata*, Islam, and indigenous folklore. In this sense, painting on glass becomes a microcosm of certain kinds of folk tradition which are not only valuable for the study of art but also for partly understanding past and present popular cultures.

Two great epics, the *Ramayana* and *Mahabharata*, are the major sources for traditional drama in Java. The *Ramayana* is a grand and extremely popular Indian folk epic comprising some 48,000 lines of poetry. The story devolves partly upon a conflict over who is to be heir apparent to the throne of King Dasartha: Rama or his half-brother Bharata. Its extreme popularity, however, derives primarily from the abduction of Rama's bride, Sita, by Rawana (the evil and powerful king of Ceylon) and the exploits of Hanuman (the white monkey soldier) to recover her. Rawana is eventually killed. Sita returns only to have her fidelity questioned and is banished to a forest. Rama, the virtuous hero, finally ascends the throne and after many years is reunited with Sita who becomes his queen. The Indian *Ramayana*, over the course of many centuries, has become, with certain changes and additions, a popular part of the folk tradition of all South-East Asian countries.

The *Mahabharata* is also a very long and great Indian epic poem of more than 88,000 verses. It became, over time, an important and popular part, as well, of traditional literature and performance throughout South-East Asia, especially in Indonesia (particularly in Java and Bali). Its central story involves battles, wars, catastrophes, intrigues, and fantastic events that stem from the legitimacy of succession to the legendary ancient kingdom of Kuruksetra in northern India. It pits the rightful heirs, the Pandawas, who are eventually victorious, against their opposers (and losers), the Kaurawas. The most prominent members of the Pandawa clan are the five brothers: Karna, Yudistira, Bima, Arjuna, and Nakula. Their principal opponents are Duryodana and a host of giants and ogres. In the Javanese *Mahabharata*, there are, in addition to more than twenty-five major characters, five *punakawan* (*panakawan* in Indonesian) that do not appear in the originial Indian version. There is also a host of minor characters including, among others, various servants, buffoons, ogres, giants, lepers, blind men, gossiping women, male braggerts, babies, anthropomorphic figures, and all kinds of real and mythical animals.

These popular epics include episodes of war, diplomacy, family feuds, abduction, love, loyalty, deceit, bawdiness, and humour, all of which are exemplified by the individual characters of the *wayang* theatre. It is these characters and each *lakon* (episode) that are the principal subjects of one of the three main types of glass painting. Here are displayed some of the most popular and famous figures in the folk and urban culture, including—from the *Ramayana*—Hanuman, Laksmana, Rawana, Sugriwa, Rama, and Sita, and from the *Mahabharata*, Kresna, Bima, Narada, Arjuna, Semar, Petruk, Gareng, Bagong, and Togog.[10] In addition, there are gods, goddesses, giants, ogres, buffoons, animals, and a host of other figures. Typical is Plate 66 which shows Bima fighting an elephant (*gajah*), a wild buffalo (*banteng*), and a tiger (*harimau*) with Garuda (the vehicle of the god Vishnu) hovering above everything. This scene from the *Mahabharata* is packed with action, full of vibrant colours, and great attention to detail. It was probably painted in either Yogyakarta or Surakarta. Another example, Plate 67, is that of Bima and a *gunungan*, the mountain and tree-of-life

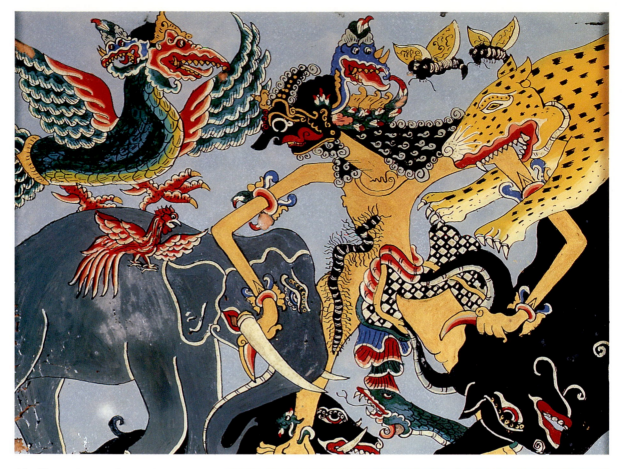

66. Glass painting of Bima fighting an
 elephant and a wild buffalo.

67. Glass painting of Bima and a
 gunungan.

68. Glass painting of the ogre, Buta
 Terong.

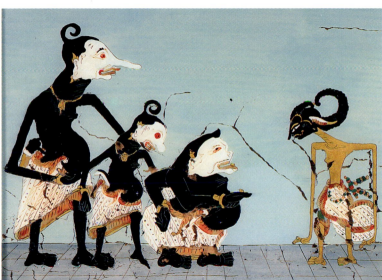

69. Glass painting of Petruk, Gareng,
 Semar, and Arjuna.

puppet and symbol that begins and ends all shadow play perform-
ances. This glass painting, with its wave decoration at the bottom, is
characteristic of the so-called Çirebon style which was influenced by
Chinese motifs in rendering clouds, rocks, and waves.[11] An example
of a portrayal of an ogre is Plate 68, which shows Buta Terong with
his large bulbous nose confronting, in clear contrast, a graceful and
slender figure, probably Arjuna. The obvious symmetry in the pairing
is there and the juxtaposition of two such different *wayang* personal-
ities creates a kind of amusing tension and dichotomy that is evident
in so much folk art. Within the same *wayang* glass painting tradition,
there are also characters represented in their typical forms, such as in
Plate 69 showing the three *panakawan* and Arjuna. The clown-servants
sport their usual white faces and black bodies and are grouped from

41

the tallest to the shortest respectively, Semar pointing with his ring finger and Gareng and Petruk with puny, hatchet-like weapons attached to their sides.

There are many episodes and scenes stemming from the *Ramayana* and *Mahabharata* that are represented in the *wayang* tradition as depicted in glass painting. One is the story of Dewa Ruci which concerns the search by Bima for the elixir of life. It is an addition that uses the original character but whose story is a unique contribution of the Javanese. It is said that the purpose of this tale is to demonstrate mastery over, and understanding of, one's own character, a philosophical concept that is distinctly Javanese.

Another popular episode from the *Mahabharata* to be found in glass paintings is the Mintaraga story or Arjuna Wiwaha. In it, Arjuna is depicted meditating under a tree or in a grotto in the forest in preparation for his forthcoming participation in the *Bharatayuddha* or the heroic struggle between the great Pandawa and Kaurawa families in the land of India. He is sorely tempted by seven beautiful heavenly maidens but he resists and is rewarded by the gods with a powerful weapon to defeat his enemies. The glass painting usually depicts Arjuna with long hair sitting cross-legged in an utterly serene pose under a tree with the seductive maidens beckoning from behind. Arjuna represents, particularly in this story, the Javanese ideal man, both in body and mind. As such, he appears to be revered by both the court and vernacular cultures. His representation as a finely carved and gilded *wayang kulit* (shadow play) figure signifies the Javanese aristocratic tradition; his simple depiction in paintings on glass represents the preferences of Javanese folk culture.

A second type of glass painting deals with folklore, folk humour, and everyday aspects of people's lives. One of the most common stories, which apparently is only depicted on glass, is that of Joko Tarub. It is to be seen especially in the Yogyakarta and Surakarta areas though it appears elsewhere in Java as well. It is the tale of an ordinary farmer who watches eight maidens/goddesses bathing in a natural spring. His eye catches sight of one of the most beautiful of these, Dewi Nawang Wulan (goddess of the light of the moon), who with her seven companions has descended from heaven for a brief interlude. Joko steals the clothes of Dewi Nawang Wulan, including her *selendang* (shawl). The shawl represents the wings of the goddess without which she cannot fly back to Kahyangan, her celestial home. The other seven goddesses depart leaving Dewi Nawang Wulan no choice but to do as Joko commands. They are married, the only condition being that Joko must not look at his wife's food preparations. Joko agrees and hides his new bride's wings at the bottom of a rice granary. The couple prosper. A child is born and Joko keeps his promise. Dewi Nawang Wulan, because of her divine origins, needs only one grain of rice to provide an entire meal for her family. Joko notices that the supply of rice in his granary never diminishes. He is puzzled and curious and sneaks a look at a pot of rice which is left cooking while his wife leaves the room. She returns and notices that the rice is still undercooked. She surmises that in her brief absence Joko has broken his

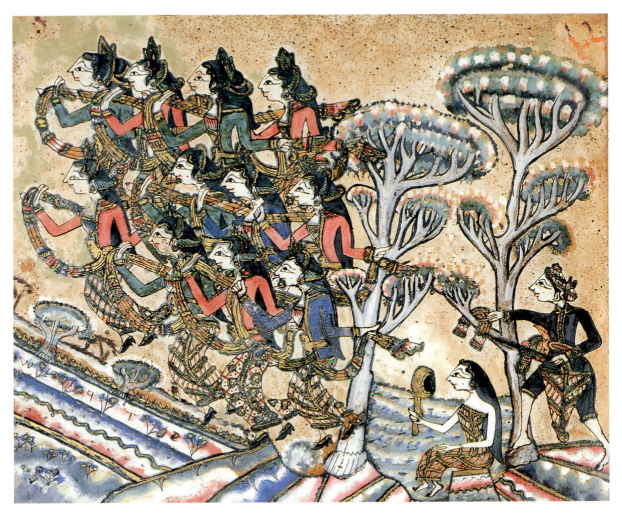

70. Glass painting of Joko Tarub stealing the shawl (that is, the 'wings') of a goddess.

promise not to look at her cooking. She says nothing but now her power is gone and she must use a full amount of rice for each meal. Time passes and the rice supply in the granary dwindles until it is all gone. When this happens, she finds the hidden *selendang* and flies back to her heavenly abode.

It is the first part of this tale that is represented in glass painting, an example of which is in Plate 70. The seven goddesses are seen with their shawls, flying away into the sky while Dewi Nawang Wulan, with her long, beautiful black tresses sits demurely under a tree looking at her face in a mirror. Joko is hiding just behind her with the stolen shawl hanging from a branch. The painting has some bright colours, yet on the whole is subdued and, of course, does not show the maidens unclothed. It is a composition of three parts: the seven goddesses, the goddess of moonlight, and the *pak tani*, Joko Tarub. All of them are characters in a folk-tale that appears like an illustration in a story book. The story has several obvious morals, including the consequences of a broken promise, the ephemerality of happiness, and the powers of divinity. However, given what is known in general

about folk culture, the painting may represent the ardent desire of an ordinary man to possess a beautiful woman or a goddess, though in this case through artifice, not seduction. It is a fantasy that is not uncommon in the folk literature of the world.

In the folk mode of glass painting is a diversity of genre subjects which one would expect in such an art form. These include scenes of the countryside, pictures of ordinary life, people at work, ceremonies, games, and festivities. Plate 71 illustrates a bride and groom in full formal dress with two attendants. It is very stylized and probably is only representative of those families that can afford a traditional wedding; yet anyone can hang the picture on their wall as a reminder of custom. Some paintings in this type also have a symbolic content, like the family scene shown in Plate 72. A modest village house raised high above ground is shown in the background. In the foreground, a mother is holding an infant; she is extending her hand in a gesture towards a kneeling man in traditional Javanese dress. It is not clear what this scene signifies, for the woman has a pair of feathered angel wings attached to her back.[12]

71. Glass painting of a bride and groom in traditional dress, Yogyakarta.

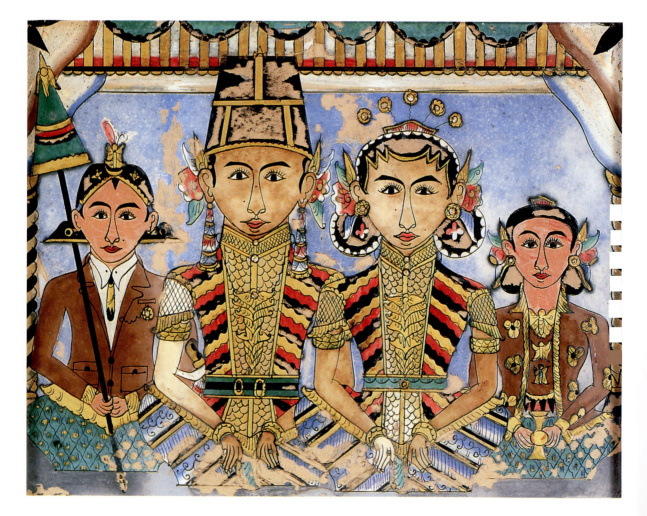

A glass painting which illustrates something of urban or town life but intends as well an underlying folk satire is Plate 73. Depicted are a *becak* (three-wheeled bicycle taxi) with a driver who has the face of Gareng, a female passenger, a man selling *saté* (cooked, skewered meat), a motor car of 1950 vintage, a middle-class couple in Western dress (the man with the face of Semar but wearing Muslim head-dress), and in the background a rural *pendopo* (audience hall) or an official building. The painting partly reflects a small town scene yet its components are a mixture of humour (the *panakawan* faces) and social commentary. The traditional *becak* on the left and the modern motor car on the right are juxtaposed. The Westernized couple are in the middle. The two women in the picture are in obvious contrast, one in traditional Javanese clothing, the other in European dress. Another glass painting in the humorous folk mode shows Petruk out for a stroll arm in arm with a woman holding an umbrella. She is wearing traditional Javanese clothing, as is Petruk except for a jacket and tie (Plate 74). In a similar vein is the glass painting of Petruk, Gareng, and Semar sitting cross-legged and socializing together (Plate 75). Two of

72. Glass painting of a village family scene.

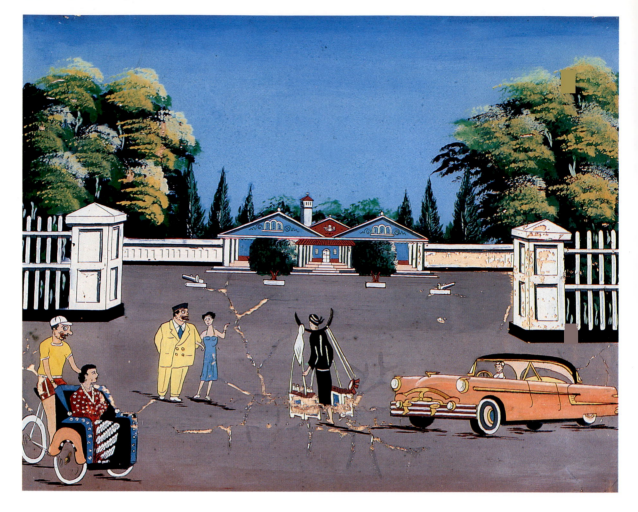

73. Glass painting of an urban scene with a *saté* seller, a *beçak* (tricycle taxi), a couple, and a motor car.

them are smoking cigarettes; a pot of coffee, three cups, a pack of cigarettes, and a box of matches are on the floor in front of them. A *wayang* screen forms their background. It is one of those humorous yet cosy representations of the three most famous *panakawan* of whom so many Javanese are fond. The depiction of the *panakawan* in various unlikely guises and settings is very common in glass painting, the significance of which is discussed later in Chapter 4.

Finally, in this second type are perhaps the two most common of all subjects in this painting genre, that of a mosque and a *pendopo*. Typical are Plate 76, a rural *pendopo* with a diminutive steam train in front of it and aeroplanes flying above it, and Plate 77, a mosque with a motor car parked in front.

The *pendopo* is for local official meetings, for special events and ceremonies, and the mosque is for religious gatherings. The *pendopo* is perhaps the most common traditional architectural form in Java, followed by the mosque. Both are, by definition, places for the gathering of people. The *pendopo* and the mosque are almost always depicted in conjunction with a train, bus, aeroplane, motor car, or

74. Glass painting of Petruk and a lady friend out for a stroll, Surakarta.

75. Glass painting of Petruk, Gareng, and Semar smoking and drinking coffee.

76. Glass painting of a *pendopo* (audience hall) and a train.

some other means of transportation. The popularity of the *pendopo* and the mosque symbolizes the communal nature of rural life. There is also a certain naïve quality about the style of the painting and, at the same time, a relatively sophisticated symbolizing of the main connection (that is, via transport) between rural and urban life and tradition and modernity.

The third type of glass painting is derived from the Islamic tradition in Java. It consists of Arabic calligraphy used to decorate or complement other sacred forms, of sayings from the Koran in Arabic, of various Islamic stories, and of scenes relating to the establishment and spread of Islam in Indonesia. Çirebon was the main centre for producing these glass paintings, together with other cities connected to the beginnings of Islam in East Java.

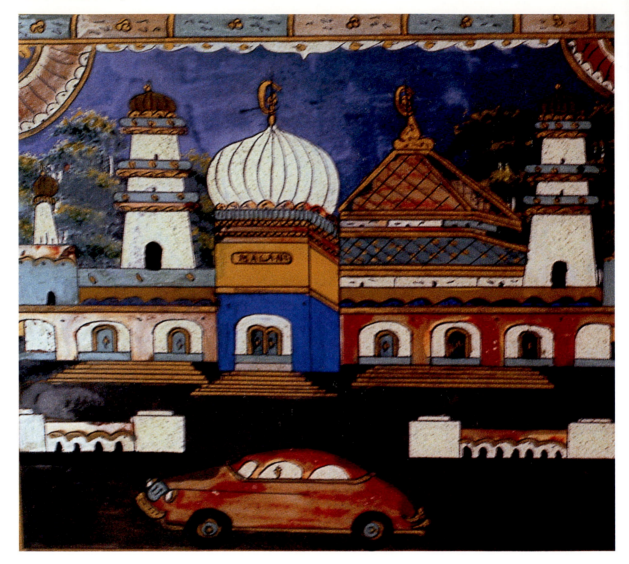

77. Glass painting of a mosque and a
 motor car.

78. Glass painting of Islamic motifs and
 Arabic calligraphy, Cirebon.

The simplest expressions of Islam are those showing its religious symbols and Koranic verses. A typical example is Plate 78 which depicts the emblem of the crescent and star, Arabic calligraphy and Arabic writing from religious scripture, and three decorative Islamic forms.[13] Glass paintings whose subjects are personages and folk stories

79. Glass painting of Nabi Sulaiman summoning the creatures of the sea.

80. Glass painting of Nabi Sulaiman summoning the animals of the land.

that reflect Islam are, in terms of art history and aesthetics, the most interesting. Take, for example, the Islamic story of Nabi Sulaiman (Solomon) magically summoning and naming the creatures of the sea (Plate 79) and the animals of the land (Plate 80). If one closely examines this latter painting, a veritable microcosm, seemingly of the entire animal world, is deftly crowded into one composition. Sulaiman is seated holding a bird in his left hand. In the lower left-hand corner are eight ogres and a Javanese woman carrying a pole with a hook, while in the lower right-hand corner there is a *wayang naga* (snake puppet figure) and eight other snakes. One of the birds in the sky is holding a necklace and another a piece of paper with writing. A great number of other animals, including a tiger, an elephant, two wolf-like animals, an odd horse, a cat, five small dogs, a water buffalo, a bull, a ferret, a wild boar, a zebra, a sheep, two goats, a leopard-like animal, a camel, a rooster, a lizard, a rat, three monkeys, a tree viper, a tree lizard, a centipede, a peacock, and many ducks and geese complete the picture. Despite this almost overwhelming number of parts, the painting, like the similarly overcrowded designs in *kain* (sarong) batik, forms an organic whole. At the same time, it conveys exactly what an illustrated folk-tale should do: tell a story simply and attractively so that the viewer will be both informed and pleased. The sea creature painting exhibits the same qualities.

Plate 81 is an Islamic glass painting in its most attractive and powerful form. It symbolizes the early expansion of Islam through the story of Prince Mursada. He is seen riding on the back of a giant fish; just behind him are two devout Muslims, Masruh and Mashud, wearing skull caps. There is an Arabic inscription in the upper left-hand corner extolling the virtues of Islam. The composition is animated, indicating a journey, in this case to Salaka Island, to find a talisman to sustain the faith of the travellers. It is richly decorated with attractive colours and there are many smaller fish to provide additional decoration. Again, there is an obvious illustrative intention of conveying a historical story yet, at the same time, it works admirably as a work of art.

Plate 82 illustrates one of the most popular stories of the Koran. It is of the Bouraq who supposedly transports Muhammad on his journey to Heaven. The Bouraq, as described earlier, has the face of a woman, the body of a horse, the tail of a peacock, and large wings. Two mosques are shown, one on each side of the picture, and an Arabic inscription at the top that identifies the event. This figure is one of the most common and effective religious folk images in Java, in a culture where rendering a beautiful face is appropriate for Muslims and not viewed as sacrilegious as in most Islamic countries. This syncretic and tolerant tradition is even more dramatically illustrated in Plate 83, a glass painting from Çirebon,[14] which shows Semar, the most famous clown-servant in the Javanese version of the Hindu epic, the *Mahabharata*, formed by Arabic calligraphy. No better example could be given of the openness, diversity, and ingenuity of a folk art that uses history, indigenous tradition, and a foreign faith, and extols them all.

81. Glass painting of Prince Mursada searching for a talisman, Çirebon, 1985.

82. Glass painting of the Bouraq who transported Muhammad to Heaven.

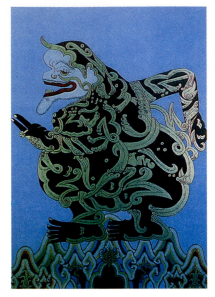

83. Glass painting of Semar formed by Arabic calligraphy, Çirebon.

The re-emergence in Java of both interest in, and production of, paintings on glass is recent, dating from about 1970. In 1976, a Master's thesis (noted in the Bibliography) on the glass painting of Çirebon was completed. There were, in 1977 and 1978, exhibitions of glass paintings by Rastika of Çirebon, the most renowned artist in this medium, held in Jakarta, while in 1980, an article by Wahyono on glass painting was published in *Mutiara*. In 1983, a calendar with reproductions of glass paintings from the collection of Adji Damais was issued by P.T. Pembangunan Jaya; a similar one was published in 1984. In the same year, a major exhibition of seventy works from China, Europe, India, and Indonesia—mostly owned by Indonesian collectors—was sponsored by Kingkar Mitra Budaya Jakarta. During the same year, an important first academic conference on glass painting was convened in Jakarta, sponsored by the Indonesian Ministry of Education.[15] Also in 1984, a new generation of glass painters held an exhibition at Sasono Mulya in Surakarta, followed, in 1986, by an exhibition of Rastika and nine other painters in Jakarta. An article also appeared in the November 1986 issue of *Travel Indonesia* on the glass paintings installed at the Indonesian Museum in Taman Mini Indonesia in Jakarta. It dealt, in particular, with the largest extant glass painting done by Rastika that measures 3 metres in height and 11 metres in length. Entitled *Citra Indonesia*, it depicts an episode from the *Bharatayuddha*. It is executed in characteristic Çirebon style with decorations of *wasadan* (rocks) and *mega* (clouds). More recently, in June 1990, an exhibition of new works by thirty glass painters from Surakarta was held in the Archipelago Modern Art Gallery in Jakarta. The paintings were all modelled after those in the *wayang beber*, and were the effort of a particular group in Surakarta called the Paguyban Seniman Surakarta. Among the group are the painters Sutarno, Barata Seno, Aboe Bakar, Gatot Priyono, Surya Indratmo, Sudarwanto Budi Rahardjo, Sunarno, and Soegang Toeki. A skilled young artist from Yogyakarta also working in traditional glass painting is Selasno.

The previously mentioned calendar of 1984 is an extremely apt example of the complexity, diversity, and quality of Indonesian reverse painting on glass. Its reproductions and subject-matter are a microcosm of this art form and the various folk traditions it represents; it also provides a convenient and instructive summary to this chapter. Fourteen reproductions of glass paintings in this calendar were shown as follows:

1. Twelve prominent figures from the *Mahabharata* set among a five-pointed star;

2. Three clowns chatting in a coffee-shop smoking *rokok klobat* (tobacco rolled in corn husks) (Plate 75);

3. The spread of Islam in Indonesia by the nine *wali* or *Wali Songo* (preachers) surrounded by houses, trees, a *pendopo*, and fifteen other figures, one with the head of a cow;

4. A mosque in Central Java (Plate 77);

5. Kuda Sembrani, a magnetic iron horse with wings used to transport the gods and goddesses to their celestial homes; probably of Persian origin;

6. The chief commanders of the monkey army in the *Ramayana* led by Sugriwa reporting to Rama who is assisted by Laksmana and Wibisono, with two representations of Ganesha in the background;

7. A diminutive-sized Rama with a conical hat and fishing-rod trying to stop the giant Yuyurumpang assigned by Rawana to destroy a stone bridge constructed by Rama's soldiers;

8. Goddesses and animals sent by Narada, who is hovering above, to tempt Arjuna to end his meditation; Arjuna is holding fast with Semar and Togog as his watchmen;

9. Arabic calligraphy formed into a curled and knotted rope which reads, 'When the name of Allah is used, we will be protected. The light of Allah means mercy and love.'

10. The miracle of Nabi Sulaiman talking to the sea creatures (Plate 79);

11. Singa Ali (the lion of Ali) drawn with Arabic letters, serving as a talisman for its owner;

12. Radan Mursada riding on a giant fish (Plate 81);

13. Joko Tarub stealing the clothes of a goddess (Plate 70);

14. Narayana (a manifestation of Vishnu) holding the sacred pronged Hindu symbol while standing on two elephants; a scene from the *Mahabharata*.

1. The only comprehensive study of this type of performance is Mally Kant-Achilles, Friedrich Seltmann, and Rüdiger Schumacher, *Wayang Beber*, Stuttgart: Franz Steiner Verlag, 1990; see also *Album Wayang Beber: Pacitan*, Jakarta: Ministry of Education and Culture, 1983–4.

2. The best recent publication on the history and techniques of glass painting is Rudy Eswarin (ed.), *Reverse Paintings on Glass: The Ryser Collection*, Corning: Corning Museum of Glass, 1992.

3. The best reference for this development is Josef Vydra, *Folk Painting on Glass*, London: Spring Books, *c*.1955. In this volume, there is an extensive bibliography mostly of sources in German. For an example of the art in a particular country, see Juliana Dancu and Dumitru Dancu, *Folk Glass-Painting in Romania*, Bucharest: Meridiane, 1982.

4. The main reference is Jaya Appasamy, *Indian Paintings on Glass*, Delhi: Asia Book Corporation, 1980.

5. Glass paintings done by the Chinese consisted mostly of portraits of family members and ancestors.

6. Eswarin, *Reverse Paintings on Glass*, p. 10.

7. Appasamy, *Indian Paintings on Glass*, p. 7.

8. A serious beginning was made in an unpublished report by a Japanese research team and an Indonesian expert, in Seiichi Sasaki, Wahyono Martowikrido, and Tatsuro Hirai, 'A Report on Indonesian Painting on Glass', 2 vols., Tokyo: Tama Art University, 1984, 1986.

9. These are described in ibid., Vol. I, pp. 249–53.

10. There is an extensive literature on the characters and stories of traditional *wayang* in Java. Four of the most comprehensive studies dealing with the shadow plays are J. Kats, *Het Javaansche Tooneel: Wajang Poerwa*, Weltvreden: Commissie voor de Volkslectuur, 1923; Ward Keeler, *Javanese Shadow Plays, Javanese Selves*, Princeton: Princeton University Press, 1987; Roger Long, *Javanese Shadow Theater*, Ann Arbor: UMI Research Press, 1982; and Ward Keeler, *Javanese Shadow Puppets*, Singapore: Oxford University Press, 1992. For works that deal with either the *wayang kulit*

or *wayang golek* or both, see R. L. Mellema, *Wayang Puppets*, Amsterdam: Royal Tropical Institute, 1954; *Lordly Shades: Wayang Purwa Indonesia*, Jakarta: 1984; and Mary K. Foley, 'The Sundanese Wayang Golek: The Rod Puppet Theatre of West Java', Ph.D. dissertation, University of Hawaii, 1979. A perceptive and general theoretical analysis of the *wayang* tradition is Benedict R. O'G. Anderson, *Mythology and the Tolerance of the Javanese*, Ithaca: Cornell University Southeast Asia Program, 1965. For the insights of a Javanese prince, see K.G.P.A.A. Mangkunagara VII of Surakarta, *On the Wayang Kulit (Purwa) and Its Symbolic and Mystical Elements*, Ithaca: Cornell University Southeast Asia Program, 1957.

11. The only scholarly source on the history and character of the Çirebon tradition in glass painting that could be located appears to be Izah D. Syahril, 'Lukisan Kaça Çirebon', MA thesis, Institute of Technology Bandung, 1975.

12. There is a folk painting entitled *Nyonyah Miber* by Ibu Masmundari of Gresik that shows a similar winged woman, but a source for decoding this image could not be found.

13. Unfortunately, neither time nor opportunity permitted obtaining translations of the Arabic, and in many cases the calligraphy was so decoratively stylized that useful translations would have been almost impossible to determine.

14. This painting is in the collection of the West Java Museum in Bandung.

15. The following unpublished papers, among others, were presented: Agus Dermawan T., 'Seni Itu Sulit, Sulit Itu Seni'; Irsam, 'Lukisan Kaca di Indonesia dari Pembinaannya'; and Sri Warso Wahono, 'Seni Lukis Kaca di Beberapa Daerah Indonesia dan Gerak Perkembangannya Hingga Sekarang Ini'.

4 *Panakawan* in the Folk Tradition of Java

THE *panakawan*, those special attendants who serve, among others, the great heroes, Arjuna and Kresna, in the Javanese version of the *Mahabharata*, are perhaps unique in the folk drama of the world. As a group (Plate 84) they consist of Semar (the central father figure) and his three sons, Gareng, Petruk, and Bagong. In West Java, Bagong is referred to as Çepot or Astrajingga. They have variously been defined as clowns, attendants, and servants. However, the term clown alone is a misnomer and the other two designations by themselves are inadequate. The Javanese name for them is *punakawan* (or in Indonesian, *panakawan*) which includes the elements of humour and service but signifies much more. The fact that there is no adequate term for them

84. Four *panakawan* in a live *wayang orang* performance, Surakarta, c.1957.

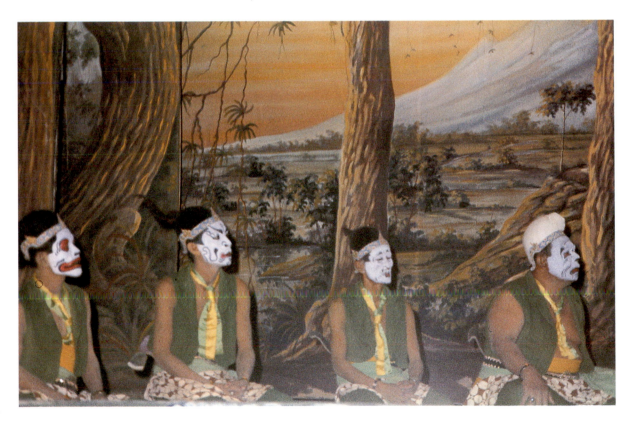

in English is because it is difficult to find a comparable group any-where that functions and is symbolized in the same way. The *panakawan* occupy a number of mystical, religious, and social roles. It has been written that they are 'old indigenous Indonesian deities who have been demoted to the status of servants with the ascendancy of the Hindu gods and the semi-divine heroes of the [Indian] epics'. At the same time, 'panakawan are the "people". They represent the voice of the simple village folk.'[1] They perform many roles and serve, in the most active sense, both aristocratic personages and the folk public. However, it is clear to anyone 'familiar with Javanese liter-ature that a certain identity is obvious between the *panakawans* and their masters. Their actions, and all their doings are a reflex of what is done by the hero or heroine they accompany.'[2] On the other hand, their subservience is a form of escape in that they avoid 'social con-straints not by concentrating potency ... but rather by abjuring all claims to status'.[3] In this sense as well, they become exempt from his-tory and time and are 'virtually without genealogy'.[4] Any audience, any age-group, any social class finds the *panakawan* instantly accessible in terms of their stage presence and the style of their speech and man-ners. Their characteristics have been listed as follows: 'directness of speech,... practical concern with food and money,... a willingness to use any means to defeat their opponents, and ... a complete lack of fortitude and self-restraint.'[5] A Javanese expert of the *wayang* describes their functions in several ways. They act as advisers and supporters to their lordly masters, particularly when these rulers are depressed, con-fused, or in doubt. They act as jesters during periods of sadness, as friends to counter loneliness, and as becalming agents to control the anger of others. They assume the roles of doctor and healer in attend-ing to illness and fatigue. And finally, and perhaps most importantly in terms of the outcome for Pandawa success in intrigue and battle, they are saviours during crucial times of danger.[6] Some of these roles may be derived from the very term *panakawan* itself. *Pana* means 'witty', 'clear', or 'accurate in observing' and *kawan* means 'friend', 'partner', or 'colleague'. The *panakawan*, then, are among other things trust-worthy, clever, and perceptive friends. Their *abdi* (servant) roles appear quite nominal, for *panakawan* do not literally wait upon their masters. They have been described as the eyes, ears, and voice of the or-dinary people and, as such, they appear democratic and down to earth. In performance they speak a direct and popular language; they tell *risqué* jokes, engage in satire, act as buffoons, and challenge the social and political *status quo*. They fulfil roles and display feelings and fan-tasies that many a *pak kromo* (the Indonesian everyman) may aspire to but cannot act out in the conventional real world, bounded by cus-tom and proscription.[7]

In contrast, it is none the less obvious that the '*panakawan* are divine by nature; they are half-way between gods and humans and their simplicity of mind bestows a supernatural power on them. The *panakawan* are a specifically Javanese creation; they personify the early men, the "fathers" of mankind.... They are faithful allies of the

Pandawa heroes.'[8] The popularity of *panakawan* across all social classes and regions is not surprising given the essential role of the *wayang* theatre as the most dramatic artistic expression of Indonesian civilization. It is clear that the 'performing arts in Indonesia are intimately identified with daily life in its individual and collective expression'.[9] This being so, one must regard the *wayang* as 'probably the most characteristic expression of Javanese culture'.[10]

Perhaps the most highly regarded personage in the *wayang* tradition is Semar. He is 'a being who is neither man nor woman and thus personifies the undivided whole, the divine mystery itself'.[11] Semar is 'the guardian spirit of all the Javanese from the first appearance until the end of time, he is perhaps the most important figure in the whole wayang mythology'.[12] In traditional shadow plays, Semar is

popularly described as a person whose identity is completely unclear, completely vague. If we say he is a man, he is indeed a man because he is called by some male term like kakang [brother] ... but his posture looks like a woman, completely round with a developing ... woman's breast. If we say he is elderly, his hair, however has a tuft like a child.... People cannot differentiate whether he is crying or laughing. In the presence of his masters ... he assumes a humble attitude (*andhap sor*), talks using cultured language (*Krama*) and calls them their majesty. But in front ... even of the god of the highest position (Batara Guru), he addresses him with just his name without title of nobility ... and takes a superior attitude. We even cannot guess his age, but clearly he has been serving his masters for generations. Throughout time he has stayed young. It seems that he is an eternal person.[13]

There is a story related by a *dalang* (puppeteer) of Semar's polemical discussion with an important Hindu–Muslim religious figure. Semar scolds him for the incursions of Hinduism and Islam into Indonesia; he replies it was inevitable in the order of things and is curious that Semar, a man, should be so concerned. Semar answers, 'In truth I am not a man, I am the guardian spirit—the *danjang* of Java.'[14]

Typical of this also is Semar's reply to Arjuna when his master states that in order to find his missing son he must 'cut all the bushes in the jungle, uproot all the big trees and scour the hills, so I can find what I am searching for!' Semar firmly but gently states, 'As guardian of yours, oh, Master Arjuna ... I say it is not very wise to do so. Because this jungle is not only an inheritance from the ancestors but a loan from your own children and grandchildren.'[15] Semar's behaviour in the *wayang* is typical of the fact that good and bad are not moral categories but social ones. Despite his appearance and actions, his ideals are *halus* (refined); he fulfils those *priyayi* (upper class) ideals that are also aspired to by common people.[16]

Javanese connoisseurs of the *wayang* are extremely fond of speculating about the origins, virtues, and symbolism of Semar. Among both the highly educated and the average *wayang* enthusiast it amounts to a kind of cultural and philosophical game. Claims are continually made that Semar 'still resides in certain caves in Java, and he crosses the boundary between the world of *wayang* and the everyday world more than any other character'.[17] He is believed to be a reincarnation of a

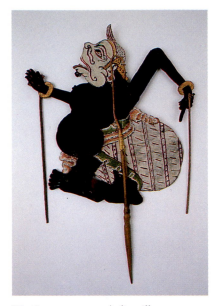

85. Semar, *wayang kulit*, village type, East Java.

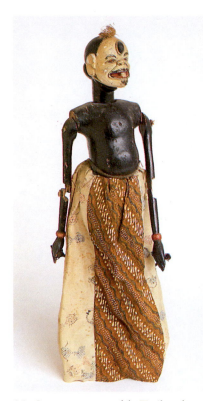

86. Semar, *wayang golek*, Tasikmalaya, West Java.

god named Bathara Ismaya, having descended from being a village chief. He appears in both the *Ramayana* and *Mahabharata*, but is not in the original Indian version of these epics; he is clearly a Javanese creation.

Because of his ambiguous roles, his often contradictory behaviour, and his assertion of a variety of moral values, individual Javanese can choose and favour the character and qualities they prefer. Typical of such choices are those of an Indonesian *wayang* scholar[18] who believes that because Semar's round face is neither handsome nor ugly, he is therefore wise and stands between all extremes. Since his facial expression is unpredictable, neither happy nor sad nor angry, it is indicative of Semar's complete control of himself, even during tumultuous events, a highly desirable Javanese attribute. His countenance, without wrinkles, reflects maturity but not age; he appears always alert to present problems and very conscious of those that have passed. His head seems always to be tilted upwards, perhaps looking up to God, and thus reminding himself and everyone that we humans are all anchored to the earth under the protective and watchful eyes of the great Creator. Semar wears a pair of chilli red ear-rings (*sumping lombok abang*) which, our scholar has stated, symbolize his sensitivity to the world's anxiety and suffering (Plate 85). He has no gender and no obvious sexual endowments. He is thus immune to physical passion. He is not in this world to foster children but rather to be a nurse for everyone and an overseer of noble values for society.

Semar is very obviously short and fat. His large belly symbolizes the necessity to fulfil basic needs such as food. He appears compact with a low profile that makes him more visually accessible and connects him more comfortably to ordinary folk. He has a black 'caste mark' in the middle of his forehead which is said to be a vestige of his former divine origins (Plate 86).

Such analyses could be made over and over again and these would be, as those above, merely indicative of the great extent of Semar's popularity and his importance as a folk figure. Streets are named after him, the fort (*regol*) of a security structure that surrounds some upper-class homes has a roof whose name derives from ancient Javanese architecture called Semar Tinandhu. Semar Tinandhu is also the name for a special shape of kris blade. There are some places of pilgrimage to which many Javanese journey on certain sacred Islamic days, like the first day of Asurya or the first day of Muharram (the anniversary of the flight of Muhammad from Mecca to Medina), because these sites are associated with the *panakawan*. In Central Java these include the Srandil in South Kroya and Candi Semar, a temple on the Dieng Plateau.

Many Javanese believe that Semar and his cohorts still live—or at least culturally survive—in the countryside through the *wayang*. It may well be that this is further enhanced by some people believing that Semar is a *dalang*, the grand puppeteer, and thus mediator between commoners and the gods.[19] It is also evident in his representation in books, magazines, comics, newspapers, movies, radio,

television, sculpture, and crafts (Plate 87) and as logos on a variety of commercial products, public advertisements (Plate 88), popular prints (Plate 89), traditional paintings (Plate 90), and modern art (see Plates 171 and 172). Semar is also represented in a variety of other forms, including wooden printing blocks (Plate 91), terracotta masks for decorating walls (Plate 92), and a portrait of unknown use made of layered iron (Plate 93). Then there are those culturally revealing art forms, such as the glass painting in Plate 94, in which Semar is delineated by letters of the Javanese script (which are indecipherable). This style was most likely based on the techniques of Arabic calligraphy and perhaps intends to further sanctify Semar by bringing him closer to a style derived from Islamic art.

In summary, Semar represents for the Javanese a realistic as opposed to an idealistic view of the world. However, 'whether or not Semar is ... a master symbol of the peasantry, a criticism of gentry values ... he does, in his *kasar* [crude] human form, remind the *halus* [refined] Arjuna of his own humble animal origins and, most crucially, resists any attempt to make humans into gods and end the *kasar* contingency by flight to the *halus* world of absolute order, a final stilling of the

87. Semar, Gareng, Çepot, and Petruk, wood, tourist craft, Bandung, West Java.

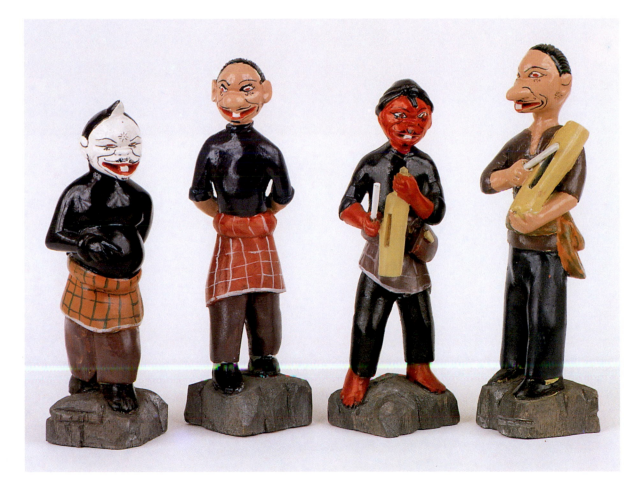

88. Billboard advertisement, 'A clean city is a beautiful city', with Gareng, Petruk, and Semar, Yogyakarta, 1993.

89. Four *panakawan*, popular colour print, 1992.

90. Traditional painting on paper,
 *Ghost Force of the Karawas Fighting
 the Pandawa Panakawan*,
 mid-nineteenth century.

eternal psychological-metaphysical struggle'[20] If 'the typical *lakon* of the Pandawa cycle ... are unthinkable without him',[21] then the folk arts of Java are unimaginable without him, such is Semar's widespread popularity.

A striking aspect of *panakawan* behaviour and speech is that which is sensual and erotic, sometimes bordering on the pornographic. In a traditional and conservative culture, these actions obviously fill a need for Javanese audiences to have an acceptable arena for pleasures and titillation. Phallic symbolism is very common in the *wayang* and is particularly associated with the *panakawan*.[22] A Dutch scholar, in analysing the erotic role of Semar, compares him to Gatoloco (the chief character in a book on Javanese morals and mysticism), to a court jester, and to the head of a troupe of female dancers/prostitutes.

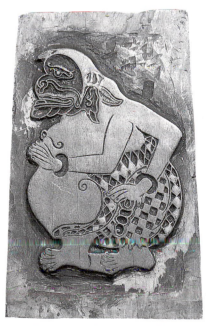

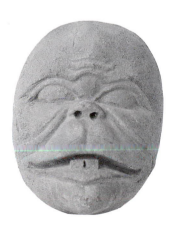

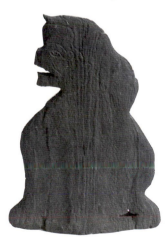

91. Semar, wooden printing block, pre-1957.

92. Face of Semar, wall decoration, terracotta, 1992.

93. Semar, layered iron, pre-1800.

94. Glass painting of Semar formed by
 letters of the Javanese script,
 pre-1957.

He sees him as a god of fertility and discusses some of the other
panakawan in relation to this and to the general sexual tone of their
behaviour.[23] Still, *panakawan* are often impersonated by ordinary
people, indicating how popular they are. It is common for Javanese
men and boys to imitate the voices and walk of the clowns in joking
situations at home, at play, and on social occasions. It is clear this affords
many Indonesians opportunities for, literally, 'clowning around',
which would be inappropriate otherwise. In addition, many *dalang*
often name one of the *panakawan* as their favourite character[24] and
may use one in particular to express their own thoughts. For example,
Semar 'complains constantly about his progeny' but these complaints
may just be a cover for the *dalang*'s own criticisms of Indonesian soci-
ety and, in particular, its politics.[25]

In a scholarly study of the *wayang golek* (rod puppet) repertoire
from West Java, Mary Foley cites five or more stories that demon-
strate the importance and characteristic involvements of the
panakawan, or *pawongan* as they are called in the Sundanese language.
They include the following:

1. Stories that involve seeking some particular end, such as curing
a plague or defeating a foe, in which a human sacrifice is required,
most often Semar;

2. A tale in which a murdered person returns to life disguised or in
a different form to seek revenge, that turns out to be one of the
panakawan;

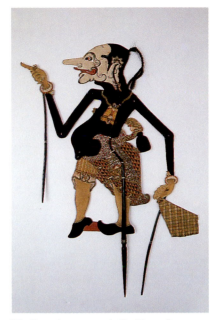

95. Petruk, *wayang kulit*, Yogyakarta.

3. A story in which a piece of jewellery that has magical power goes missing, with confusion reigning as the object becomes a person, such as a princess who falls in love with one of the *panakawan*;

4. A story about a monster king kidnapping somebody else's wife, for example, Siti Ragen, the wife of Semar;

5. A tale in which the heavenly world is besieged by a great warrior whom the gods are not strong enough to defeat; one of the *panakawan* enters to save the day.

In all of these and other tales, the *panakawan* 'are marrying the princesses, winning the contests,... subduing their foes',[26] but they are also generally fighting among themselves rather than actually assisting anyone in battle. 'The clown-servants of the Javanese *wayang kulit* are uniformly ugly, deformed, and irreverent.'[27] Grotesque comedy is the characteristic that unifies them. It is no wonder that they are such an essential as well as a common part of the folk tradition of Java.

Much of the above discussion has focused upon Semar because of his central role in the *wayang* and the regard in which he is held by the Javanese. However, his image in folk art is no more common than that of his sons, Gareng and Petruk. They supply as much humour, farce, and trickery as their father and, in burlesque terms, perhaps even more so. For example, there is a famous story of Petruk who became a king by absconding with a talisman that was the key to attaining the throne. As king, he is constantly gibing at the newly rich and using his long arms to dramatize his often bawdy jokes.[28] His reign is chaotic; he is grateful finally to be dethroned with the nagging help of his father, Semar.[29] Another typical scene of farce involves Gareng and Bagong imitating the smoothing of a young knight's brow. 'They stroke their own foreheads as a hint to the king or seer that they, too, are ... willing recipients of affection. When their more subtle hints fail, they ... take the king's hand, and rub it on their heads in order to "prime the pump" of kindness. Their reward is usually a sharp crack on the ... head.'[30] Petruk and Gareng often fight with each other. Petruk uses standard techniques but Gareng butts like a goat. In one sequence, Gareng and Petruk find a dead ogre and with great bravado challenge the corpse to a fight. They make scatological remarks when the corpse does not respond.[31]

Petruk's face in a shadow puppet is coloured white (pink in the *wayang golek* puppet form), sometimes with spots but always with his main feature, a long pointed nose. He has big eyes, protruding jaws, and a bump at the back of his head (Plate 95). There is a fanciful and unusual glass painting of an unadorned Petruk in a kind of strange skirt (Plate 96). Gareng shares Petruk's face colours but has a black cap or black hair, a big round nose, eyes full of wonder (sometimes crossed), a sad expression, and a lame left leg (Plate 97). Bagong, who was created from Semar's shadow, is short and rather squat with protruding jaws, big lips, and a hair knot (Plate 98). He is Semar's son but is neither as witty nor as wise as his father. He is a very popular figure in the West Java *wayang golek* where he is called Çepot.[32] Semar, Gareng, and Petruk are always allied to the Pandawa side in

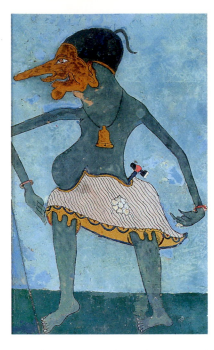

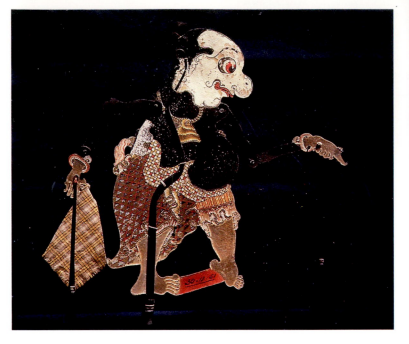

96. Glass painting of Petruk in unusual
 attire.

97. Gareng, *wayang kulit*, Yogyakarta.

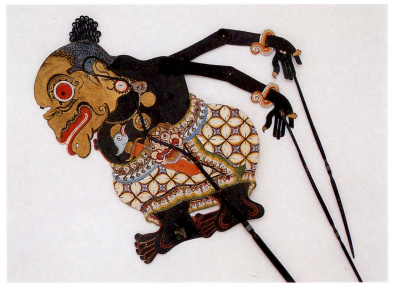

98. Bagong, *wayang kulit*, Central Java.

the great struggles in the Javanese version of the *Mahabharata*.

A *panakawan* on the other, or Kaurawa, side is Togog (Plate 99). He has very protuberant jaws that are shaped like a duck's beak, and is rather squat with a pink body. He looks rather stupid. He is much more popular in East Java than he is in the rest of the island where he is depicted differently (Plate 100). In some *wayang golek* stories, he is a brother of Semar and Şiva.[33]

The *panakawan* are a group apart from the rest of the *wayang* puppets. Be they the mysterious and witty Semar, the sad Gareng, the

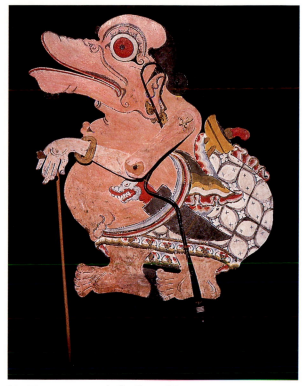

99. Togog, *wayang kulit*, Central Java.

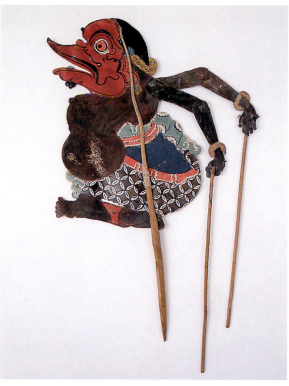

100. Togog, *wayang kulit*, East Java.

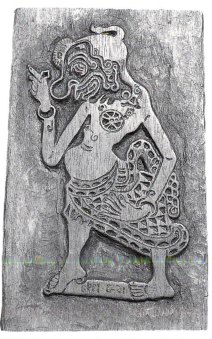

101. Gareng, wooden printing block, pre–1957.

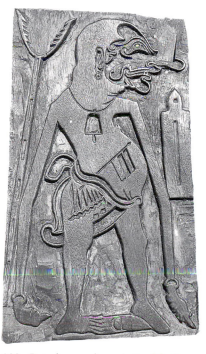

102. Petruk, wooden printing block, pre–1957.

103. Glass painting of the *panakawan* playing soccer.

104. Decorative wall medallions of the four *panakawan*, 1992.

clever Petruk, or the stupid Bagong they are a special Javanese creation that has been endowed with particular characteristics and behaviour, endearing to the people and visible in folk art. Gareng and Petruk appear on decorative cloths, their impressions being made by wooden printing blocks (Plates 101 and 102). The four *panakawan* are also humorously depicted in reverse paintings on glass participating in popular pastimes such as soccer (Plate 103).[34] They also appear on a variety of decorative and gift items such as wall medallions (Plate 104).

In Java, they are thus part of a widespread folk art tradition which contains beauty, simplicity, humour, and mystery. This combination was no better exemplified for the writer than in a group of small stone figures purchased in 1989 in Jalan Malioboro from a pavement trader selling *jimat* (talisman) (Plate 105). They are representations of the four *panakawan*—talismans and objects that sum up what the folk tradition means. They are a kind of symbol of the deep-rooted connections between urban and rural cultures, between ordinary and highly educated people, and between the traditional past and the present day.

1. Soedarsono, 'Wayang Kulit: A Javanese Theatre', in P. L. Amin Sweeney and Akira Goto (eds.), 'An International Seminar on the Shadow Plays of Asia', *East Asian Cultural Studies*, XV, 1–4 (1976): 90.

2. W. H. Rassers, *Panji, the Culture Hero: A Structural Study of Religion in Java*, The Hague: Martinus Nijhoff, 1959, p. 36.

105. Small stone talismans of the four *panakawan*, 1989.

3. Ward Keeler, *Javanese Shadow Plays, Javanese Selves*, Princeton: Princeton University Press, 1987, p. 209.

4. Ibid.

5. Ibid.

6. My source for these is a recent (1993) privately submitted paper by Haryoguritno.

7. Such things are discussed more fully in Boediardjo, '*Wayang*: A Reflection of the Aspirations of the Javanese', in Haryati Soebadio and Carine A. du Marchie Sarvaas, *Dynamics of Indonesian History*, Amsterdam: North-Holland Publishers, 1978, pp. 97–121.

8. Milena Salvini, 'Performing Arts in Indonesia', in James R. Brandon (ed.), *The Performing Arts in Asia*, Paris: UNESCO, 1971, p. 53.

9. Ibid., p. 50.

10. Ibid.

11. K.G.P.A.A. Mangkunagara VII of Surakarta, *On the Wayang Kulit (Purwa) and Its Symbolic and Mystical Elements*, Ithaca: Cornell University Southeast Asia Program, 1957, p. 11.

12. Clifford Geertz, *The Religion of Java*, Chicago: University of Chicago Press, 1976, p. 264.

13. This is a translation from the Indonesian of Soenarto Timoer in his *Wayang and the Cerita Rakyat*, Surabaya: Lembaga Javanologi, 1987, pp. 11–12.

14. Geertz, *The Religion of Java*, p. 23.

15. Translation by Haryoguritno; see fn. 6 above.

16. Franz Magnis-Susena, *Javanische Weisheit und Ethik*, München-Wien: Oldenbourg, 1981, quoted in Victoria M. Clara Van Groenendael, *The Dalang Behind the Wayang*, Dordrecht-Holland/Cinnaminson-USA: Foris Publications, 1985, p. 103.

17. Keeler, *Javanese Shadow Plays*, p. 112.

18. These observations were made by Haryoguritno, a retired engineer, whose passion and knowledge of both *wayang* and the kris are great and perceptive.

19. C. P. Epskamp, *Semar as Trickster, Wayang as a Multi-classificatory Representation of Javanese Society*, Leiden: Rijksuniversiteit Instituut voor Antropologie en Sociologie Niet-Westerse Volken, 1976, p. 5.

20. Geertz, *The Religion of Java*, p. 277.

21. H. Ulbricht, *Wayang Purwa: Shadows of the Past*, Kuala Lumpur: Oxford University Press, 1970, p. 26.

22. An old but intriguing analysis of their eroticism may be found in L. Serrurier, *De Wayang Poerwa: eena Ethnologische Studie*, Leiden: E. J. Brill, 1896. The accompanying volume of quarto plates contains some of the finest colour prints of *wayang* characters and *lakon* to be found.

23. J. J. Ras, 'De clownfiguren in de wajang', *Bijdragen Tot De Taal-, Land- en Volkenkunde (van Nederlandsch Indie)*, 134 (1978): 451–65.

24. Mary K. Foley, 'The Sundanese Wayang Golek: The Rod Puppet Theatre of West Java', Ph.D. dissertation, University of Hawaii, 1979, p. 137.

25. Ibid., p. 189.

26. Ibid., pp. 104–6.

27. Roger Long, *Javanese Shadow Theater*, Ann Arbor: UMI Research Press, 1982, p. 105.

28. *Lordly Shades: Wayang Purwa Indonesia*, Jakarta: 1984, p. 36.

29. Moebirman, *Wayang Purwa: The Shadow Play of Indonesia*, The Hague: Van Deventer-Maasstichting, 1960, pp. 39–40.

30. Long, *Javanese Shadow Theater*, p. 107.

31. Ibid., p. 108.

32. In one of the stories, Çepot is seeking information about his origins but is told he has no mother and was begotten when Semar passed wind; see Foley, 'The Sundanese Wayang Golek', p. 300.

33. For descriptions of the *wayang golek panakawan* repertoire and a list of alternate names, see Peter Buurman, *Wayang Golek: The Entrancing World of Classical West Javanese Puppet Theatre*, Singapore: Oxford University Press, 1988, pp. 98 and 131.

34. There is a striking example of the presence of Semar in a *kain panjang* (long batik sarong) where he is suspended from a parachute while tanks and armoured cars are battling the Japanese invaders of Indonesia during the Second World War. It is reproduced in Robyn Maxwell, *Textiles of Southeast Asia: Tradition, Trade and Transformation*, Melbourne: Oxford University Press and Australian National Gallery, 1990, Plate 555, p. 387.

5 Folk Characters and Folk Art

THE traditional literature of performance in Java is so extensive as to provide an extremely large popular arena for a cast of varying personalities, an abundance of folk customs, and a remarkable display of folklore, myths, and stories. This bountiful concentration of traditional culture is to be seen in the appearances, roles, and values of certain figures in drama, but especially in the puppet theatre. The *wayang wong/topeng* (dance drama with human performers), *wayang kulit* (shadow puppet play), *wayang golek* (wooden rod puppet play), or *wayang klitik* (flat wooden puppet play) all present marvellous opportunities for folk display.

In the *wayang* world of Java, there are two very different orientations. The first is that of the so-called (and misnamed) 'great tradition', with its kings and princesses, gods and goddesses, noble heroes and heroines, battles and wars, romances and political intrigues, all the trappings of royalty and rule, and victory and defeat. These are all embodied in the famous epics, the *Ramayana* and the *Mahabharata*, which feature great characters like Arjuna, Kresna, Rama, Hanuman, Sita, Laksmana, Batara Guru, Bima, and Gatotkaça. It is these epics and characters which are the best known and most studied in and outside Indonesia. In the aristocratic puppet tradition of the courts and the highly educated, they are represented, whether in leather (*wayang kulit*) or in wood (*wayang golek* or *wayang topeng*), by elaborate decoration, great attention to detail, the use of gilt, and the best materials and techniques, all culminating in elegant figures that constitute 'high' art. Puppets of this style and quality are still being made in Java. One only need visit the workshops of Sagio in Bantul, Haryoguritno in Jakarta, or Aming Sutisna in Bandung to find them.

Villagers throughout Java, however, are using and making puppets in which simplicity, inexpensive materials, less attention to detail, and cruder forms are the rule. Here, the characteristics of village or rural folk art are prominent and reflect the main purpose of puppets or masks, which is not to impress but merely to represent plainly and recognizably a character in a story. Take, for example, the differences in detail and effect between two shadow puppets of village origin and one made for the nobility or collector.

Plate 106 shows an elegant version of Batara Guru that was made in the workshop of Sagio in Bantul and is a copy of one made for the Yogyakarta *kraton* (palace). Since this figure is usually equated with the awesome god Şiva, it is always kept in a cotton or velvet bag, and

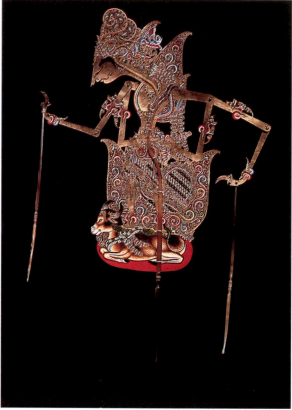

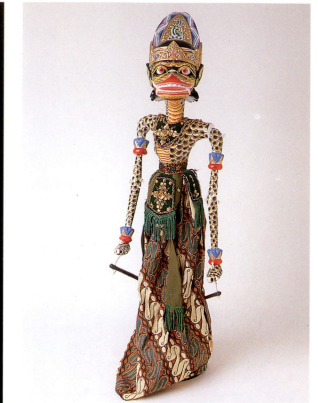

106. Batara Guru, *wayang kulit* from the workshop of Sagio, Bantul, Yogyakarta, 1993.

107. Antaboga, *wayang golek* from the workshop of Aming Sutisna, Bandung, 1993.

though it is essential to every *wayang* set, it is rarely used. This Batara Guru stands on a sacred bull and has an elaborate, enlarged, highly decorated sarong. The figure is colourfully painted on carefully cured, young water buffalo skin to which is attached select sticks of horn. The most prominent colour is bright gold, which in this case is gilt, and in former days might have been pure gold leaf. The effect of the figure is of refinement and an eminently attractive quality based upon the highest tradition of convention and authenticity. Such a representation, whether intended or not, inspires awe, respect, and a certain reserve; it is meant, in any case, to be impressive (see also Plate 107).[1]

In contrast is a village Batara Guru puppet from East Java (Plate 108). It is coloured with cheap, store-bought paint that peels off the leather which, because of its thickness, warps easily. The essential shape is there; Batara Guru is standing on the bull, but there is no extraneous decoration. Clearly it has been used over and over again—use, not art, was its function—yet it has a strength of form that makes it effective in meeting the cultural norms and needs of rural customers. The quality of the materials and the craftsmanship in this puppet are obviously minimal and it stands at the opposite end of the folk art continuum from the example first given. However, *wayang* artisanship permits great variety in execution and even, if only to a lesser extent, in design. It is hard to find two Batara Guru puppets that

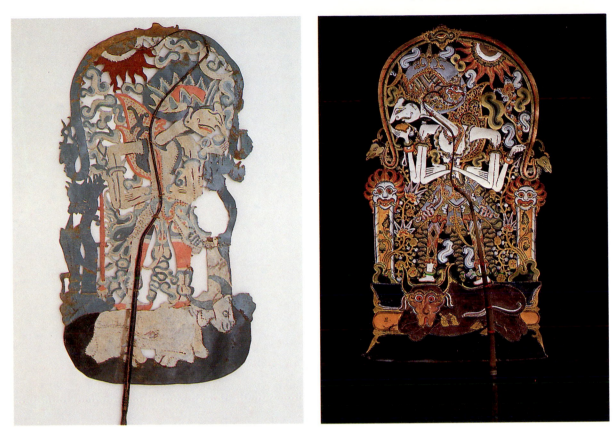

108. Batara Guru, *wayang kulit*, village-type, East Java.

109. Batara Guru, *wayang kulit*, a highly refined example from Yogyakarta.

are exactly the same, yet the basic form is always there and easily recognized (Plate 109).

A Batara Guru puppet from a village near Surakarta shows different features from the two earlier examples (Plate 110). Its attraction, though, as a folk art piece rests on its overall design and compact composition in which both the painting and carving are skilfully executed. There is, however, much less concern with refined colouring and controlled details of carving. It is then, in terms of aesthetics, an artistic compromise between the elaborate examples in Plates 106 and 109 and the cruder example in Plate 108. Such a rendition has the effect of fulfilling both higher- and lower-class values (as does Semar himself) and at the same time exhibiting those characteristics which make it an excellent example of folk art.

Within the so-called 'higher' tradition of *wayang* puppets is a cultural value that is quite opposite to that which requires elaborate decoration and vibrant colouring. It is a reflection of another essential part of Javanese aesthetics and philosophy: that which emphasizes simplicity and tight control in design and form. In the *wayang* tradition, this ideal is no better exemplified than in the characters of Arjuna and Yudistira,[2] two princely aristocrats whose refined behaviour is governed by absolute self-control. They are designed in the simplest terms with no excessive decoration; stately body form and a

71

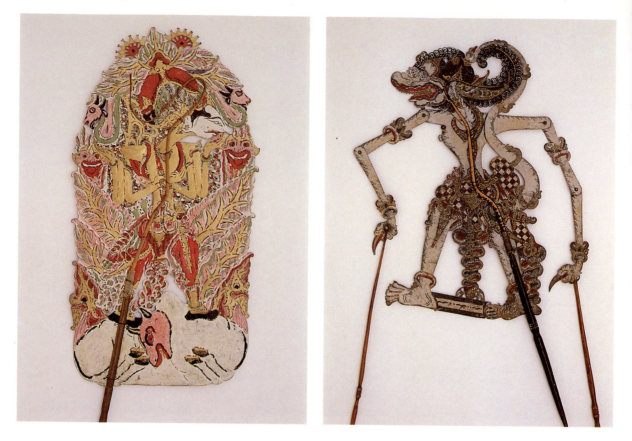

110. Batara Guru, *wayang kulit* from a village near Surakarta.

111. Hanuman, *wayang kulit* from the Yogyakarta area.

meditative demeanour are clearly shown and highly prized. This mode, however, may not translate so easily into folk renditions of the same or similar characters. The relative unimportance of decoration, colouring, and carving details perhaps work against folk art as do the rigid conventions of form so necessary in conveying the exact feeling and look of ascetic characters. There are thus no folk reproductions of *wayang* characters like Arjuna presented in this volume.

With respect to perhaps the second most popular character in the literature of Java, Hanuman, that greatly renowned white monkey soldier of the *Ramayana*, the situation is quite different.[3] Representations of Hanuman are executed in the 'high' as well as the folk style throughout the island. Hanuman is the kind of character whose story is so common in Java that images are to be found both in the court and the countryside, but because he is so highly and widely regarded in the literature, drama, and lore of Java it is difficult to make meaningful distinctions in terms of court, urban, or rural traditions. His stature in Indonesia is, of course, a reflection of his sacred origins from India. The reverence for, and popularity of, this monkey with human attributes of courage and intelligence are well-established in many traditions throughout the eastern half of Asia.

Replicas of Hanuman exist in all special *kotak* (chests or sets) of

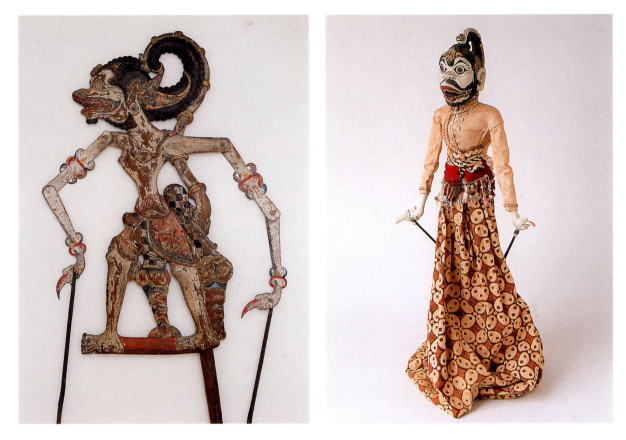

112. Hanuman, *wayang klitik* from the Yogyakarta area.

113. Hanuman, *wayang golek* from Sentolo, Central Java, 1957.

wayang as they do in ordinary ones, but some characters transcend class distinctions. The folklore of Hanuman may be found in all parts of Java and he is probably the most popular of all characters in the *Ramayana*. It is likely that this is because of his bold success in retrieving the kidnapped Sita; however, his acting as a brave and clever lieutenant in the guise of an animal is also a strong part of his folk appeal.

It is easy to find many examples of Hanuman in folk art form in city shops, homes, and village settings throughout Java. The most common form is that in the *wayang kulit* as shown in Plate 111. The sticks are made of bamboo rather than *kerbau* (buffalo) horn, the paint is a faded greyish-white, but all the distinguishing characteristics are there: a long tail, a protruding claw on each hand, a checked (*polang*) sarong, and exposed sharp teeth in an extended jaw. There is hardly a child or adult in Java—and in most other islands—who would not recognize Hanuman. He is most popular in the *wayang wong* where his striking white costume and lively antics as an actor-dancer appeal to all audiences.

The Hanuman mask in Plate 17, his depiction in *wayang klitik* form in Plate 112, and the superb example of a *wayang golek* in Plate 113,[4] all demonstrate the variety and ubiquity of this folk figure. He is also often represented in various crafts such as the bronze figure in Plate 114 and the wooden printing block in Plate 115, and is also a

73

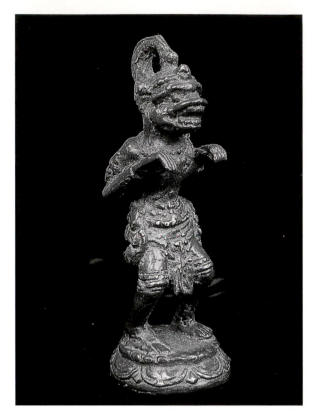

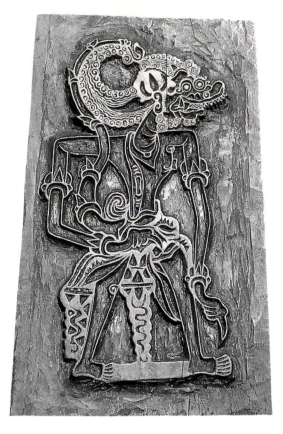

114. Hanuman, bronze statuette,
 contemporary craft, East Java.

115. Hanuman, wooden printing
 block, pre-1957.

common subject for schoolchildren in art classes; an example is shown in Plate 116. He often appears as a logo on commercial products and on billboards such as the one in Plate 117 which advertises a festival of the arts held in Yogyakarta in July 1992. Including the examples already shown in Plates 1 and 3, one must conclude that Hanuman, in all his forms, represents an extraordinary and intriguing figure in the lore and folk art of Java.

Within the *wayang* tradition, the *panakawan* constitute a special and separate group of characters. In addition to those like Semar that have already been discussed, there are similar characters who play minor roles but who are very much a part of what is defined here as the folk tradition; they include such figures as Togog, Sarawita, Cantrik, and Limbok. Their attraction as folk figures has as much to do with their dress and form as it does with their part in the various scenes and episodes. A representative example of this group is the fat female figure of Limbok (Plates 118 and 119) who is a constant gossip and loves to dance with ludicrous gyrations of her ample body.[5] She is the epitome of the stereotyped female who always butts into conversations, wanted or not, relevant or not. She has a vulgar, earthy quality that makes her a part of this humorous, slightly raucous, and highly visible folk tradition. A character very much like her in behaviour but of opposite body type is Çantrik (Plate 120). She is a nervous busybody, tall and very thin, and is always either looking at herself in a

116. *Hanuman in Battle*, pastel crayon
drawing, Sigit Pamangkas, aged 9,
Yogyakarta, 1987.

117. Hanuman on a 'Festival of Arts'
billboard, Yogyakarta, 1992.

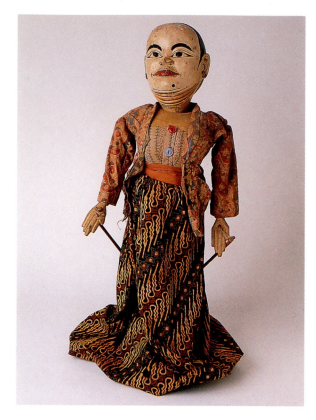

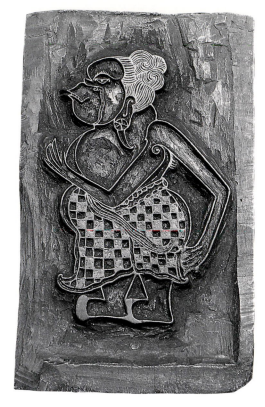

118. Limbok, *wayang golek*, Central Java, pre-1960.

119. Limbok, wooden printing block, pre-1957.

mirror or combing her hair. Her ostensible role is that of a disciple of a hermit but this appears to be a cover for her irritating personality.

Throughout many parts of rural Central Java there exist *wayang golek* puppets that are not used as part of the *Ramayana* or *Mahabharata* epics. Instead, they form a part of various stories and legends with Islamic origins or taken from the adventures of Prince Panji (*wayang gedhog*) or as part of the Majapahit hero Damar Wulan (*wayang klitik*) or from various other local traditions that have yet to be properly studied. A few examples are presented here merely to stimulate others to make serious inquiry. These include two *wayang golek* (Plates 121 and 122) from Central Java and a flat wooden puppet from East Java out of the Panji legend (Plate 123).

In addition, there is an assortment of ancillary shadow and rod puppets that are interesting from a folk art perspective, including puppets of animals such as birds (Plate 124), horses (Plates 125 and 126), ferrets (Plate 127), and elephants (Plate 128). Animals of all kinds also appear on batik sarongs, decorative household cloths, various commercial logos, and a variety of other forms like printing blocks, kris handles, pottery, and glass paintings. In the traditional *wayang* literature of Java, the distinctions between people and some animals are ambiguous and have a dual character, such as the monkey-soldier Hanuman and Ganesha, the half-man half-elephant. It is not surprising, then, that animals are not only popular folk figures in Java

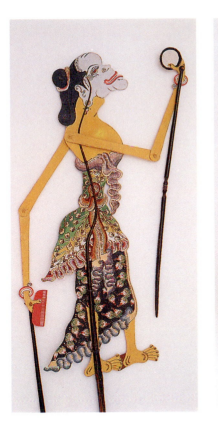

120. Çantrik, *wayang kulit*, Yogyakarta, pre-1971.

121. Çepot, *wayang golek*, Central Java, pre-1961.

122. *Wayang golek* of a villain, Central Java, pre-1961.

123. *Wayang klitik*, probably a character in a Panji story, East Java.

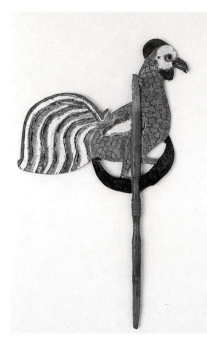

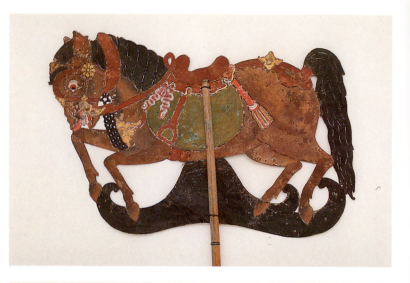

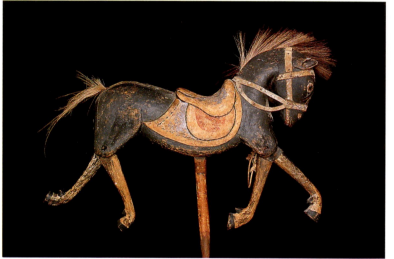

124. Rooster, *wayang kulit*.

125. Horse, *wayang kulit*.

126. Horse, *wayang golek* with movable legs and hole for the puppet rod, Sentolo, Central Java, 1957.

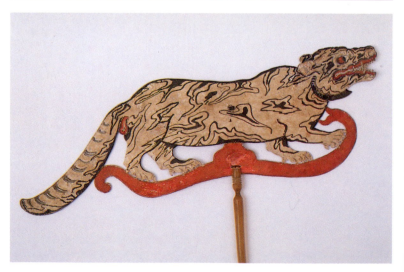

127. Ferret-like animal, *wayang kulit*.

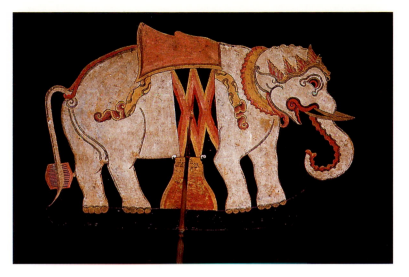

128. Elephant, *wayang kulit*, Yogyakarta.

like they are in most Asian countries, but their duality makes them folk heroes and even more common subjects for folk design.

There are also various additions to standard shadow puppet figures which clearly reflect a folk element; they involve adding something to a figure that is not part of its conventional appearance. These include a checked handkerchief, dangled by Gareng; Petruk playing a slit drum; characters wearing inappropriate jewellery or clothing; and the addition of things that are humorous or merely pleasing to the maker or serve some unrelated cultural or political purpose.

Plate 129 illustrates a *gunungan* or *kayon* (mountain or tree) from Central Java. The horn stick, usually in the middle, is missing but otherwise this is a conventionally rendered puppet in shape and content, with one noticeable exception. A clock showing twenty-two minutes past nine has been carved into the design. The two guardian figures with clubs seated at either side of the entrance at the bottom, a *kala* (guardian face) above each of the guards, the sinuous branches with leaves and flowers rising to the top from each side, and the general symbolized mountain shape of the whole puppet are characteristics of all *gunungan*. Yet, out of whimsy or boredom with convention or for some other reason, the maker has included an anomalous clock. Folk artisans are always doing such things, even with traditional objects.

Folk art is never static, but by its very nature is responsive to changes in the folk condition. There are thus shadow puppets depicting the Indonesian revolution against the Dutch in 1945. There are shadow puppets showing former President Soekarno addressing a large crowd and *panakawan* berating well-known politicians. There are shadow puppets made of cardboard, tin, sticks, and rice straw (Plates 130 and 131). And, finally, there are figures that appear to be puppets that are so close to folk origins, so marked by folk creativity, and so connected to folk culture as to constitute almost by themselves a basic definition of Javanese folk art. They are largely village objects made out of simple local materials that depict some important aspect

129. *Gunungan, wayang kulit* with a clock.

130. Puppet made of sticks and rice straw, Central Java.

of everyday life with humour, satire, and reality. A prime example of this genre is the figure shown in Plate 132. It depicts a woman carrying nine children and one infant while giving birth to another. She is holding a comb in one hand and in appearance looks like a combination of the previously mentioned *wayang* figures, Limbok and Çantrik. How does one form an opinion of the maker's intent? Is it really a puppet used in some story or is it merely a folk art object made out of animal hide to convey some other purpose or some particular message? Could it have been used by Indonesian health agencies to dramatize the need for family planning in one of the most heavily populated regions of the world? Or does it signify the heavy childbearing burden borne by the average woman in Java? Or is she merely celebrating the size of her family and her continuing fecundity? Similar questions can be asked in connection with another example of this type of figure (Plate 133). Here is an apparently ordinary man but with the face of a *wayang* character and with a kris tucked into his sarong. He is carrying a wooden yolk on his back to which are attached two buckets filled with nine children. One of the buckets contains two krises and a sword, the handles of which are just

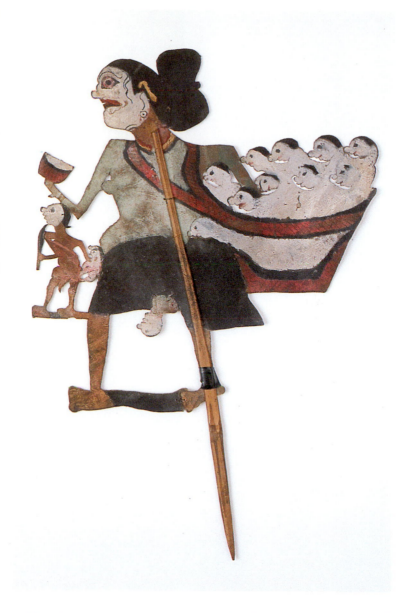

131. Puppet made of wood and grass, Central Java.

132. Figure (or puppet) of a woman carrying many children, animal hide and wood.

visible. Two children in one corner are holding a rooster; a dog stands amidst two children in the other corner. Again, the same questions can be asked of this example. Is it a puppet or a folk object or an instrument of official propaganda? Understanding the image and its uses requires fieldwork on an entire category of Javanese folk art that has barely been considered. It is a dimension of the folk society and its products that may reveal yet unrecognized but significant aspects of Javanese culture and contemporary life.

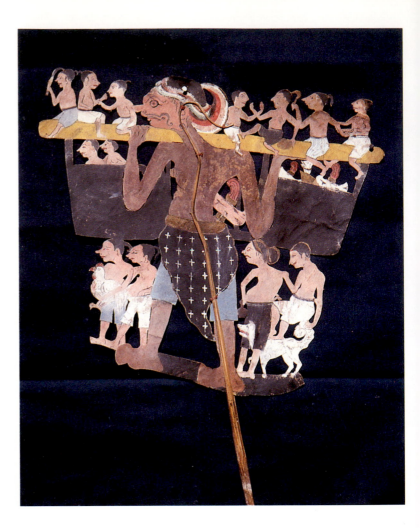

133. Figure (or puppet) of a man
carrying many children, animal
hide and wood.

1. The same can be said of a striking example of a *wayang golek* character, Antaboga (ruler of the undersea snake kingdom), made in 1992 by Aming Sutisna of Bandung (Plate 107).

2. Two excellent full-page colour reproductions of them are shown in Helen Ibbitson Jessup, *Court Arts of Indonesia*, New York: The Asia Society Galleries and Harry N. Abrams, 1990, Figures 56–57, pp. 81–3.

3. There are apparently no scholarly studies of the image of Hanuman in Indonesian traditional art. The literature in India, however, is quite extensive; a prime source is K. C. Aryan and Subhashini Aryan, *Hanuman in Art and Mythology*, Delhi: Rekha Prakashan, n.d.

4. This is a highly refined, meticulously dressed puppet of Hanuman made by a famous, now deceased, *dalang* from Sentolo in Central Java.

5. Descriptions of the movements and manner of many characters in the *wayang kulit* of Yogyakarta are given in Roger Long, 'The Function of Movement in Characterization', in his *Javanese Shadow Theater*, Ann Arbor: UMI Research Press, 1982, pp. 69–109.

6 Folk Art, Games, and Magic Play in Java

ONE of the most direct and expressive activities of any culture is the game. There is a considerable literature on games but surprisingly little of this has been compiled by anthropologists.[1] Most of the studies have concentrated on the rules and components of individual games, with particular attention to origins and regional and national differences. Many of these field studies also have a psychological orientation, with little analysis of the objects that are used in such activities.[2] Most outdoor games, in fact, require very little equipment and those that do are devoid of elements that would be pertinent to folk art analysis.[3] Children's games that involve toys are, of course, a different matter but as so many of them are universal in nature, like tops, for example, they have little place in the study of indigenous culture. This chapter, then, is a modest introduction to the possibilities of using the objects (toys, boards, or various props) associated with traditional games and play, in this case in Java, to further research into folk art. It is confined to those games engaged in by the *wong cili* (the ordinary person), and for the most part played by children in villages and rural areas.[4]

A Javanese folk-game that belongs to the so-called play category is called in Javanese 'Nini Thowo', or, more commonly in Indonesian, Nini Towong; it has many other names as well. It has been described as 'magic play' which had its origin in ancient Javanese Malayo-Polynesian animistic belief.[5] Nini Towong is a doll-like figure of a female man whose head is made of a coconut shell water-dipper, his hair of dry, shredded banana leaves, and his body of wood (Plate 134). (The Javanese believe that the water-dipper must have been stolen from a cantankerous widow.) The manikin is first placed by the side of a mirror or under a large tree so that it may be possessed by a spirit. After a while, it is brought back to the yard in front of a village house and two little girls begin to play with the figure. They rock it back and forth, accompanied by traditional musical instruments, until it eventually begins to rock by itself. It is thought that this activity is a survival of an old religious ritual that has lost its meaning and become a children's game. This has, in part, been determined through field research on this play-game done in the village of Banyumedal where it is re-enacted during the dry season as a fertility rite to bring forth

134 Man holding a Nini Towong manikin used in a play-game of a spirit who is asked and answers questions. The figure is made of coconut shell, dry, shredded banana leaves, and wood. (Photograph courtesy of Professor James Danandjaja.)

rain.[6] During the enactment, male participants, who are usually related to the children, go into a deep trance and appear to be possessed by animal spirits, such as snakes and monkeys, the effect of which is to both inspire awe and entertain.

Another similar 'magic play' is called 'Jelangkung'; it is played by both children and adults. It involves using a headless manikin whose body is made from a bamboo market basket dressed in a man's shirt. A writing slate and chalk are placed near the image so that it can 'communicate' with the player. To encourage the image to write, it is presented with food and tea which can be consumed with the assistance of a key that has a hole for swallowing. The manikin is held by a man and must be covered with the smoke of a joss-stick to attract a spirit. If the manikin suddenly becomes heavier, then the spirit has indeed entered it and the man begins to sway. At this point, the slate and chalk attached to a stick are placed in front of the 'finger' of the manikin and the players wait for a message to be written. It is said that if the spirit enters the manikin at night, it is a teenage spirit who will play pranks on all the participants. The spirit that enters after midnight is that of an old man who never plays tricks and who seriously, if somewhat mystically, answers all questions put to him by the players. Since the Jelangkung comes from the Chinese words *Joy Lan Kung*, which mean 'grandfather market basket', it is not clear whether the spirit would answer questions in Indonesian, Javanese, or Chinese. In any case, the game is played by many persons. Villagers concerned with crops and city students concerned with the outcome of their examinations may be players, holding the enigmatic Nini Towong in their hands, seeking answers, seeking predictions, and calling for good fortune.

One of the most popular folk-games in Java and in many other parts of Indonesia is *dakon*, or *conglak* as it is called in Jakarta. The game,

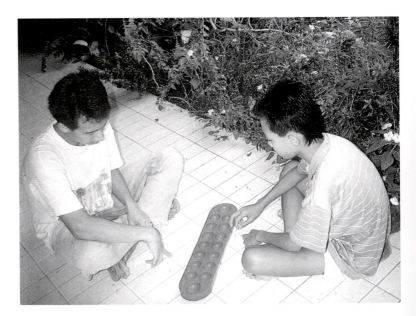

135. Children playing the *dakon* game. (Photograph courtesy of Professor James Danandjaja.)

apparently, has peasant or folk origins and was used in former times in Indonesia to settle land disputes.[7] The *dakon* is a long, boat-shaped wooden board with two big depressions at each end and seven or nine pairs of smaller depressions along each side (Plate 135). To play the game, each little hole is filled with seven or nine tamarind pips or cowrie shells. The winner is the one who captures the most pieces by moving them around the board, according to certain rules, from one depression to another. This is one of the most universal board games in existence. It is generally classified as a *mancala* game; is called *wari* in Africa, and has other names in other countries.[8] Some of the boards are very ornate with finely carved decoration and gilding; sometimes the entire board is lacquered. The most common boards, however, are relatively plain, though sometimes animal paws are carved on their undersides as supports. Examples exist in most museum collections in Java as well as in Sumatra and Bali.

Another game which is culturally interesting is the one called *goba sobor* or, in Jakarta, *galasing*. It is a game of physical skill for six to eight children which only requires drawing rectangles on the ground (Plate 136). There are no objects used when playing it. Its only significance here is that it may have been a part of fertility rituals in ancient Java and is today the basis of a similar rite to bring rain, performed once a year, in the mountains of Bali.

Another popular game in Java which has considerable folk art content is called *umbulan*, which means something 'that can be tossed up in the air'. It is a children's game for two players in which a card is tossed by one player in the air. If it lands face up, the opponent wins, if face down, victory belongs to his competitor. During play, children will blow on the card and say 'Bismillah' before tossing it. This is equivalent to the Islamic saying, 'In the name of Allah, the Merciful, the Charitable' which may bring luck to the player. The items

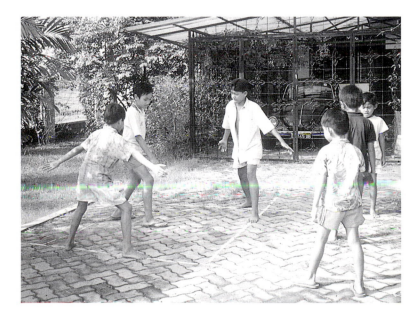

136. Children playing the *goba sobor* game. (Photograph courtesy of Professor James Danandjaja.)

137. *Wayang* cards of major *Ramayana* and *Mahabharata* characters used as wagers in a children's game called *umbulan*.

wagered are coloured picture cards of *wayang kulit* (Plate 137). Some cards may have more value than others according to the characters portrayed. For example, Semar, Arjuna, Bima, Kresna, or Gatotkaça may be worth twice or three times the value of lesser figures. Various real and mythical animals are also pictured (Plate 138). These cards at one time could be bought anywhere in big city stores and small village shops, but today bookstores and stationery stores are the main outlets. The large sheets of printed pictures must be cut into individual cards after purchase. The coloured cards with traditional figures that are used in Java add a folk art dimension to the game and differentiate it from the many other similar games such as coin toss that are played by children around the world.

Javanese literature contains mention of some games, the most common of which is dice. In a *lakon* called 'Pandawa dadoe' there is a depiction of Yudistira and Sujudana playing dice. This is shown in a 1925 colour print from a folio of *wayang* illustrations (Plate 139).

Smaller sized shadow and rod puppets have always been made for children in Java. Inexpensive examples can be found mainly in big city department stores like Sarinah in Jakarta and Bandung. They are usually of inferior quality but they do provide a supply of traditional toys for children. Children unable to afford even these cheaper puppets have often fashioned their own out of paper or cardboard.

138. *Wayang* cards of animals and
ogres used in the *umbulan* game.

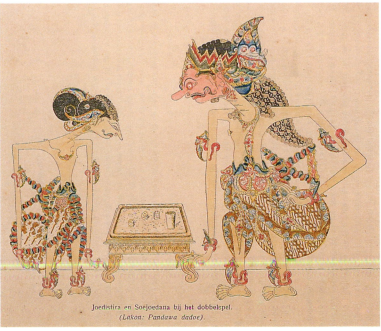

139. Yudistira and Sujudana playing
dice, from a colour print, 1925.

87

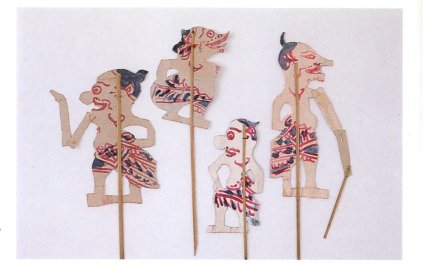

140. Four cardboard puppets of Semar, Bagong, Gareng, and Petruk, Yogyakarta, 1992.

141. Children's miniature shadow puppet of Basuki, Kota Gede, pre-1940.

142. Children's miniature shadow puppets of Kunti, Rokmini, and Durga, Kota Gede, pre-1940.

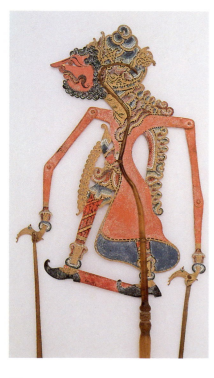

Plate 140 illustrates four such creations consisting of the main *panakawan* made of painted cardboard with bamboo sticks. The materials used are ubiquitous, the ingenuity is natural, and the traditional folk culture is again present. Compare these simple puppets with an elegant set that was made for wealthy children by an artisan in Kota Gede before the Second World War. Examples include the regal figure of Basuki (Plate 141), figures of three important women, Kunti, Rokmini, and Durga (Plate 142), and that of a charming tiger (Plate 143). These are very fine creations, fully representative of the highest traditions of shadow puppetry, yet were intended for regular use by children. This provision for traditional cultural transmission through the youngest members of Javanese society is perhaps dying out. It has been more and more replaced by other objects (for example, skipping ropes), other games (ring-around-the-roses, Plate 144), and other means (television and movies). In Java, children are

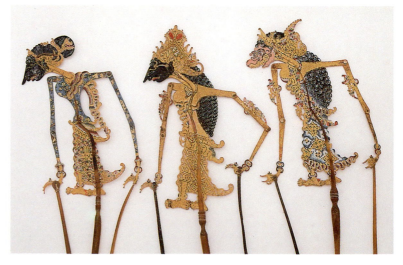

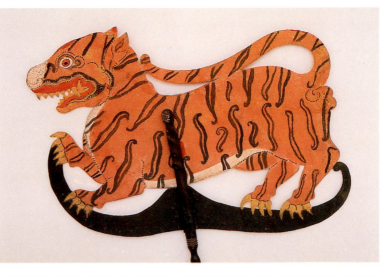

143. Children's miniature shadow puppet of a tiger, Kota Gede, pre–1940.

144. *Javanese Children's Game*, water-colour, Devie Caroline, aged 8, Yogyakarta, 1992.

still playing traditional games and, as shown in Chapter 7, are still responsive to old tales and to many old cultural values.

1. Some of the more useful studies are by Elliott M. Avedon and Brian Sutton-Smith, *The Study of Games*, New York: John Wiley, 1971; Alan Milberg, *Street Games*, New York: McGraw-Hill, 1976; Iris Vinton, *The Folkways Omnibus of Children's Games*, Harrisburg: Stackpole Books, 1970; and Brian Sutton-Smith, *The Folkgames of Children*, Austin: University of Texas for the American Folklore Society, 1972.

2. A standard psychological reference is Jerome S. Bruner, Alison Jolly, and Kathy Sylvia (eds.), *Play: Its Role in Development and Evolution*, New York: Basic Books, 1976.

3. Art historians and folk art specialists have also shown little interest in the objects associated with games. Their main focus has been on the toys of play where the objects have an obvious visual dimension. A superb example is Kiyoshi Sonobe and Kazuya Sakamoto, *Japanese Toys: Playing with History*, Tokyo and Rutland: Bijutshu Shuppan-sha and Charles E. Tuttle, 1965.

4. This chapter is based almost entirely on the information supplied by Professor James Danandjaja of the University of Indonesia who is Indonesia's most renowned folklorist; see his book, *Folklor Indonesia*, Jakarta: Grafitipers, 1986.

5. G. A. J. Hazeu, 'Nini Towong', *Tijdschrift voor Indische Taal-, Land-en Volkenkunde*, XLIII (1901): 36-107.

6. Pariwatri Wahyono, 'Nini Towo', Ph.D. dissertation, University of Indonesia, 1990. An example of the doll is reproduced and another description of its use given in John Miksic (ed.), *Art of Indonesia*, New York: The Vendome Press, 1993, pp. 18–19.

7. A. J. Resink-Wilkens, 'Het Dakonspel', *Djawa*, VI, 1 (1926): 24–6. For more comprehensive treatment of children's games, see H. Overbeck, *Javaansche Meisjesspelen en Kinderliedjes*, Jogjakarta: Java-Instituut, 1939, and Catharina H. Kool, *Das Kinderspiel im Indischen Archipel*, Kempen-Rhein: Thomas Druckerei, 1923. There are apparently no recent studies.

8. The *wari* game is discussed and illustrated in Frederic V. Grunfeld (ed.), *Games of the World*, New York: Holt, Rinehart and Winston, 1975, pp. 20–5.

7 Children's Art and Tradition in Yogyakarta

DRAWING and painting are probably practised in more ways by more children than any other group in the world. Children between the ages of three and twelve, in practically all cultures, appear naturally to take to illustrating themselves, their daily life, and the traditions of culture into which they are born. Such artistic activity is so universal in children that it constitutes a major part of childhood everywhere. It is not surprising, then, that there is a very extensive literature on children's art. However, it is almost entirely confined to studies of children in the Western world.[1] Furthermore, these studies are dominated by psychological perspectives largely motivated by a deep interest in child development which has come to constitute a separate field of study. In this contemporary world-wide concern with children, there is a geographical hiatus: much of this interest and scholarship hardly involves Asia or Africa; and there is a much more profound bias in that psychology dominates Western and even Third World inquiry. This further results in attention to children's art if it can be related to mental and personality development. Neither the connections of children's art to traditional culture nor the aesthetic and creative aspects of individual art pieces have received much scholarly attention from anthropologists, art critics, or art historians. Typically, popular response to, and appreciation of, children's art tends either to be overly sentimentalized by adult nostalgia or regarded as quaint and primitive reflections of the child. Most art intended for children is done by adults and produced in books to accompany stories. When the art of children is published or exhibited, it is rarely organized by theme or selected according to stated aesthetic principles. What often results is a *mélange* of pictures, of animals, buildings, people, landscapes, flowers, comic book characters, and media characters from various countries, which does not contribute either to art appreciation or cultural understanding.

It is clear that most children's art does not meet the criteria of what constitutes the academic definition of folk art, unless very careful selections and distinctions are made. However, a case for the children's art from Java, presented and discussed here, can be made once the essential connection to traditional culture is established. There are other variables which can demonstrate the repetition of treatment of

certain characters, images, rituals, tales, and the like within a representative group of children, located in certain places with a specific cultural identity. In selection, careful screening must determine how much of this children's art is merely a response to pedagogy, to popular media, or to unconscious imitation. There is among some of the children in Yogyakarta, for example, evidence that they are purveyors of folk culture through their art, regardless of the intervention of parents, television, and school. An even stronger case could be made for some of the children in a place like Ubud, Bali, where many are encouraged at a very early age to transmit tradition through drawing and painting, both as a cultural obligation and as a preparation for future economic success. As for Java, 'the cultivation of the aesthetic aspect of a child's sensibility is a key aspect of Javanese education. This is not, as in Western society, to provide a chance for gifted children to develop their talents but in order that every child should learn to order all aspects of his life in a harmonious way.'[2] The dictum of Professor Dundes in the Foreword for rigour in assigning a folk dimension to children's art can be met here partially through examples that are 'part of a tradition displaying multiple versions and variations'. Though this kind of assignment is more difficult to document than, say, children's games, jokes, riddles, and songs, it can be done, albeit carefully and not without complexity.

Take, for example, the drawing by Reza Setiawan entitled *A Giant Eating the Moon* (Plate 145). When this was done, she was only four years old and residing in Yogyakarta. The drawing is based on an important *wayang* myth about Bathara Kala, a giant ogre who was a forbidden offspring of the great god Batara Guru and his consort Dewi Uma. It is about the behaviour of the ogre during a solar or lunar eclipse and the response of the villagers to allay fear and promote safety. Women strike the side of a *lesung* (rice pounder); this is called doing the *gejog*. Men and women play a *kenthongan*, which is an

145. *A Giant Eating the Moon*, pastel crayon, Reza Setiawan, aged 4, Yogyakarta, 1992.

instrument of wood or bamboo. At the same time, an orderly beat and tempo is established; this is called doing the *gendhong-titir*. Villagers respond to what is described as a 'beautiful and magical' sound.[3] The sounds and the activity associated with it are aimed at preventing Bathara Kala from swallowing or eating the sun or the moon. The eclipse is, after all, an awesome event. The *gejog* and the *gendhong-titir* are continued until the sky clears and all is calm again. In Reza's drawing, the giant has already bitten a chunk out of the sun and is about to swallow it. Five tiny people in the lower left corner are making sounds with musical instruments; the ogre is resting on a large blue rain cloud. It is a simple, faithful, and colourful interpretation of a traditional myth, in a striking manner, with the 'right' perspective, yet without artifice or unnecessary decoration or detail. Other examples of children's art depicting this particular myth in various ways can be shown (Plate 146) for it appears to be a common subject.[4]

A young girl living in Yogyakarta, Trisna Ratna Sari, was very interested in seeing a *jatilan* (itinerant troupe) which she had only heard about but not seen. Although she conscientiously attempted to make drawings of the *kuda lumping* (trance dance prop) there was always something missing in them. She was hesitant and unable to readily visualize a popular tradition which she had not seen. She beseeched her parents to take her to a performance, which they did; it took place on the great *alun-alun* (open square) in front of the sultan's palace in Yogyakarta. She enjoyed it thoroughly and later was given some toy replicas of the horse figure. The result is a composition called *Kuda Lumping* which she painted in 1992 when she was five years old (Plate 147). It is partly a collage with water-colour, pastel crayon, cloth fragments, and glitter. It is hard to imagine that this is the art of a child so young and inexperienced. Because of its patent individuality and obvious sophistication of design and technique, it is difficult to label this particular example as folk art. It is certainly not

146. *Eclipse of the Moon*, pastel crayon, Devi Caroline, aged 8, Yogyakarta, 1988.

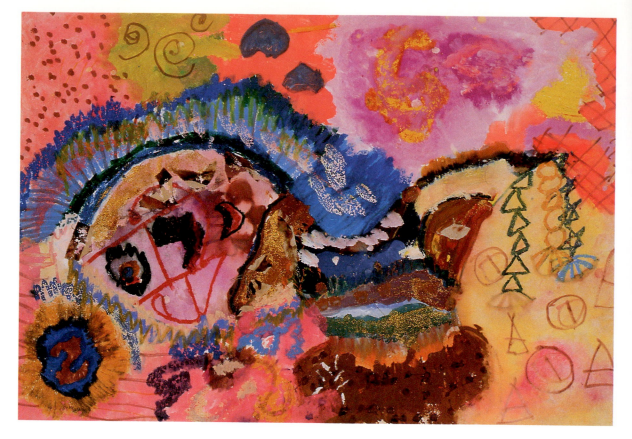

147. *Kuda Lumping*, collage,
 Trisna Ratna Sari, aged 5,
 Yogyakarta, 1992.

naïve art, nor is it merely the product of a singularly creative child's imagination. What gives it cultural as well as artistic status is the identification of the subject-matter with an important aspect of Javanese tradition. In this case, it is Ratna's response to, and understanding of, her traditional world as she is gradually incorporated in an otherwise increasingly fragmented society. Somehow she has reached the depths of folk culture, and depicted and reinterpreted part of it for herself.

Many of her contemporaries are doing similar things, though finding them may be extraordinarily difficult. Classmates have drawn more conventional pictures of the same subject; they are a relatively literal rendering of a *jatilan* troupe performing the *kuda lumping* dance in a park with many children looking on (Plates 148 and 149). In the case of both Reza and Ratna, what draws their work together is cultural not aesthetic; they are both involved, though in different ways, in reproducing and transmitting folk tradition. The same can be said of a painting of a Javanese bride and groom in traditional dress (Plate 150). It is probably just a portrait of a couple but it could also be considered a folk representation of one of the most important rites of passage in Javanese culture.

In assigning folk art status to children's art, the line has to be drawn somewhere. It would involve identifying and separating unique individual efforts from those that can be clearly documented as a part of

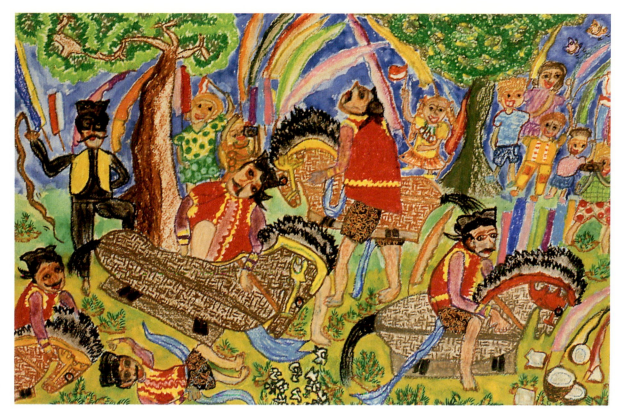

148. *Kuda Lumping/Jatilan*, pastel crayon, Nike Putri Handayani, aged 9, Yogyakarta, 1991.

indigenous tradition. Certainly, children's art can be used as a source for locating folklore and other elements or vestiges of traditional culture. Many children in places like Yogyakarta are still connected, for example, to objects that are found in *wayang*. Whether it is the representation of a shadow play performance (Plates 151 and 152) or of its famous characters (Plates 153 and 154), this traditional drama and what it visually signifies is still in the minds of many, though a decreasing number of, children in Java.

Children's art is just as important as a source of folk-tale and myth. The eclipse already discussed is merely one of many that is depicted by children. Another example, entitled *Bandung Cursing Jonggrang*, is shown in Plate 155. It is the story of Bandung Bondowoso, who in order to marry his great love, Roro or Loro Jonggrang, must build 1,000 temples in a single night. With a superhuman effort and an army of spirits to help, he is able to build 999 just as the sun begins to rise. His helpers, hearing cocks crowing and rice being pounded by villagers, are afraid of being melted and flee at the approach of daybreak, returning to the graveyards, large rocks, and big trees from whence they came. Bandung had not realized that time had passed so quickly and became very angry when his helpers fled. He suspects that Roro Jonggrang has conspired to trick him by getting the village women to prematurely start pounding rice which customarily signals sunrise. Out of frustration he turns her into stone.

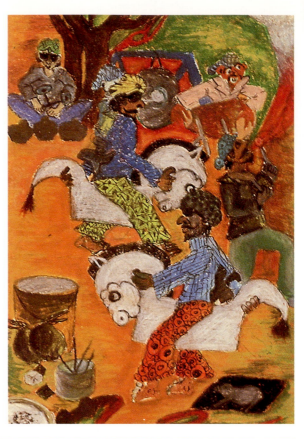

149. *Kuda Lumping*, pastel crayon,
Andang Tedjo, aged 11,
Yogyakarta, 1990.

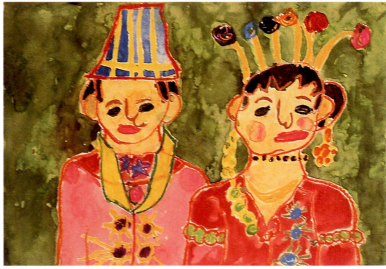

150. *Pengantin (Bride and Groom)*,
water–colour and pastel crayon,
Adia Pithaka, aged 5, Yogyakarta,
1988.

151. *Shadow Play of the Animals*, pastel crayon, Antonius Pramono, aged 9, Yogyakarta, 1990.

152. *Shadow Puppet Show*, pastel crayon, Artha Ritchie, aged 10, Yogyakarta, 1990.

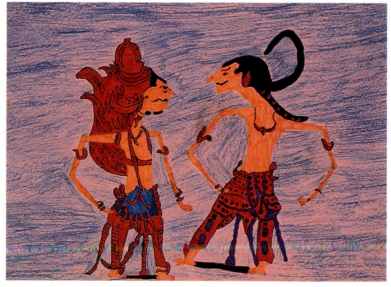

153. *Wayang Characters*, pastel crayon, Puti Gupari, aged 9, Yogyakarta, 1992.

154. *King Kresna*, ink on paper, Prima, aged 9, Yogyakarta, 1992.

155. *Bandung Cursing Jonggrang*, pastel crayon, Erik Setiawan, aged 10, Yogyakarta, 1992.

This story unfolded in the village of Prambanan, some 10 kilometres from Yogyakarta, the location of one of the great temple sites of Indonesia, the Siva complex called Loro Jonggrang, named after the unfortunate woman who was petrified there. Our child artist portrays Bandung pointing at, and laying the curse upon, Roro Jonggrang amidst the various structures at the temple site. Brightly coloured ghosts or spirits, about to disappear, are seen rising in the air above the temple. A child of ten has thus captured on paper a Javanese myth that unfolded in an actual historical place and which still lives on in the local traditional culture. To what extent this child artist is consciously or unconsciously transmitting and preserving elements of tradition is difficult to say. It is clear that he was responding to a teacher's call to draw something related to this myth, but perhaps there was something in his mind and in his brief life experience that enabled him to do something other than produce a drawing on demand. If so, it certainly had something to do with being connected to a folk tradition that has flourished for 1,000 years.

Children's art may serve as a barometer of change in societies like Java. It may indicate the extent to which traditions are continuing, being altered, or being replaced; it may say something about the culture of the future. There are different faces on the *wayang* cards used

in the *umbulan* game; Tarzan and Bat Man have joined the ranks of Arjuna and Semar. The art of children in such countries as Indonesia is worth exploring for reasons that have more to do with understanding culture than has been generally thought. It is known that 'drawing is a language that children master in their quest to understand their world and to express their feelings'.[5] A Western specialist on children's art has written:

Drawing is a personally meaningful process for the child who expresses ... thoughts and feelings in her choice of theme, the manner in which she draws ... figures, uses color and structures the composition. There are qualitative aspects that require attention to the social and cultural context in which the drawing is made, the child's developmental level, her motivation for drawing, her practice with the medium, and, a very important factor, graphic talent. Finally, the child is a privileged informer and her thoughts about the drawing or painting ought to be taken seriously.[6]

In fact, the purpose of this brief introduction to children's art in one place in Java is to show that it demands consideration for both artistic and cultural reasons. No matter whether this creative work of children can be identified as folk art or not, it can nevertheless provide a source for the study of traditional culture, both in its continuity and in its passing.[7]

1. Some of the more prominent studies in this connection are Maureen Cox, *Children's Drawings*, London: Penguin Books, 1992; Wayne Dennis, *Group Values Through Children's Drawings*, New York: John Wiley and Sons, 1966; Claire Golomb, *The Child's Creation of a Pictorial World*, Berkeley: University of California Press, 1992; and Rhoda Kellogg, *Analyzing Children's Art*, Palo Alto: Mayfield Publishing, 1970.

2. Benedict R. O'G. Anderson, *Mythology and the Tolerance of the Javanese*, Ithaca: Cornell University Southeast Asia Program, 1965, p. 25.

3. The information on this myth and the activity associated with it was provided by Haryoguritno.

4. The author has a drawing by Aditya, aged 8, entitled *The Green Giant Swallowing the Moon*. It is a much more crowded composition than that by Reza Setiawan shown in Plate 145, with an ogre of greater size (only giant arms and a huge head are showing) and three colourfully dressed children making the sounds.

5. Golomb, *The Child's Creation of a Pictorial World*, p. 305.

6. Ibid., p. 307.

7. Most of the material and all the examples of children's art in this chapter were provided by A. Hari Santosa, a dedicated art teacher from Yogyakarta.

8 Images of Ratu Kidul,
Queen of the South Sea

THE powerful, mysterious presence of a female sea-dweller residing in the waters off the coast of Parangtritis near the Central Javanese city of Yogyakarta is recorded in most popular travel accounts and guide books about Java.[1] Variously known as 'lady', 'goddess', or 'queen' of the South Sea, Ratu Kidul is portrayed as a beautiful woman rising from the depths to make her regal presence known. She is depicted by some as 'malevolent', exercising her power to take lives; by others as a generous and just provider who assures health and prosperity.[2] In all cases, she is a force to be reckoned with, to respect, and to appease. Perhaps the most widely accepted understanding of Ratu Kidul's authority is her taste for those who swim in her waters wearing green. She is reported to drown those who transgress, especially men who have clothed themselves in this unfortunate colour.[3]

Myth and history meet in the narratives about the sea queen, indicating the importance of Hindu, Javanese, and Islamic sources and the themes of cosmic connection, royal lineage, spiritual practice, and seduction. Three story-lines will be explored here which demonstrate the vitality of the belief in Ratu Kidul. The first serves to answer the general question of how the sea queen assumed her royal status; in other words, how and when did her underwater reign originate? This inquiry focuses upon a princess from ancient Sunda (West Java) who was disinherited from her position at the palace of Pajajaran and her transformation from an earthly being into a sea spirit. The second story explores Ratu Kidul's prominence in the founding and preservation of the kingdom of Mataram where we encounter her as the wise, able, and confident patroness of this dynasty. Commanding an awesome army of jinn and other spirits, Ratu Kidul assures both the expansion and prosperity of the earthly kingdom she is associated with through her marriage to the sultans of Yogyakarta and Surakarta.

A third story-line emerges from the image of Ratu Kidul as administrator of her realm, which includes deployment of her ministers and the instruction of human residents of the surrounding countryside in certain moral lessons. These folk-tales often confuse the queen and her court assistants and contribute to the conflation of names attributed to Ratu Kidul.[4]

In Plate 156 a batik artist has provided an image of Ratu Kidul as winged mermaid, swimming through tranquil waters in the midst of

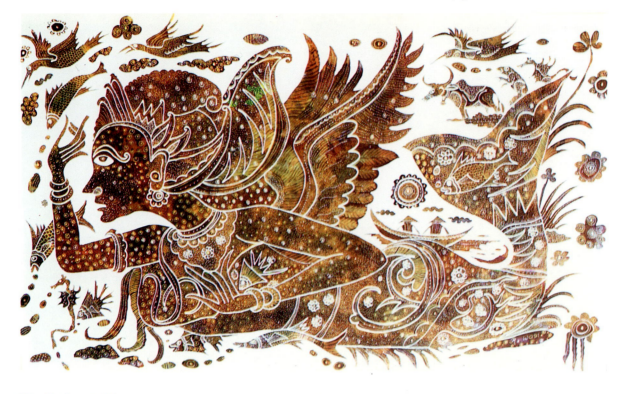

156. *Nyi Loro Kidul as a Mermaid*, batik painting, artist unknown, Yogyakarta, 1992.

her subjects—fish, sea-horse, fishermen. She is clearly large, given the scale of the fishermen and boat atop her tail and her authority appears to extend to life in the sky and upon the earth as well. Birds and live-stock populate her territory in an orderly composition suggesting that Ratu Kidul reigns in harmony. The artist renders the queen's skin speckled, possibly dotted with sea life but more likely a reference to the story of Dewi Kadita and the skin disease that brought the Sundanese princess to the South Sea (the Indian Ocean).

Originally part of Javanese oral tradition, the story of Dewi Kadita is a popular children's folk-tale today.[5] Dramatic in its testimony of a young woman's desperate exile, disease, disfiguration, and loss, readers learn that justice is redeemed in the transformation of the adolescent into a majestic figure ruling the South Sea.

In various renditions of the story, what happens to the disfigured princess at the sea-shore is the same: her immersion into the waters of the South Sea proves to be healing and her beauty is immediately restored. However, there are varying accounts regarding the trans-formation of Dewi Kadita from a diseased landed princess into a beautiful sea queen. Most generally, we find an account of the sea with a calming voice, enticing the weary maiden into the healing waters. The sea promises not only a cure for her abscessed skin but marriage to a waiting prince. While in all accounts her skin heals immediately, the regal groom makes no appearance and Dewi Kadita is beside herself with disappointment and rage. According to some narratives, she beats the water with fury and this is the reason why the sea appears turbulent. In one story, Dewi Kadita accepts the sea's

101

invitation to leave a harsh world that not only cheated her of her inheritance but mocked and rejected her for her appearance. In this telling, she finds neither peace nor groom in the waters of the South Sea and the gods appease her wrath by elevating her to the status of a queen. Finally, there is the story of a meeting with a young prince on the beach prior to her plunge into the sea. It is he who coaxes her to depart from the land but when she attempts to swim he has disappeared and she discovers that she has become a mermaid. No longer a woman with legs, she glides through the sea with an agile tail and scaly skin from her waist down.

Clearly, these stories address woman's beauty and the fragility of appearance. There is some indication of a psychological underpinning, suggesting that the once sweet and patient maiden has become demanding and violent. When she remembers her life on earth and the loss of her home or the promise of a royal partner which remains unfulfilled, her mood is dark and she creates a tumultuous environment. However, it is believed that Dewi Kadita, now Ratu Kidul, can be called forth by offering her flowers and fruit of her choice. The painting by Otto Djaja (1916–92) in Plate 157 illustrates an environment of calm and turbulence, indicating that the realm of the sea queen is both harmonious and treacherous. In this characterization,

157. *Ratu Kidul*, oil-painting on canvas, Otto Djaja, 1980.

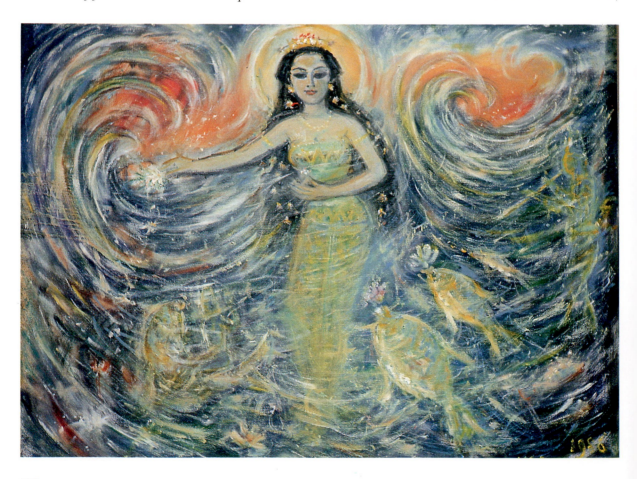

Ratu Kidul emerges from the sea as a somewhat meditative figure, perhaps engaged in the graceful dance steps of one of the court's dances. We cannot decipher whether she possesses the body of a human or whether her legs become a tail but there is little ambiguity about Ratu Kidul's presence as a regal form. She patiently awaits the floral offering (perhaps of *melati*, a jasmine blossom) being borne to her by a pair of fish. Her head is circled by a golden halo, a hint of mysterious illumination from this graced woman within a churning sea.

Both Ratu Kidul and Dewi Kadita represent a form of autonomy that allows us to encounter unusual female independence in spite of their respective alliances. For example, there are alternative stories about Dewi Kadita's departure from the Pajajaran court, indicating that she either refused a suitor of her father's choice or that she was stead-fast in her desire not to marry.[6] This latter theme is echoed in some accounts of Ratu Kidul's incarnation prior to her residence in the sea.

Finally, mention of the geographical setting of both stories is important because there is a north–south movement that suggests the expanse of Javanese activity symbolized through Dewi Kadita and Ratu Kidul. The disinheritance of the former and her settling in the South Sea has already been described. In the quasi-historical chronicles of the court, known as the *Babad*, we encounter a different figure who eventually is to be transformed into the reigning sovereign of the sea.[7] Known as Cemara Tunggal or Ratna Suwida, this earlier appearance is also connected to the royal court of Pajajaran but her tale is quite distinct from that of Dewi Kadita.

Unlike the story of Dewi Kadita, which takes place mainly on the land and traces her pilgrimage to the South Sea, the narrative of Ratu Kidul focuses upon her authority under the sea and her relationship to the founding events of Mataram. As one author puts it, the story is not a 'fairy-tale' but 'the story of the union of the founder of the dynasty with the princess ruling the waters and the nether world'.[8] Senopati is the founder (in most accounts), a somewhat mythical figure (living from 1584 to 1601), who experiences a prophecy upon seeing a bright star. He understands that he will be a great king and his descendants will rule for three generations before the kingdom withers. The story indicates that this extraordinary experience was witnessed by his uncle, who asked him to look for further signs of divine will. Senopati proceeds to the south and begins to meditate. His meditation was so powerful that it created a disturbance; storms arose, trees were felled, fish died.

Ratu Kidul was distressed by the prayers of Senopati which were destroying her domain and she emerged at the site now known as Parangkusomo, a short distance from Parangtritis. There she beheld Senopati deep in prayer and she assured him that his desires would be met, that he would become ruler of all Java. Ratu Kidul asked him to abandon his meditation and come with her to her palace under the sea. In Plate 158 an artist has represented this moment, showing the queen in Javanese courtly attire inviting the future king to her realm.

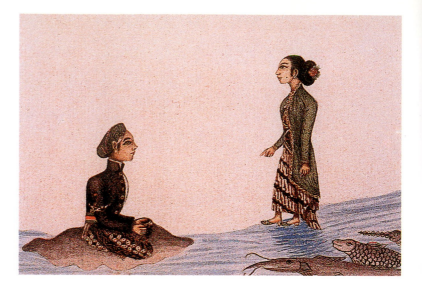

158. *Ratu Kidul and Senopati*, glass painting, artist unknown. (Reproduced from Erik Oey (ed.), *Java, Garden of the East*, 1991, p. 172.)

He is seated upon one of the rocks still revered by Javanese people and the site of ritual activity in the Labuhan ceremony (see the discussion which follows); she is accompanied by three water creatures.

According to the *Babad* account, Senopati entered the sea and spent three days and nights with the queen. During their romantic interlude, Ratu Kidul tutored Senopati in military strategies, magic, and art and promised that she would come to his aid whenever he called upon her and her army of spirits. According to this account, the couple were married but Senopati remembers that he must pursue his royal destiny and return to land. However, Knappert writes that when Senopati proposed marriage Ratu Kidul refused, arguing that it is 'better to be a queen than be married. I don't want anyone to give me orders.'[9] This interpretation of Ratu Kidul's resistance to marriage recalls the alternative story of Dewi Kadita as well as that of Cemara Tunggal. As it happens, the sea queen is not abandoned nor is there any suggestion that she would have Senopati live permanently with her in her palace. He has the work of dynasty-building to undertake and the action must shift to Central Java and away from the sea.

Ricklefs reports that some regard Senopati as solely a mythic figure and that it is the son or grandson of this figure who must be embraced as the virtual founder and expander of the Mataram realm. He disagrees and writes that the meeting of Senopati and the 'goddess of the Southern Ocean' began a liaison important to the courts of Java.[10] Yet Agung is the pivotal character in a later chronicle, the *Babad Nitik*, which tells of the heroic efforts of this future sultan of Mataram to avoid his brother's murderous plotting.[11] Agung first encounters Ratu Kidul (who is called Dewi Rarasati in this account) in the forest where he is meditating. She attempts to distract him by seductively performing the *bedoyo* dance but to no avail. Later in the story, Agung is instructed by his grandparents to marry the sea queen. He obeys and lives with his bride for forty days before becoming restless and

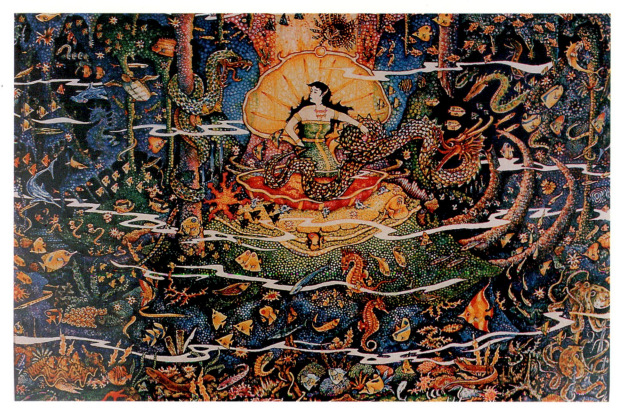

159. *Ratu Kidul*, water-colour, Ronny Lesmana, aged 15, Yogyakarta, 1992.

anxious to explore the surrounding land. His adventures are chronicled which entail exercising some of the magic he has learned from his teachers before meeting Dewi Rarasati. Eventually, he is informed that he cannot be buried in holy ground unless he forsakes his reliance upon the sea queen and her supernatural forces. One can readily interpret this as an effort of the later writer to strengthen the Islamic character of the hero. It might be noted here that Agung was the first ruler to assume the Islamic title of sultan in 1641 and to adopt the Islamic lunar calendar.[12]

The physical appearance of the sea queen is a matter of some controversy. We have observed that she can be perceived as a mermaid or a lady of the court. Her hair can be combed into a neat bun or worn loose; it is always black. Her skin may or may not show traces of a previous disorder and may be light tan or brown. In the drawing created by the young artist Ronny Lesmana (Plate 159), we see an imperious figure upon her underwater throne, dressed in a sleeveless green garment, and without a crown. Her kneeling posture upon a large shell hints at a meditative pose and she is calm amidst an abundant, lush undersea life. There is an awesome *naga* (mythical snake) entwined around her throne and she holds a portion of this awesome creature but all is seemingly in harmony in this depiction of Ratu Kidul's realm.

Ambiguity is infused in the attempts to capture Ratu Kidul's

105

appearance, especially with respect to the colour green which may or may not please her. Some write that her hair is seaweed, encrusted with sea life, others that she wore only seaweed when entering the South Sea for the first time. Then there are writers who would provide no head-dress, no hair, and no clothes for the sea queen.[13] Finally, some report that she may not be glimpsed at all, and if this should occur Ratu Kidul would surely strike the viewer with a terrible malady. However diverse these opinions are, there is little or no visual evidence of these characterizations. She is invariably portrayed as a rather glamorized, youthful woman who looks either demure or fierce but never afflicted, cruel, or ugly.

Ratu Kidul's skills and deeds are many, including the capacity to work magic on behalf of the sultan, to deploy her sea troops for protecting the dynasty and instructing the martial arts to the sultans. She can prophesize and control both climate and sea conditions in the immediate vicinity of her South Sea realm. She is an inspiration for court music and dance and promotes the standard of excellence in performance at the courts. Finally, as a queen, she rewards and punishes behaviour in accord with her own moral standards and attention to ritual obligation. She gives and takes, bountiful and withholding as well as dangerous to those swimmers who would disregard her rules.

An example of Ratu Kidul as inspiration and teacher of the arts is provided in the *Babad Nitik*, a chronicle composed later than the previously cited court documents.[14] It is reported that when Sultan Agung accompanied Ratu Kidul to her underwater palace, he was inspired by the sounds of the undersea vegetation in their rhythmic motion and created the royal *gamelan* (orchestra) as a consequence of his listening. He called this Gamelan Sekati, a name he deemed fit for a king. While the sultan created music for this ensemble, Ratu Kidul performed her royal dance for the groom which is known as *bedoyo* and remains associated with the court of Surakarta's wedding ceremonies. This sacred dance of nine women performers is meditative and very constrained. It is extremely demanding for the dancers given its exacting composition and mood.

Ratu Kidul is pictured as a *bedoyo* dancer by the batik artist (Plate 160) who represents her gracefully moving upon the sea's wavy surface. Adorned in red, pink, and blue (not the green so often found in graphic representation), she wears a bridal head-dress and her waist is wrapped in the scarves worn by dancers. According to one commentator regarding the *bedoyo* performance, dancers move with such precision that they appear as one; a unison of women dedicated to the spirituality of the sea queen. It is said, according to this observer, 'that at the annual performance of the Bedoyo Ketawang in the Solo [Surakarta] court, Ratu Kidul appears as a shimmering tenth dancer, and afterwards retires with the ruler to his bedchamber'.[15] It is fair to conclude that the *bedoyo* dance is perceived as both meditative and seductive. Recall that Sultan Agung first encountered Ratu Kidul in the forest as a *bedoyo* dancer but he refused to be seduced at that time because he was deeply engaged in meditation.

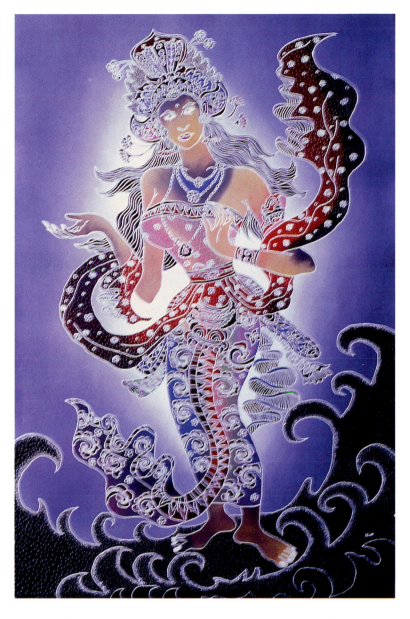

160. *Ratu Kidul*, contemporary batik painting, artist unknown, Yogyakarta.

Central to the Yogyakarta court's remembrance of the queen's betrothal to Senopati/Agung, is the ritual celebration of Labuhan, which occurs annually as part of the sultan's birthday commemoration.[16] Offerings are prepared for Ratu Kidul, including cloths, coins, food, and the hair and nail clippings from the sultan, and carried in an elaborate procession from Yogyakarta to the coast where the queen resides. The ritual moves from Parangtritis to the site where Ratu Kidul and the founder of Mataram were said to have first met, at Parangkusomo. At this latter site, the bodily offerings from the sultan are buried and then the balance of goods are taken to the ocean where they are sent off to the queen in small bamboo floats. It is believed

that Ratu Kidul will choose from among these gifts of cloth, flower petals, and coins as well as rice offerings, and send the remainder back to the beach. Young swimmers, eager to secure some of this boon, place themselves in the hazardous surf and bring back these items which are said to contain power and good fortune.

Along the Parangkusomo beach there are men and women deeply engaged in prayer. Some of the women attest to seeing Ratu Kidul; this is only possible after a week-long preparation of ritual cleansing and fasting not unlike that done by the *bedoyo* dancers before a performance. They report that she is beautiful, a woman with flowing black hair, wearing a head-dress, green bodice, and batik skirt, and holding flowers in her right hand. They see her as a figure who is walking upon the surface of the sea.[17]

At the time of the offertory activity at Parangkusomo, one of the sultan's highly placed servants calls out to Ratu Kidul and her two *patih* (ministers) who are to receive gifts from the court as well. Both assistants to the queen have their own history prior to their respective duties in Ratu Kidul's court. One, Patih Njero, serves as the minister of external affairs and was known as Nawangsi in her former life. The other, Patih Njaba, is the minister of internal affairs and oversees the efforts of the spirits.[18] It is reported that these women ministers sought refuge from their earthly destiny and that Ratu Kidul took pity on them and brought them into trusted positions in her palace.

It is especially noteworthy that the minister of external affairs was the daughter of a nymph and a human in her earlier incarnation. Her story derives from that of the *widadari* (nymphs) whose visit to Java and bathing in the island's waters brought about the encounter of Dewi Nawang Wulan and Joko Tarub.[19] He stole her shawl and she could not fly back to heaven until time had passed and she recovered her magical garment in the bottom of the rice container where her husband and father of her child, Joko Tarub, had hidden it. Although she was then capable of ascending to heaven, her daughter was not. Instead, she eventually descends into the sea's depths and proves herself to be an able administrator in Ratu Kidul's realm.

Ratu Kidul's appearance depends upon which manifestation of her regal authority concerns the life of people who have come to the sea for special assistance. A good example of this merging is found in the double telling of the same basic narrative about a poor peasant and his encounters with the powerful, magical dweller in the sea. According to de Wit's rendition, Pak Sidin meets the servant of Ratu Kidul, Kyai Belorong, and negotiates an exchange of wealth for his person.[20] The female minister requests love from the peasant and when he sees her tail he faints, only to discover upon his awakening that her scales have been flaked off and they are made of gold. He returns to the beach, recognizing the possibilities of great wealth, and requests that he be given help in advancing his station. Kyai Belorong agrees to do so in exchange for his eventual surrender to her as a transformed person who will serve as her threshold. A second exchange occurs after years have gone by, wherein Pak Sidin requests another opportunity

for wealth, and the sea minister accepts one of his family as a substitute. This same negotiation happens a third time but Kyai Belorong, impatient with the peasant's insatiable ambition and dissatisfaction, turns him into a hearth stone in the palace.

Other folk-tales enlarge upon various moral lessons. Several tell of offerings made by wives who send their husbands off to the shore to bring them to the queen and her personnel.[21] Basuki Abdullah's (1915–93) painting of the semi-seated figure (Plate 161) suggests the waiting *patih* whose location close to shore might symbolize the potential of encounter between the realm's representative and a Javanese carrier of food offering. She wears green, no crown, and while seemingly patient, her surroundings are not placid. She combs her hair with one hand and holds the other open to the viewer. Is she expecting a visitor? Indeed, those who come to the sea-shore will find that she either metes out fortune or misery depending upon how

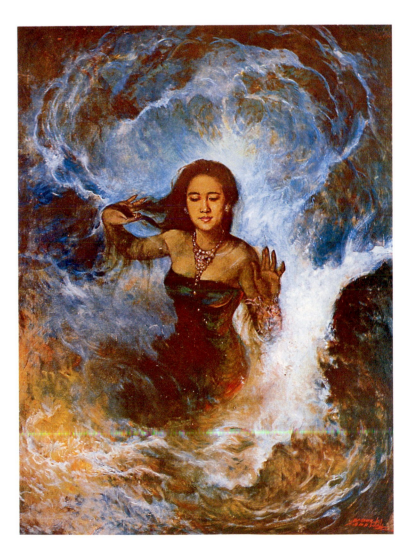

161. *Njai Loro Kidul, Queen of the South Sea*, oil-painting on canvas, Basuki Abdullah, *c*.1960.

offerings are made to her. When the food has not been tampered with, she rewards, but when the bearer has taken a token piece of her offering, she will retaliate with harsh penalties for this transgression. Knowing that Dewi Kadita was deprived of her royal entitlement, and that the half-nymph *patih* could not resume life with her mother in heaven, one gives pause to the meaning of the narrative. Is there a psychological underpinning that enforces fairness in intention and deed? The realm's administrators need not tolerate theft from their gifts and are highly appreciative of those who carry offerings which remain untouched and uneaten.

The symbolic dimension of land and sea can be deciphered in these stories. In the exchange of goods for obedience, of seaborne women who encounter humans with expectations of some palpable return for their gifts, there is a tension between history and the transcendent ways of supernatural beings. Each mortal approaches the sea queen and her assistants with particular hopes and concrete needs. The sea responds through its royal inhabitants in an enduring and ever-recurring fashion, yielding to some, dangerous for others. Yet there is no dualism here. The powerful dwellers of the undersea palace originated on the land and they return to it now and then. When Ratu Kidul observes the dancers in the court, when she visits the sultan, when she enters the hotel room set aside for her at Pelabuhan Ratu, when she used to swim to her meeting-place with the sultan of

162. *Ratu Kidul*, contemporary batik painting, artist unknown, Yogyakarta.

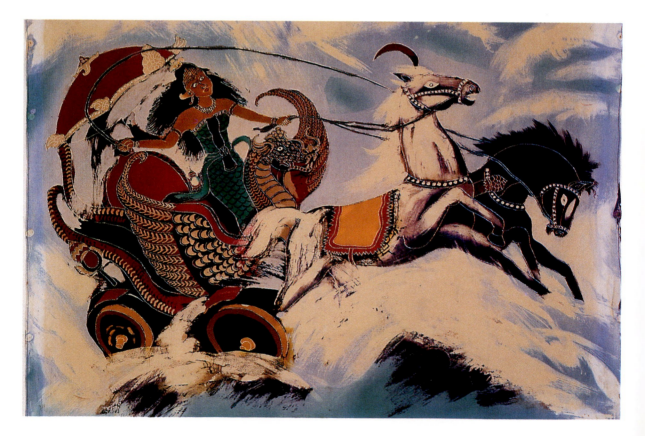

Yogyakarta at Taman Sari, the sea queen exercises her power to be of the sea and with the land.[22] This is graphically illustrated in the batik painting (Plate 162) of the queen driving her sea dragon chariot through the water. Dressed in green with her hair loosely windblown under her dancer's head-dress, she urges her horses, one black, the other white, through the surf and possibly to the shore. The wheels of the chariot most certainly indicate that Ratu Kidul's vehicle will take her to land. There is a story told that she travels north on the Opak River *en route* to the volcanic mountain Merapi where she will try to encourage the spirit there to marry her.[23]

There is little doubt about Ratu Kidul's sustained prominence in the folk narrative of the Javanese. Her contemporary interpretation by batik artists demonstrates the continuing vitality of her representations while at the same time it must be noted that such representations are uncommon. While two of the best known of the older painters, Basuki Abdullah and Otto Djaja, portrayed some of the scarce representations of Ratu Kidul in modern art, few traditional images of the sea queen can be found. Is it likely that Ratu Kidul is so revered and respected that very few images of her or the *patih* exist in traditional folk art? There are many questions concerning Javanese folk art which remain to be answered. For this, we must await further serious study and writing about the material culture of Java and particularly the queen of the South Sea.

1. Among the travel accounts are Harold Forster, *Flowering Lotus: A View of Java*, London: Longmans, Green, 1958, and Augusta de Wit, *Java: Facts and Fancies*, The Hague: W. P. van Stockum, 1912. Two useful guide books are Peter Hutton, *Java*, Hong Kong: APA Productions, 1980, and Eric Oey (ed.), *Java: Garden of the East*, Lincolnwood: Passport Books, 1991.

2. Hutton, *Java*, p. 187. Jan Knappert, *Myths and Legends of Indonesia*, Singapore: Heinemann Educational Books (Asia), 1977, p. 78, writes that 'the sea-goddess is just because she gives generously to her faithful worshippers'.

3. Note 'Njai Roro Kidul—Goddess of the South Sea', in Alwan Soebiantoro and Manel Ratnatunga, *Folk Tales of Indonesia*, Delhi: Sterling Books, 1979.

4. In a confusion of identities in popular literature, Ratu Kidul is referred to as Njai Loro, or Roro Kidul, or Kjai Belorong.

5. *The Story of Damar-wulan and Lady of the South Sea*, Semarang: Lim Yoe Siang, n.d., and *Nyai Roro Kidul: Cerita Dari Jawa*, Bandung: Penerbit Citra Budaya, 1984.

6. Mally Kant-Achilles, 'Macht durch Magie', from an unpublished manuscript.

7. The three chronicles of the Yogyakarta court referred to are: *Babad Tanah Jawi*, *Babad Pajajaran*, and *Babad Nitik*. The following provide excellent analyses of the *Babad* tradition: J. J. Ras, 'The Babad Tanah Jawi and Its Reliability', in C. D. Grijns and S. O. Robson (eds.), *Cultural Contact and Textual Interpretation*, Dordrecht: Foris Publications, 1986, pp. 257–66, and M. C. Ricklefs, *Jogjakarta under Sultan Mangkubumi, 1749–1792*, London: Oxford University Press, 1974.

8. Ras, 'The Babad Tanah Jawi', p. 266.

9. Knappert, *Myths and Legends*, p. 69.

10. Ricklefs, *Jogjakarta*, p. 13.

11. *Babad Nitik dan Cebolek, Pentang Sejarah Sultan Agung di Mataram*, Yogyakarta: Widyaparwa 17, 1980. This chronicle is attributed to Sultan Hamengkubuwana VII and was written in 1872.

12. Ricklefs, *Jogjakarta*, p. 14; Sultan Agung lived between 1613 and 1645.

13. Kant-Achilles in an unpublished manuscript cites as a reference for this, H. A. van Hien, *De Javaanische Geestenwereld en den Betrekking*, 1912.

14. See Jan Hostetler, 'Bedhaya Semang: The Sacred Dance of Yogyakarta', *Archipel*, 24 (1982): 127–41.

15. Valerie Mau Vetter, 'Dance and Drama', in Eric Oey (ed.), *Java: Garden of the East*, Lincolnwood: Passport Books, 1991, p. 79. In the Solo palace, the *bedoyo ketawang* dancers wear a *dodot gadung melati alasalasan pinarada mas* (waistcloth) as 'green as the turnip on its snakelike stem (*gadung*) and as white as jasmine (*melati*)'; see K. R. T. Hardjonagoro, 'The Place of Batik in the History and Philosophy of Javanese Textiles: A Personal View', in Mattiebelle Gittinger (ed.), *Indonesian Textiles: Irene Emery Roundtable*, Washington, DC: The Textile Museum, 1980, p. 228.

16. An excellent account is provided by Cécile Bigeon, 'Labuhan: Rite royal du kraton de Yogyakarta célébré sur la plage de Parangtritis', *Archipel*, 24 (1982): 117–26.

17. Personal field notes, 1992. In this connection, I wish to thank Susantri Sahar whose research about *labuhan* and assistance to me has proven invaluable.

18. Bigeon, 'Labuhan', p. 124.

19. The reference for this folk-tale is Marguerite Siek, *More Favorite Stories from Indonesia*, Jakarta: PT Rosda Jayaputra, 1986, pp. 10–19.

20. De Wit, *Java: Facts and Fancies*, p. 170 *passim*. She refers in the same page to Kyai Belorong as a 'wicked goddess'.

21. Knappert, *Myths and Legends*, for example, at pp. 77–8.

22. See Joan Suyenaga, 'Ratu Kidul, Goddess of the Southern Seas', in Eric Oey (ed.), *Java: Garden of the East*, Lincolnwood: Passport Books, 1991, p. 173.

23. J. J. Resink, 'Mers Javanese', *Archipel*, 24 (1982): 98.

9 Some Contemporary Artists in the Folk Tradition

IN 'Developing World' countries like Indonesia, the debates over contemporary art tend to be centred on questions of national and ethnic identity, on ideology and political acceptability, and on what constitutes tradition and modernity. These are questions which dominated Western art thought some seventy-five years ago but for the most part, except for the impact of politics and the polemics over what is 'modern', have largely disappeared from the arena of criticism. Modernism of the past and recent post-Modernism have been—and are—concerned with other quite different considerations that have more to do with science, technology, industrialization, artistic autonomy, and human variety.

Modern art in Indonesia, from its true beginnings just before the Second World War, was involved with debates among artists about what constituted national identity, how to deal with the vestiges of colonialism, and what art should be promoted and taught. These debates are still going on among many Indonesian artists who label themselves as 'modern'. It is not the purpose of this chapter to deal with such questions. It is, rather, to present the work of artists that in some significant way demonstrate connections with their traditional culture regardless of intellectual considerations or academic designations. In any case, the very definitions of what constitutes beauty and creativity in aesthetics are themselves the centre of much world-wide debate in the arts.[1] Exhibitions and publications on modern Indonesian art originating outside Indonesia have only very recently existed. There had been a twenty-five year hiatus between the first book in English that dealt in any way with modern Indonesian art[2] and a catalogue that accompanied the first major exhibition in the United States in 1990.[3] During May 1993, another major exhibition was held in Amsterdam. At Indonesian art exhibitions a great deal of traditional cultural subject-matter is to be seen. Indirectly, all this may have some influence on promoting the folk art of Java which, compared to Sumatra, Kalimantan, and Sulawesi, has been little studied.

Since we are focusing on the broader relationships of art to what is termed here the 'folk tradition', the question of the relevance of individual artists and their works to folkloristics, as noted before, is not a principal concern. Rather, the focus is on those three categories of artists as noted: the folk artist, the naïve artist, and the modern artist.

In Java, they are the painters of the *wayang beber* scrolls and glass paintings, the illustrators of traditional chronicles and books, the sculptors of statues and bas-reliefs on sacred temples, and the weavers of indigenous textiles. They are mostly unknown; their individuality was never considered important enough to name; the only test of their worth was the self-evident skill and authenticity reflected in their work and thus acceptable to local traditional consumers. Though examples of traditional painting are shown in Plates 90 and 139, as noted before, paintings of this kind, as well as classical sculpture and textiles, are not treated here. The major example of painting as folk art is that which has been, and is being done, on glass. It is that art which uses indigenous themes and stories from both the Buddhist–Hindu and Islamic traditions in Java. (Numerous examples are shown in Plates 66–83 and details have been discussed in Chapter 4.)

The category of naïve artists presents a number of problems. Strictly speaking, they are 'folk' artists but their work is not considered to be 'folk art' because each piece is unique and therefore not a recurring part of traditional culture. Rather, they are regarded as persons painting or carving or sculpting out of their individual and personal desire to create, to please, to pass the time, and sometimes to exchange what they produce for goods or money. They rarely repeat what they do; their naïveté derives from a simplicity of technique, composition, and message. Most children's art also falls into this category:

Both the child and the naive painter strive to shape and interpret their experience of the world in images. Their disregard for anatomy and perspective are not the result of a deliberate choice of style, but rather the stamp of a less developed level of consciousness. This perceptual limitation at the same time favors the presentation of total expressiveness and originality of image.[4]

However, there are clear distinctions to be made between the two:

When one compares the work of children and naïves, there is ... a constant divergence to the point of separation between the permanence of children's recreations and those of the naïves. The child's artistic output is ephemeral; as [the child] develops his instinctive powers are reduced and the creative act is generally supplanted by deliberate and rational conceptions. The work of the naïve artist has a chance at permanence; the art of the child passes away.[5]

In the chapter on children's art, a suggestion was made that this may not be always necessarily so. It is true that in Indonesia and elsewhere the art of children is rarely saved, and in that sense it mostly disappears. There is, however, a growing number of large collections of children's art in the world that could be used as cultural documents as well as objects of visual pleasure. The focus here, however, is on two adult artists who can be described as mainly working in this naïve style although there are some problems in strictly applying such an appellation. The first artist is Ibu Masmundari who is over eighty years old and lives in Telogo Pojok, a village near Gresik in East Java. A grandmother, she took up painting to earn additional

income after her husband died. She also sold herbs and various kinds of snacks but there was little profit from such an activity. She is called a *damar kurung* artist from the word *damar* which means 'lamp' and *kurung* which means 'that which is contained in a cage or wired form'. In her technique, scenes of everyday life are painted using *sumbo*, an artificial textile paint, on to a standing lantern, the four sides of which are made of yam paper. The yam paper is translucent and the light bulb or flame when placed inside illuminates the paintings, creating both a stained glass effect and one of moving shadows. Masmundari paints in her modest house sitting on a stool, with a chair as an easel. She uses a bamboo brush and the holes on a *dakon* game board to hold her liquid colours.

Masmundari is working in a folk craft tradition that dates back many decades in Gresik where such lanterns were marketed around the town's harbour. Around 1970, there were still ten or so artisans producing *damar kurung*, but it is likely that Masmundari is now the

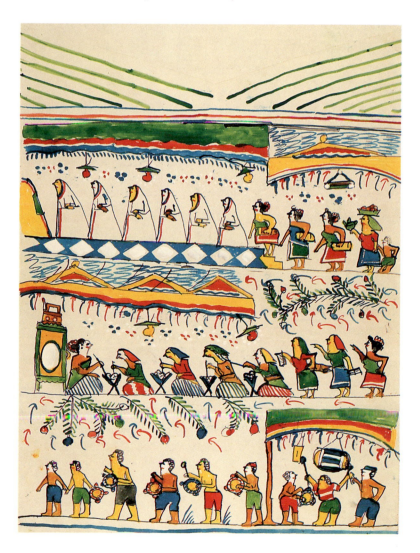

163. *Praying, Fasting and Breaking the Fast*, textile paint on yam paper, Masmundari, 1987. (Phototgraph courtesy of Duta Fine Arts Foundation, Jakarta.)

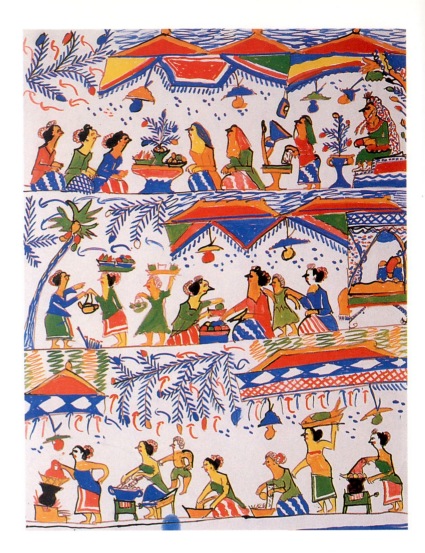

164. *Preparing for a Village Wedding Ceremony*, textile paint on yam paper, Masmundari, 1989. (Reprinted from *Bentara Budaya Calendar*, 1989.)

only one doing so. She mainly sells her art near the Sindujoyo Cemetery, which many Indonesians visit during the fasting month marking Ramadan, which precedes Hari Raya Lebaran, the most important Islamic holiday. The lanterns are bought as gifts for children and grandchildren.

Masmundari's paintings deal with traditional religious activities and festivals or with the routines of daily village life. Plate 163 shows villagers at prayer during Ramadan and then breaking the fast. For Muslims this is a most important and holy rite; it signals both adherence to the faith of Islam and the re-entry into ordinary life after being purified and renewed. Plate 164 is entitled *Preparing for a Village Wedding Ceremony* and is typical of Ibu Masmundari's folk-like rendering.

Plate 165 illustrates a fisherman's festival with four rows of active participants. Fish are jumping about and being caught; one very large fish (a dolphin or shark) is being hauled in by several villagers. Children are celebrating with balloons. Women in boats are making

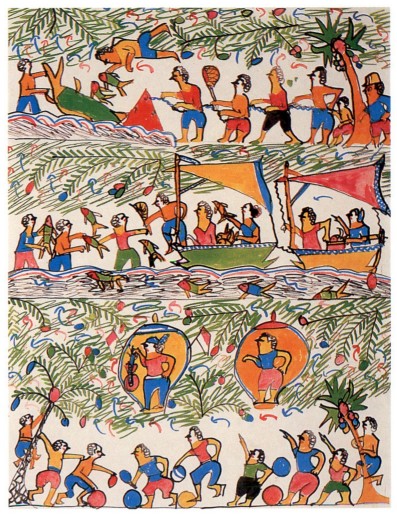

165. *Fisherman's Festival*, textile paint on yam paper, Masmundari, 1989. (Reproduced from *Bentara Budaya Calendar*, 1989.)

offerings to the sea. The spacing of characters into different rows is typical of Masmundari's compositions; the arrangement highlights the story-telling effect of her paintings and also gives them a feeling of movement from scene to scene. Her paintings have the effect of movie stills which have been briefly stopped to highlight the action for the viewer. The illumination from light would further heighten this effect.

Masmundari's paintings are almost certainly in the folk tradition of Java. She is clearly a naïve artist in that her works are highly individualistic, one of a kind, and exhibit in composition and technique the features so characteristic of this category. Masmundari reminds one of the women folk painters from Madhubani, Bihar, and Mithila in India.[6] She is also deeply concerned not only with the daily life around her but more importantly, for the purposes of this analysis, with the roots and rituals of Javanese culture. She lives in an area that was an important part of the very early history of Islam in Indonesia. As such, Masmundari is a vital example of a folk artist and cultural

informant living and portraying an ancient tradition. She has received considerable recognition from Indonesian collectors and art critics since an exhibition of her work was held in Jakarta and a calendar of her paintings was published in 1989. There are other persons like Masmundari in Java and the other islands; they only need to be discovered also to become a recognized part of the folk art heritage that is so vital a cultural resource in countries like Indonesia.

The painter Sukamto Dwi Susanto represents a very different type of artist. He was born in 1952 and lives in the midst of a sugar plantation in a small village (Godean) near Yogyakarta. He attended the ASRI art school in Yogyakarta before becoming a full-time artist. He has had a major exhibition at the Duta Gallery in Jakarta and continues to sell his work in the Pasar Seni (art market) which is part of the Ancol entertainment and shopping complex in Jakarta. Sukamto works entirely in pastel on cardboard, portraying the folk stories of Java, his own dream versions, and the traditional village life of his experience. The effect of his work is like that of glass paintings and Indian miniatures.

Naïve artist, folk artist, professional artist—all these designations partly fit, and it is precisely because of this that his work is included here. Neat distinctions and even neater categories are not useful in either describing his paintings or labelling his vocation. Sukamto, however, is clearly working in, and using the folk tradition of, Central Java. Typical of his dream-like representation of a powerful natural

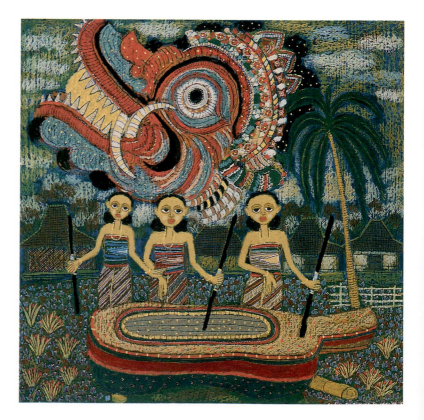

166. *Lunar Eclipse*, oil pastel on board, Sukamto Dwi Susanto, 1992. (Photograph courtesy of Duta Fine Arts Foundation.)

118

event is that of the eclipse of the moon shown in Plate 166. Three women villagers in traditional Javanese dress are attempting to dispel fear while an enormous monster mask or a *kala* (guardian) head looms above them blocking the moon. This figure is obviously derived from the *wayang* or temple sculpture tradition; the women with bare shoulders and batik sarongs are typically represented. Sukamto has made a fantasy out of a momentous occurrence of nature which is often found in traditional folklore and responded to in folk ritual throughout Java.

He also depicts Javanese customary activities and events in a relatively straightforward manner such as illustrated in Plate 167 of a Javanese bride and groom. The groom is wearing a traditional batik hat, a striped *lurik* cloth jacket with a kris tucked in at the waist, and a sarong which is likely to be of batik or possibly of some machine-printed cotton. The bride is also traditionally dressed. The type of clothing worn by the couple and the lack of any elegant *coiffure* or jewellery mark them as villagers of modest means. They have been drawn in a folk *loro blonyo* (bride–groom) mode as portraits marking the nuptial event, similar to the photographs of bridal couples displayed in many Javanese households.

Sukamto also portrays events and symbols associated with Islam. A typical example is his representation of the Bouraq, the winged woman who carried the Prophet to heaven (Plate 168). The colour of her face and of her horse is white. The face of another woman is seen peering straight ahead from a kind of saddle that is draped over the

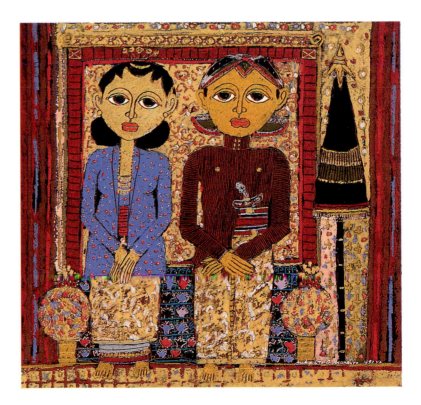

167. *Wedding*, oil pastel on board, Sukamto Dwi Susanto, 1990. (Photograph courtesy of Duta Fine Arts Foundation.)

119

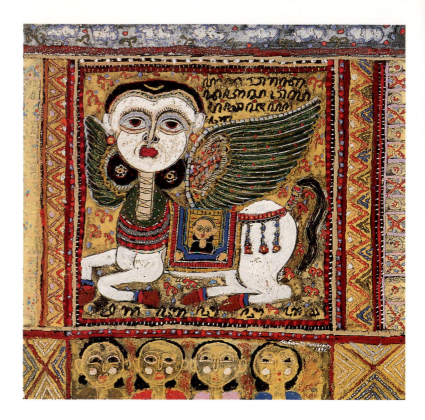

168. *Bouraq*, oil pastel on board, Sukamto Dwi Susanto, 1992. (Photograph courtesy of Duta Fine Arts Foundation.)

Bouraq's lower back. In the upper right-hand corner are four lines of Javanese script naming the scene.[7]

As in the case of many 'folk' artists, there is a humorous element in Sukamto's works. Typical is his colourful rendition of Semar with decorative pock marks all over his body and a wooden bell hanging from his neck. A cat, dog, and horse are featured in the lower left-hand corner, a man in traditional Javanese dress is sitting in the lower right-hand corner, and an erupting volcano has been drawn in the upper left corner. In the middle of the pastel drawing is the small figure of Batara Guru (Şiva) standing on a bull. The work is entitled *Semar Wakes Up*; its meaning is ambiguous, though clearly Semar is seen as being near, or a part of, the great divinity Şiva (Plate 169). Humour, in fact, is inherent in virtually any picture of Semar because of his outlandish physical features. However, this is Sukamto's vision of a Semar that is surrounded by common animal life, by the power of the eruptive forces of nature, by being given homage from an ordinary villager, and by the presence of an omnipotent god. It may be looked upon as a symbolic combination of all these elements of both the élite and common folk tradition, which is so characteristic of syncretic Javanese culture as so often expressed in art. Similar is the drawing of Petruk entertaining children by manipulating a dancing *wayang golek* (rod puppet) of a woman (Plate 170). A food offering on the ground in front of Petruk and a *gunungan* (mountain) drawn in a rectangle above his head (that also contains script in Javanese) form part of the picture. It is again Sukamto Dwi Susanto's personal portrayal of

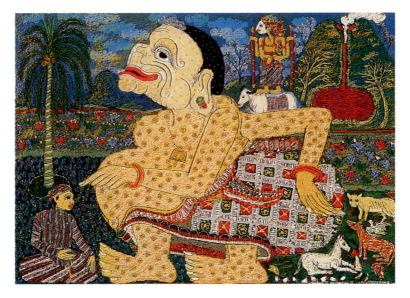

169. *Semar Wakes Up*, oil pastel on board, Sukamto Dwi Susanto, 1991. (Photograph courtesy of Duta Fine Arts Foundation.)

the *panakawan* (clown-servants). Petruk, costumed from head to toe in traditional Javanese clothing, making himself accessible to children, is an essential part of past and contemporary Javanese village culture.

It can be argued that modern art by definition has no place in a book on folk art. Strictly speaking, this is so. However, there is a broader purpose here of demonstrating significant artistic connections between tradition and modernity in Indonesia. Java is an appropriate place to examine artists whose work links these two spheres because most of them today reside there, or were born there, or were trained in art schools there. (The author has written elsewhere of the significance of tradition in modern Indonesian art.)[8] In Indonesia, where cultural identity is still an important concern of modern artists,

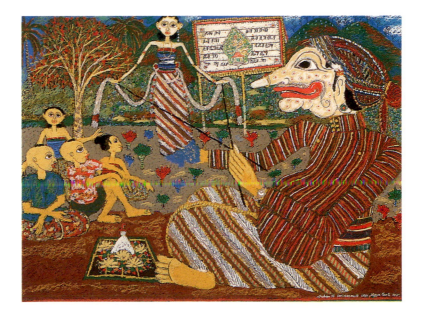

170. *Petruk and Children*, oil pastel on board, Sukamto Dwi Susanto, 1991. (Photograph courtesy of Duta Fine Arts Foundation.)

and where politically much is made of 'Unity in Diversity', the impact and use of tradition is significant.

During the period just before the Second World War, a movement had started to encourage Indonesian artists to paint reality and not continue in the so-called 'Beautiful Indies' school of romantic landscapes, idyllic village scenes, and flattering portraiture. Many artists became involved in the revolution against the Dutch, and immediately after independence much of their work reflected this struggle and the labours that followed. From this early period to the present, a significant number of Indonesian painters, many of whom are Javanese or Sundanese, have used tradition as a source and inspiration for their work. They are presented here to illustrate this connection and thereby reinforce the importance of tradition in contemporary creativity. Their works will also document that certain elements in this tradition, for example, the *panakawan*, constantly recur in various arts and crafts in Java and elsewhere in Indonesia. Art historians interested in socially inspired art might examine the diversity of relationships between traditional culture and contemporary society.[9] Social scientists could look to similar connections as sources for the extent to which tradition and modernity have had an impact on each other. There are thus anthropological, economic, political, and sociological, as well as aesthetic reasons for looking at art and traditional culture, past and present.

Many Indonesian artists have, particularly since 1947, used traditional motifs, images, cultural events, rituals, and stories within the context of what they consider to be modern. During the period from 1950 to 1980, most of this was a reflection of the artists' natural connection with traditional culture from which they had come and to which they were still partly attached. It was this ancient 'stuff', still in their creative psyche, that accounted for some of the traditional subject-matter in their art. Once a middle and leisure class began to emerge in the larger cities of Java, artists discovered that using themes such as the *wayang* characters, dancing figures, and festivals in paintings made them very saleable. The examples of modern art shown here were selected from those that appear to have been more culturally and aesthetically motivated. No such claim is made of their folk content other than the fact that it is there and may illustrate the positive and ambiguous forces at work on some Indonesian artists who were shaped both by tradition and modernity.[10]

One of the prime movers in the shift of Indonesian art from academic conventionalism to realism and modernism was Soedjojono (1914–86), a poetic painter of dreams and fantasies as well as of traditional subjects. Shown here is a 1971 painting of the four *panakawan* that combines his innate Javanese feeling for popular *wayang* characters and his creative ingenuity as a modern artist (Plate 171). Similar is a painting by O. H. Supono (1937–92) of the *panakawan* figures, although their appearances are closer to the actual *wayang* depictions (Plate 172). Another popular theme, the *wayang* performance, is also well-represented in modern art. An example by one of the grand old

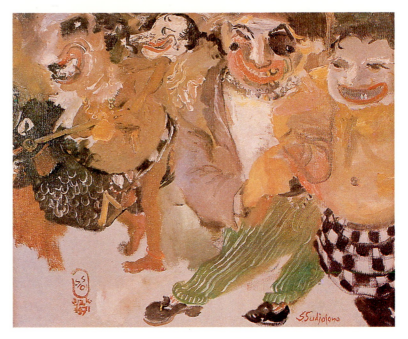

171. *Punadawan, the Faithful Jesters*, oil on canvas, Soedjojono, 1971. (Collection of the Adam Malik Museum, Jakarta.)

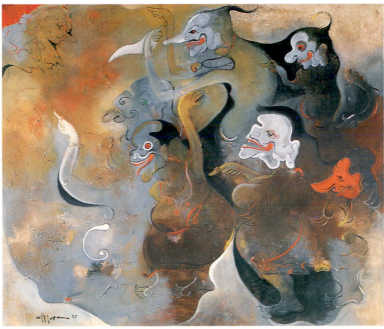

172. *Semar*, oil on canvas, O. H. Supono, 1985. (Collection of Duta Fine Arts Foundation.)

men of modern Indonesian art, Otto Djaja (1916–92), is that of a *wayang golek* performance in all its mystery showing a hazy light in the centre of the stage with distinct representations of the *gamelan* musicians in the foreground (Plate 173). Two pictures of the *kuda lumping* (trance dance prop) done almost thirty years apart are shown in Plates 174 and 175. The first is by Hendra Gunawan (1918–83) whom many consider to have been Indonesia's most important

173. *Wayang Golek*, oil on canvas,
Otto Djaja, 1977. (Collection of
Taman Ismail Marzuki, Jakarta.)

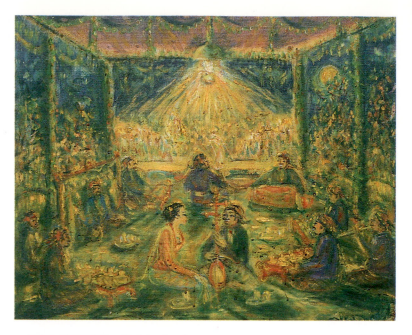

174. *Kuda Lumping*, oil on canvas,
Hendra Gunawan, 1962.
(Collection of Duta Fine Arts
Foundation.)

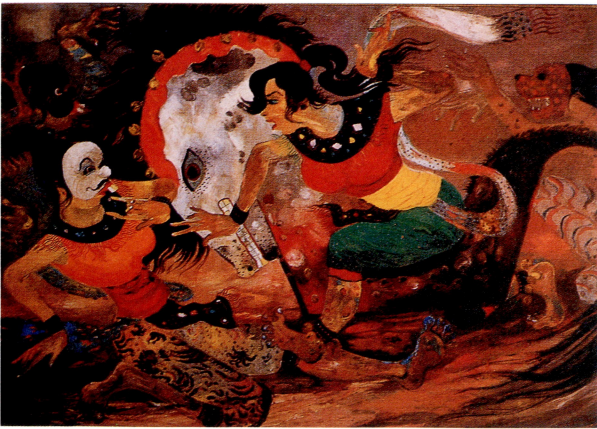

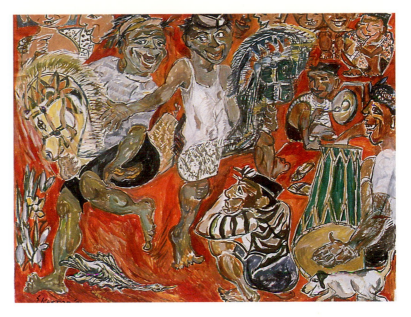

175. *Kuda Lumping*, oil on canvas, Sudjana Kerton, 1990. (Photograph courtesy of the artist.)

modern artist. His painting is full of vibrant colours and purposeful animation; it generates a visual power that comes both from the artist's imaginative composition and the compelling attraction of a traditional and sometimes awesome ritual. Compare this with a *kuda lumping* painting done in 1990 by Sudjana Kerton (1922–). Here is a simpler folk-like portrayal of an itinerant performing troupe riding their bamboo horses and playing instruments. It is a painting close to an actual performance in which the actors appear down to earth in their ragged clothes, with unrestrained facial expressions. It is a folk genre *par excellence* and reflects Kerton's great interest in portraying, often in stark form, the realities, both happy and tragic, of ordinary people.

To conclude this chapter, three other examples of modern treatments of traditional subjects are shown. The first is a contemporary painting on glass which is a fanciful depiction of symbols and ogres drawn from the *Mahabharata* (Plate 176). The second is a glass painting by Haryadi Suadi of a *loro blonyo* with mystical, indigenous inscriptions and various faces and forms (Plate 177). The third is a screen print by T. Sutanto which forms a fitting conclusion to this chapter as it is a microcosm of some of the most common folk elements in Javanese culture. Entitled *Dermayon Parade* (Plate 178), it contains the following: the Bouraq, Hanuman, a Balinese offering doll, two men riding *kuda lumping*, a man dressed as a mythical beast, a man wearing a double mask, a blind man with dark glasses, children playing, a group of musicians playing, a man dressed as a tiger, an elephant, babies floating about, and mothers with their offspring. Little has been left out; the folk tradition is seen as alive in Dermayon, a town near Çirebon in West Java. It is also alive in the mind of this modern Indonesian artist. Many such traditions are changing and some are fading away. It may be that in the future in Java the mind of the artist will be the last depository of such cultural memories.

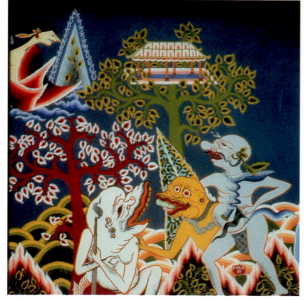

176. *Mahabharata Scene*, painting on glass, Putut H. Pramana, *c.*1987. (Collection of the Indonesian Ministry of Education and Culture.)

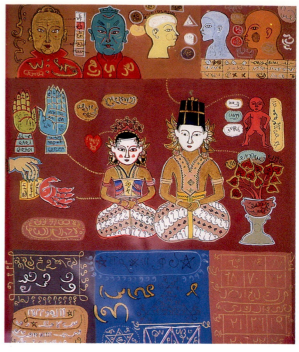

177. *Wedding Couple*, painting on glass, Haryadi Suadi, 1988.

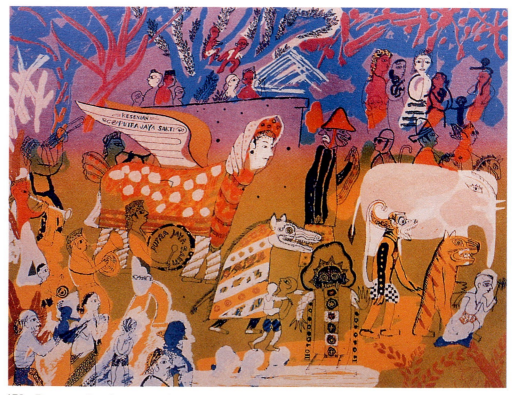

178. *Dermayon Parade*, screen print, T. Sutanto, 1978.

1. A valiant, if somewhat unsuccessful, attempt to intellectually and geographically broaden the domains of contemporary art was the purpose of a major exhibition held in Paris in 1989. The accompanying catalogue (*Magiciens de la Terre*, Paris: Centre Georges Pompidou, 1989) presented a challenging array of visual materials from all over the world accompanied by a provocative text.

2. Claire Holt, *Art in Indonesia*, Ithaca: Cornell University Press, 1967, pp. 191–254.

3. Joseph Fischer (ed.), *Modern Indonesian Art: Three Generations of Tradition and Change*, Jakarta and New York: KIAS and the Festival of Indonesia, 1990 and *Indonesian Modern Art*, Amsterdam: Gate Foundation, 1993.

4. Oto Bihalji-Merin, *Masters of Naive Art*, New York: McGraw-Hill, *c.*1970, pp. 21–2.

5. Ibid., p. 23.

6. For this comparison, see Yves Vequaud, *The Women Painters of Mithila*, London: Thames and Hudson, 1977.

7. For a comparison with a sixteenth-century Bouraq painting from a Persian manuscript, see Sheila S. Blair and Jonathan M. Bloom (eds.), *Images of Paradise in Islamic Art*, Hanover: Hood Museum of Art/Dartmouth College, 1991, Plate 17a, p. 47.

8. See Joseph Fischer, 'The Traditional Sources of Modern Indonesian Art', in *Modern Indonesian Art*, pp. 14–43.

9. A singularly useful essay is Astri Wright, 'Painting the People', in Joseph Fischer (ed.), *Modern Indonesian Art: Three Generations of Tradition and Change*, Jakarta and New York: KIAS and the Festival of Indonesia, 1990, pp. 106–59.

10. In this connection, it is interesting to look at Indian modern artists who have gone through a similar creative transition. If one compares a 1956 book on modern Indian art with the catalogue of an exhibition held in 1985 the contrasts are striking. In the earlier period, artists like Jamini Roy, Sunil Madhev Sen, and Sudha Mookerjee are featured, all of whom were clearly influenced by indigenous folk traditions. In an exhibition held thirty years later, the more obvious traditional content is gone, replaced by an Indian and international conception of modernity. The references are Ajit Mookerjee, *Modern Art in India*, Calcutta: Oxford Book and Stationery Co., 1956, and *Contemporary Indian Art*, New York: Grey Art Gallery and Study Center, New York University, 1985.

Bibliography

Album Wayang Beber: Pacitan, Jakarta: Ministry of Education and Culture, 1983–4.

Alibasah, Margaret M., *Indonesian Mouse Deer Fables*, Jakarta: Penerbit Djambatan, 1986.

Allan, Jeremy, *Yogyakarta*, Singapore: Times Editions, 1989.

Alwan Soebiantoro and Manel Ratnatunga, *Folk Tales of Indonesia*, Delhi: Sterling Books, 1979.

Anderson, Benedict R. O'G., *Mythology and the Tolerance of the Javanese*, Ithaca: Cornell University Southeast Asia Program, 1965.

Appasamy, Jaya, *Indian Paintings on Glass*, Delhi: Asia Book Corporation, 1980.

Aryan, K. C. and Aryan, Subhashini, *Hanuman in Art and Mythology*, Delhi: Rekha Prakashan, n.d.

Ashabranner, Brent and Ashabranner, Martha, '*Loro Blonyo*: Traditional Sculpture of Central Java', *Arts of Asia* (May–June 1980): 112–19.

Avedon, Elliott M. and Sutton-Smith, Brian, *The Study of Games*, New York: John Wiley, 1971.

Beasts and Superbeasts: Indonesian Folk Art. The G. W. Smith Collection, West Palm Beach: Norton Gallery and School of Art, 1981.

Benwell, Gwen and Waugh, Arthur, *Sea Enchantress: The Tale of the Mermaid and Her Kin*, New York: Citadel Press, 1965.

Berliner, Nancy Z., *Chinese Folk Art*, Boston: Little, Brown and New York Graphic Society, 1987.

Bezemer, T. J., *Indonesisches Kunstgewerbe*, Amsterdam: Aalderink, 1920.

Bigeon, Cécile, 'Labuhan: Rite royal du kraton de Yogyakarta célébré sur la plage de Parangtritis', *Archipel*, 24 (1982): 117–26.

Bihalji-Merin, Oto, *Masters of Naive Art*, New York: McGraw-Hill, *c*.1970.

Blair, Sheila S. and Bloom, Jonathan M. (eds.), *Images of Paradise in Islamic Art*, Hanover: Hood Museum of Art/Dartmouth College, 1991.

Boediardjo, '*Wayang*: A Reflection of the Aspirations of the Javanese', in Haryati Soebadio and Carine A. du Marchie Sarvass, *Dynamics of Indonesian History*, Amsterdam: North-Holland Publishers, 1978, pp. 97–121.

Bosch, F. D. K., *The Golden Germ: An Introduction to Indian Symbolism*, The Hague: Mouton, 1960.

Brandon, J., *On Thrones of Gold: Three Javanese Shadow Plays*, Cambridge: Harvard University Press, 1970.

Brandon, James R.(ed.), *The Performing Arts in Asia*, Paris: UNESCO, 1971.

Bronner, Simon J. (ed.), 'Material Culture Stories: A Symposium', *Material Culture*, 17 (Summer–Fall 1985).

Brown, Robert L. (ed.), *Ganesh: Studies of an Asian God*, Albany: State University of New York Press, 1991.

Brownrigg, Henry, *Betel Cutters from the Samuel Eilenberg Collection*, London: Thames and Hudson, 1992.

Bruner, Jerome S., Jolly, Alison, and Sylvia, Kathy (eds.), *Play: Its Role in Development and Evolution*, New York: Basic Books, 1976.

Buck, William, *Mahabharata*, Berkeley: University of California, 1973.

———, *Ramayana*, Berkeley: University of California, 1976.

Budaya-Indonesia, Amsterdam: Tropenmuseum, 1987.

Buurman, Peter, *Wayang Golek: The Entrancing World of Classical West Javanese Puppet Theatre*, Singapore: Oxford University Press, 1988.

Camman, Schuyler V., 'Symbolic Meaning in Oriental Rug Patterns', *Textile Museum Journal*, III, 3 (1972): 1–30.

Contemporary Indian Art, New York: Grey Art Gallery and Study Center New York University, 1985.

Coote, Jeremy and Shelton, Anthony (eds.), *Anthropology, Art and Aesthetics*, Oxford: Oxford University Press, 1992.

Courlander, Harold, *Kantchil's Limepit and Other Stories from Indonesia*, New York: Harcourt, Brace and Company, 1950.

Cox, Maureen, *Children's Drawings*, London: Penguin Books, 1992.

Cuisenier, Jean, *French Folk Art*, Tokyo: Kodansha International, 1977.

Danandjaja, James, *An Annotated Bibliography of Javanese Folklore*, Berkeley: University of California, Center for South and Southeast Asia Studies, 1972.

———, *Folklor Indonesia*, Jakarta: Grafitipers, 1986.

Dancu, Juliana and Dancu, Dumitru, *Folk Glass-Painting in Romania*, Bucharest: Meridiane, 1982.

Darminto, Th. A., *Album Seni Budaya: Jawa Timur*, Jakarta: Ministry of Education and Culture, 1982–3.

Dennis, Wayne, *Group Values Through Children's Drawings*, New York: John Wiley and Sons, 1966.

De Wit, Augusta, *Java: Facts and Fancies*, The Hague: W. P. van Stockum, 1912; reprinted Singapore: Oxford University Press, 1984.

Dopperen, J. W. van, 'Het Padismesje' [The Rice Cutting Knife], *NION*, XV, 9 (January 1931): 257–82.

Dow, James R. and Lixfeld, Hannjost (eds.), *German Volkskunde*, Bloomington: Indiana University Press, 1986.

Dundes, Alan, *Interpreting Folk Lore*, Bloomington: Indiana University Press, 1980.

Ecke, Tsen Yu-ho, *Chinese Folk Art II*, Honolulu: Privately published, 1977.

Engel, Jules, *Krisgrepen*, Amsterdam: Samurai Wapenhandel, 1981.

Epskamp, C. P., *Semar as Trickster, Wayang as a Multi-classifactory Representation of Javanese Society*, Leiden: Rijksuniversiteit Instituut voor Antropologie en Sociologie Niet-Westerse Volken, 1976.

Eswarin, Rudy (ed.), *Reverse Paintings on Glass: The Ryser Collection*, Corning: Corning Museum of Glass, 1992.

Fischer, Joseph, 'The Character and Study of Indonesian Textiles', in Mattiebelle Gittinger (ed.), *Indonesian Textiles: Irene Emery Roundtable*, Washington, DC: The Textile Museum, 1980, pp. 339–54.

Fischer, Joseph (ed.), *Modern Indonesian Art: Three Generations of Tradition and Change*, Jakarta and New York: KIAS and the Festival of Indonesia, 1990.

Fisher, Nora (ed.), *Mud, Mirror and Thread: Folk Traditions of Rural India*, Ahmadabad: Mapin Publishing Pte. Ltd., 1993.

Foley, Mary K., 'The Sundanese Wayang Golek: The Rod Puppet Theatre of West Java', Ph.D. dissertation, University of Hawaii, 1979.

Fontein, Jan, *The Sculpture of Indonesia*, Washington and New York: National Gallery of Art and Harry N. Abrams, 1990.

Forster, Harold, *Flowering Lotus: A View of Java*, London: Longmans, Green, 1958; reprinted Singapore: Oxford University Press, 1989.

Frey, Edward, *The Kris: Mystic Weapon of the Malay World*, Singapore: Oxford University Press, 1986.

Galestin, Th. P., *Iconografie Van Semar*, Leiden: E. J. Brill, 1959.

Gallop, Annabel Teh, *Golden Letters: Writing Traditions of Indonesia*, London and Jakarta: The British Library and Yayasan Lontar, 1991.

Geertz, Clifford, *The Religion of Java*, Chicago: University of Chicago Press, 1976.

Gittinger, Mattiebelle (ed.), *Indonesian Textiles: Irene Emery Roundtable*, Washington, DC: The Textile Museum, 1980.

Glassie, Henry, *The Spirit of Folk Art*, New York and Santa Fe: Harry N. Abrams and Museum of New Mexico, 1989.

Golomb, Claire, *The Child's Creation of a Pictorial World*, Berkeley: University of California Press, 1992.

Graburn, Nelson H. H. (ed.), *Ethnic and Tourist Arts*, Berkeley: University of California Press, 1976.

Grunfeld, Frederic V. (ed.), *Games of the World*, New York: Holt, Rinehart and Winston, 1975.

Haberlandt, Michael, 'Volkskunde und Kunstwissenschaft', *Die Volkskunde und Ihre Grenzgebiete, Jahrbuch für Historische Volkskunde*, I, Berlin: Stubenrauch, 1925, pp. 217–31.

Hardjonagoro, K. R. T., 'The Place of Batik in the History and Philosophy of Javanese Textiles: A Personal View', in Mattiebelle Gittinger (ed.), *Indonesian Textiles: Irene Emery Roundtable*, Washington, DC: The Textile Museum, 1980 pp. 223–42.

Haryati Soebadio and du Marchie Sarvass, Carine A., *Dynamics of Indonesian History*, Amsterdam: North-Holland Publishers, 1978.

Hauge, Victor and Takako, *Folk Tradition in Japanese Art*, New York and Kyoto: International Exhibitions Foundation, 1978.

Hazeu, G. A. J., 'Nini Towong', *Tijdschrift voor Indische Taal-, land-en Volkenkunde*, XLIII (1901): 36–107.

Hiller, Susan (ed.), *The Myth of Primitivism. Perspectives on Art*, London: Routledge, 1991.

Holt, Claire, *Art in Indonesia*, Ithaca: Cornell University Press, 1967.

Hostetler, Jan, 'Bedhaya Semang: The Sacred Dance of Yogyakarta', *Archipel*, 24 (1982): 127–41.

Hutton, Peter, *Java*, Hong Kong: APA Productions, 1980.

Indonesian Modern Art, Amsterdam: Gate Foundation, 1993.

Izah D. Syahril, 'Lukisan Kaça Çirebon', MA thesis, Institute of Technology Bandung, 1975.

Jayakar, Pupul, *The Earthen Drum: An Introduction to the Ritual Arts of Rural India*, New Delhi: National Museum, 1980.

Jessup, Helen Ibbitson, *Court Arts of Indonesia*, New York: The Asia Society Galleries and Harry N. Abrams, 1990.

Jones, Michael, *Exploring Folk Art*, Ann Arbor: UMI Research Press, 1987.

Juynboll, H. H., *Katalog des Ethnographischen Reichmuseums, Java*, 4 parts, Leiden: E. J. Brill, 1914–20.

Kallir, Jane, *The Folk Art Tradition: Naïve Painting in Europe and the United States*, New York: Galerie St. Etienne and Viking Press, 1981.

Kant-Achilles, Mally, 'Die Labuhan-Zeremonie am Indischen Ozean', unpublished manuscript, 1993.

Kant-Achilles, Mally, Seltmann, Friedrich, and Schumacher, Rüdiger, *Wayang Beber*, Stuttgart: Franz Steiner Verlag, 1990.

Kats, J., *Het Javaansche Tooneel: Wajang Poerwa*, Weltvreden: Commissie voor de Volkslectuur, 1923.

Keeler, Ward, *Javanese Shadow Plays, Javanese Selves*, Princeton: Princeton University Press, 1987.

_____, *Javanese Shadow Puppets*, Singapore: Oxford University Press, 1992.

Kellogg, Rhoda, *Analyzing Children's Art*, Palo Alto: Mayfield Publishing, 1970.

Kiyoshi Sonobe and Kazuya Sakamoto, *Japanese Toys: Playing with History*, Tokyo and Rutland: Bijutshu Shuppan-Sha and Charles E. Tuttle, 1965.

Knappert, Jan, *Myths and Legends of Indonesia*, Singapore: Heinemann Educational Books (Asia), 1977.

Koentjaraningrat, *Javanese Culture*, Singapore: Oxford University Press, 1985.

Kool, Catharina H., *Das Kinderspiel im Indischen Archipel*, Kempen-Rhein: Thomas Druckerei, 1923.

Laksono, P. M., *Tradition in Javanese Social Structure: Kingdom and Countryside*, Yogyakarta: Gadjah Mada University Press, 1990.

Lipman, Jean, *Provocative Parellels: Naïve Early Americans/International Sophisticates*, New York: E. P. Dutton, 1975.

Lordly Shades: Wayang Purwa Indonesia, Jakarta: 1984.

Lucas, Heinz, *Java-Masken*, Kassel: Im Erich Röth-Verlag, 1973.

Long, Roger, *Javanese Shadow Theater*, Ann Arbor: UMI Research Press, 1982.

Magiciens de la Terre, Paris: Centre Georges Pompidou, 1989.

Magnis-Susena, Franz, *Javanische Weisheit und Ethik*, München-Wien: Oldenbourg, 1981.

Mangkunagara (K.G.P.A.A. [His Highness Pangeran Adipati Ario]) VII of Surakarta, *On the Wayang Kulit (Purwa) and Its Symbolic and Mystical Elements*, Ithaca: Cornell University Southeast Asia Program, 1957.

Maquet, Jacques, *The Aesthetic Experience: An Anthropologist Looks at the Visual Arts*, New Haven: Yale University Press, 1986.

Maxwell, Robyn, *Textiles of Southeast Asia: Tradition, Trade and Transformation*, Melbourne: Oxford University Press and Australian National Gallery, 1990.

Mead, Margaret and Wolfenstein, Martha, *Childhood in Contemporary Cultures*, Chicago: Chicago University Press, 1955.

Mellema, R. L., *Wayang Puppets*, Amsterdam: Royal Tropical Institute, 1954.

Miettinen, Jukka O., *Classical Dance and Theatre in South-East Asia*, Singapore: Oxford University Press, 1992.

Miksic, John (ed.), *Art of Indonesia*, New York: The Vendome Press, 1993.

Milberg, Alan, *Street Games*, New York: McGraw-Hill, 1976.

Mode, Heinz and Chandra, Subodh, *Indian Folk Art*, New York: Alpine Fine Arts Collection, 1985.

Modern Indonesian Art, Amsterdam: Gate Foundation, 1993.

Moebirman, *Wayang Purwa: The Shadow Play of Indonesia*, The Hague: Van Deventer-Maasstichting, 1960.

Mookerjee, Ajit, *Modern Art in India*, Calcutta: Oxford Book and Stationery Co., 1956.

_____, *Ritual Art of India*, New York: Thames and Hudson, 1985.

Mulder, Niels, *Individual and Society in Java: A Cultural Analysis*, Yogyakarta: Gadjah Mada University Press, 1992.

_____, *Mysticism and Everyday Life in Contemporary Java*, Singapore: Singapore University Press, 1978.

Muller, H. R. A., *Javanese Terracottas*, Lochem: De Tijdstroom Lochem, 1978.

Narasimhan, Chakravarthi V., *The Mahābhārata: An English Version Based on Selected Verses*, New York: Columbia University Press, 1965.

Newman, Thelma R., *Contemporary Southeast Asian Arts and Crafts*, New York: Crown Publishers, 1977.

Nyai Loro Kidul: Cerita Dari Jawa, Bandung: Penerbit Citra Budaya, 1984.

Oettinger, Marion, Jr., *The Folk Art of Latin America*, New York: Dutton Studio Books and Museum of American Folk Art, 1992.

Oey, Eric (ed.), *Java: Garden of the East*, Lincolnwood: Passport Books, 1991.

Opie, Iona and Opie, Peter, *The Lore and Language of School Children*, London: Oxford University Press, 1967.

Otten, Charlotte M. (ed.), *Anthropology and Art: Readings in Cross-cultural Aesthetics*, Austin: University of Texas Press, 1971.

Overbeck, H., *Javaansche Meisjesspelen en Kinderliedjes*, Jogjakarta: Java-Instituut, 1939.

Pameran Lukisan Kaça Sulasno, Yogyakarta: Bentara Budaya, 1993.

Pameran Topeng Koleksi Museum Sono Budoyo, Yogyakarta: Directorate of Culture, 1992.

Parsudi Suparlan, *The Javanese Dukun*, Jakarta: Peka Publications, 1991.

Paramita R. Abdurachman (ed.), *Cerbon*, Jakarta: Penerbit Sinar Harapan, 1982.

Pariwatri Wahyono, 'Nini Towo', Ph.D. dissertation, University of Indonesia, 1990.

Pfister, Arnold, 'Bemerkungen zu den Grundlagen der Volkskunst', *Schweizerisches Archiv für Volkskunde*, 43 (1946): 391–438.

Ras, J. J., 'The Babad Tanah Jawi and Its Reliability', in C. D. Grijns and S. O. Robson (eds.), *Cultural Contact and Textual Interpretation*, Dordrecht: Foris Publications, 1986.

———, 'De clownfiguren in de wajang', *Bijdgragen Tot De Taal-, Land- en Volkenkunde (van Nederlandsch Indie)*, 134 (1978): 451–65.

Rassers, W. H., *Panji, the Culture Hero: A Structural Study of Religion in Java*, The Hague: Martinus Nijhoff, 1959.

Rathbun, William Jay, *Yō no Bi: The Beauty of Japanese Folk Art*, Seattle: University of Washington Press, 1983.

Redies, Michael, 'The Queen of the Indian Ocean', *Jakarta Program* (May 1990): 74–7.

Resink, J. J., 'Mers Javanese', *Archipel*, 24 (1982): 97–100.

Resink-Wilkens, A. J., 'Het Dakonspel', *Djawa*, VI, 1 (1926): 24–6.

Rhodes, Lynette I., *American Folk Art: From the Traditional to the Naïve*, Cleveland: Cleveland Museum of Art, 1978.

Ricco, Roger and Maresca, Frank, *American Primitive: Discoveries in Folk Sculpture*, New York: Alfred A. Knopf, 1988.

Richter, Anne, *Arts and Crafts of Indonesia*, San Francisco: Chronicle Books, 1994.

Ricklefs, M. C., *A History of Modern Indonesia, c.1300 to the Present*, Bloomington: Indiana University Press, 1981.

———, *Jogjakarta under Sultan Mangkubumi, 1749–1792*, London: Oxford University Press, 1974.

Rooney, Dawn F., *Betel Chewing Traditions in South-East Asia*, Kuala Lumpur: Oxford University Press, 1993.

Sagio and Ir. Samsugi, *Wayang Kulit Gagrag Yogyakarta*, Jakarta: CV Haji Masagung, 1991.

Salvini, Milena, 'Performing Arts in Indonesia', in James R. Brandon (ed.), *The Performing Arts in Asia*, Paris: UNESCO, 1971.

Scheurleer, P. L. and Klokke, M. J., *Ancient Indonesian Bronzes*, Leiden: E. J. Brill, 1988.

Schlee, Ernst, *German Folk Art*, Tokyo: Kodansha International, 1980.

Schlereth, Thomas J. (ed.), *Material Culture: A Research Guide*, Lawrence: University Press of Kansas, 1985.

Seiichi Sasaki, Wahyono Martowikrido, and Tatsuro Hirai, 'A Report on Indonesian Painting on Glass', 2 vols., Tokyo: Tama Art University, 1984, 1986.

Seni Kriya Boneka Jawa, Loro Blonyo, Golek Gambyong dan Menak, Jakarta: Bentara Budaya, 1993.

Serrurier, L., *De Wayang Poerwa: eena Ethnologische Studie*, Leiden: E. J. Brill, 1896.

Siek, Marguerite, *More Favorite Stories from Indonesia*, Jakarta: PT Rosda Jayaputra, 1986.

Smithies, Michael, *Yogyakarta: Cultural Heart of Indonesia*, Singapore: Oxford University Press, 1986.

Soedarsono, '*Wayang Kulit*: A Javanese Theatre', in P. L. Amin Sweeney and Akira Goto (eds.), 'An International Seminar on the Shadow Plays of Asia', *East Asian Cultural Studies*, XV, 1–4 (1976): 90.

——, *Wayang Wong: The State Ritual Dance Drama in the Court of Yogyakarta*, Yogyakarta: Gadjah Mada University Press, 1984.

Soenarto Timoer, *Wayang and the Cerita Rakyat*, Surabaya: Lembaga Javanologi, 1987.

Soepratno, *Ornamen Ukir Kayu: Tradisional Jawa*, Semarang: Privately published, 1984.

Soewito Santoso, *Indonesian Ramayana*, 3 vols., New Delhi: Sharadan Rani, 1980.

Solyom, Garrett and Solyom, Bronwen, *The World of the Javanese Keris*, Honolulu: East–West Center, 1978.

Steinfirst, Susan, *Folklore and Folklife: A Guide to English-language Reference Sources*, 2 vols., New York: Garland, 1992.

The Story of Damar-wulan and Lady of the South Sea, Semarang: Lim Yoe Siang, n.d.

Subagio Sastrowardoyo, Sapardi Djoko Damono, and A. Kasim Achmad (eds.), *Oral Literature of Indonesia*, Jakarta: ASEAN Committee on Culture and Information, 1985.

Subroto SM and Parsuki, *Album Seni Budaya: Jawa Barat*, Jakarta: Ministry of Education and Culture, 1983–4.

Sunardjo Haditjaroko, *Ramayana: Indonesian Wayang Show*, Djakarta: Djambatan, 1981.

Sutjipto Wirjosuparto, R. M., *Rama Stories in Indonesia*, Djakarta: Bhratara, 1969.

Sutton-Smith, Brian, *The Folkgames of Children*, Austin: University of Texas for the American Folklore Society, 1972.

Suwadji, *Album Seni Budaya: Daereh Istimewa Yogyakarta*, Jakarta: Ministry of Education and Culture, 1982–3.

Suyenaga, Joan, 'Ratu Kidul, Goddess of the Southern Seas', in Eric Oey (ed.), *Java: Garden of the East*, Lincolnwood: Passport Books, 1991.

Sweeney, P. L. Amin and Akira Goto (eds.), 'An International Seminar on the Shadow Plays of Asia', *East Asian Cultural Studies*, XV, 1–4 (1976): 1–96.

Turner, Victor W. and Bruner, Edward M., *The Anthropology of Experience*, Urbana: University of Illinois Press, 1986.

Ulbricht, H., *Wayang Purwa: Shadows of the Past*, Kuala Lumpur: Oxford University Press, 1970.

Unknown India: Tribal Art in Tribe and Village, Philadelphia: University of Pennsylvania, 1968.

Valmiki (Shri), *The Ramayana of Valmiki*, 3 vols., London: Shanti Sadan, 1970.

Van Buitenen, J. A. B. (trans. and ed.), *The Mahabharata*, 2 vols., Chicago: University of Chicago Press, 1973.

Van Der Hoop, A. N. J. Th á Th., *Indonesian Ornamental Design*, Bandung: Koninklijk Bataviaasch Genootschap Van Kunsten en Wetenschappen, 1949.

Van Groenendael, Victoria M. Clara, *The Dalang Behind the Wayang*, Dordrecht-Holland/Cinnaminson-USA: Foris Publications, 1985.

——, *Wayang Theatre in Indonesia: An Annotated Bibliography*, Dordrecht: Foris Publications, 1987.

Van Lohuizen-De Leeuw, J. E., *Indo-Javanese Metalwork*, Stuttgart: Linden-Museum, 1984.

Van Ness, Edward C. and Shita Prawirohardjo, *Javanese Wayang Kulit*, Kuala Lumpur: Oxford University Press, 1980.

Vequaud, Yves, *The Women Painters of Mithila*, London: Thames and Hudson, 1977.

Vetter, Valerie Mau, 'Dance and Drama', in Eric Oey (ed.), *Java: Garden of the East*, Lincolnwood: Passport Books, 1991.

Vinton, Iris, *The Folkways Omnibus of Children's Games*, Harrisburg: Stackpole Books, 1970.

Vlach, John Michael and Bronner, Simon J. (eds.), *Folk Art and Art Worlds*, Ann Arbor: UMI Research Press, 1986.

Vydra, Josef, *Folk Painting on Glass*, London: Spring Books, *c.*1955.

Wagner, F. A., *Indonesia: The Art of an Island Group*, New York: Crown, 1959.

Wassing, Rene S., *De Wereld van de Wayang*, Delft: Volkenkundig Museum Nusantara, 1983.

Whitten, Dorothea S. and Whitten, Norman E. (eds.), *Imagery and Creativity: Ethnoaesthetics and Art Worlds in the Americas*, Tucson: University of Arizona Press, 1993.

World Cultures, Arts and Crafts, Basel: Birhäuser Verlag, 1979.

World of Enchantment: Legends & Myths, An International Collection of Children's Art, San Francisco: Foghorn Press, 1993.

Wright, Astri, *Soul, Spirit, and Mountain: Preoccupations of Contemporary Indonesian Painters*, Kuala Lumpur: Oxford University Press, 1994.

Zimmer, Heinrich, *Myths and Symbols in Indian Art*, 2 vols., New York: Pantheon, 1946.